A LESSON IN ART & LIFE

Hugh St. Clair

A LESSON IN ART & LIFE

The Colourful World of Cedric Morris & Arthur Lett-Haines

PIMPERNEL
PRESS LTD
www.pimpernelpress.con

To Sophie, who first alerted me to the two wonderful protagonists
in this book, and my wonderfully supportive children,
Roman, Lorne and Esme

A Lesson in Art & Life
Copyright © Pimpernel Press Limited 2019, 2023
Text copyright © Hugh St. Clair 2019, 2023
Photographs copyright © see page 224
First Pimpernel Press edition 2019
This edition published 2023
www.pimpernelpress.com

This edition designed by Nicki Davis

A catalogue record for this book is available from the
British Library.

ISBN 978-1-914902-05-5

Typeset in Berkeley Oldstyle
Printed and bound in the UK

1 3 5 7 9 8 6 4 2

MIX
Paper | Supporting
responsible forestry
FSC® C171272

CONTENTS

INTRODUCTION 7

1. SONS OF WALES & LONDON 13
2. *A COUP DE FOUDRE* 25
3. PARIS: FINDING THE LOST GENERATION 35
4. TRAVELS IN EUROPE & BEYOND 45
5. BOHEMIAN LIFE IN FITZROVIA 59
6. A GARDEN IN THE COUNTRY 71
7. THE DRAW OF WALES 85
8. LETT HELPS WITH INTERNATIONAL RELATIONS 97
9. A LESSON IN ART & FUN 105
10. WARTIME AT BENTON END 119
11. PEACE AT LAST 131
12. THE GARDEN 143
13. EXCEPTIONAL FOOD 157
14. SIXTIES FLOWER POWER 169
15. LAST DAYS AT BENTON END 181

NOTES 194
SELECT BIBLIOGRAPHY 204
INDEX 207
PICTURE CREDITS 224

'IT IS THE ARTIST'S PART TO LOVE LIFE
AND SHOW THAT IT IS BEAUTIFUL;
WITHOUT HIM WE MIGHT WELL
DOUBT THE FACT.'
Anatole France, *As the Poet Says*

INTRODUCTION

THE YOUNG LUCIAN FREUD SAID THAT JUST WATCHING CEDRIC MORRIS PAINT a picture gave him a sense of sureness and purpose. Morris was one of Freud's first subjects. Maggi Hambling said Cedric Morris and his partner Arthur Lett-Haines changed her life, and credited Lett, as he called himself, for making her a professional artist. Gardener Beth Chatto said, 'It is impossible to say what Cedric Morris has meant to me. He influenced me in so many ways, made my life – a great man.'

When Lett-Haines died in 1978 and Cedric Morris in 1982 they had fallen into relative obscurity. The art world favoured Pop Art, American abstraction and work with strong emotional themes. However, shortly after Morris's death Richard Morphet, the Keeper of Modern Pictures at the Tate Gallery, persuaded the Tate to put on an exhibition of his work. Morphet described Morris as one of the greatest colourists of the twentieth century and was full of praise for 'his richness of painterly technique and his representational skill'. William Feaver, in his review of the Tate exhibition, described Morris as 'a Van Gogh or Utrillo for those of modest means'. With the general reappraisal of Modern British Art interest in Morris and Lett began to build. The lives and work of Morris and Lett-Haines have been the subject of numerous articles in newspapers and magazines. Today a bright and exuberant flower painting by Cedric Morris sells for hundreds of thousands of pounds sterling.

Morris and Lett studied in Paris and absorbed the work of the French Post-Impressionists, Cubists and Surrealists. They stayed in Montmartre, mixing with Juan Gris, Fernand Léger, Peggy Guggenheim and Ernest Hemingway. On their return to London they went to, and gave, extraordinary and memorable parties attended by Frederick Ashton, Augustus John, John Gielgud and Virginia Woolf. Cedric and Lett exhibited in many London galleries and in Rome and New York too. Cedric was praised for his use of colour and shape and his sensitivity to

nature in his landscapes and flower paintings and Lett for his designs of high order and his particular brand of Surrealism.

In 1929 they decided to forsake it all and move to an old farmhouse in Suffolk's Dedham Vale, in landscape that Gainsborough and Constable would have been familiar with. There they decided to open an art school, The East Anglian School of Painting and Drawing, which they hoped would be 'an oasis of decency for artists outside the system'. Student artists were to learn by example, diligence and experiment rather than through a prescribed curriculum. There was no formal admission requirement, conviction and commitment to work hard was the guiding principle, whether the student wanted to be a professional or painted purely for enjoyment. 'We don't believe that there are artists and students, there are degrees of proficiency', said the prospectus. Artists' models were supplied and students bearing easels were sent into the surrounding countryside. Lett put his energy into administering the school and looking after pupils' well-being. Some called him 'father'. Pupils were to include Lucian Freud and Maggi Hambling.

Cedric was insecure and sensitive, given to pique, but admired for his determination and seriousness in all he undertook. Lett had a more equable character and was mischievous and amusing, sometimes acerbic. He loved people and parties and could easily be distracted from his chosen profession. The two artists lived as a couple for over sixty years despite dalliances on both sides, Cedric exclusively with men and Lett with both men and a number of women. They were a strong and supportive union. Despite bouts of squabbling, they respected each other's differences and their shared vision that following creative pursuits would improve lives was a bond that held them together.

In 1940, after Lucian Freud allegedly set fire to the school in Dedham by dropping an unextinguished cigarette butt, the school moved to Benton End in Hadleigh, Suffolk. Visiting Benton End for the first time, the writer Ronald Blythe remarked, 'The atmosphere was well out of this world so far as I had previously witnessed and tasted it. It was robust and coarse, exquisite and tentative all at once, rough and ready and fine-mannered and also faintly dangerous.' He added that it gave him the confidence to pursue a writing career. Spartan grandeur was

how he described the bohemian set-up. Benton End was colourful, with blue doors and yellow ochre walls covered with modern paintings, and everywhere were treasures found by Cedric and Lett on their travels. Produce fresh from the garden was cooked in French style using olive oil, very difficult to find in England then, by Lett and one of the twentieth century's most influential food writers, Elizabeth David, in a distinctly primitive kitchen. 'You won't find doilies here,' she remarked. Visitors and students ate off wooden plates, with Cedric and Lett holding court but also encouraging everyone to express themselves and participate in lively conversation.

After the Second World War Cedric became an award-winning breeder of delicately coloured irises and poppies, with admirers including Vita Sackville-West and Beth Chatto. Pupils could be seen on glorious summer afternoons, easels propped among a riot of densely packed, colourful flowers. On occasion Benjamin Britten and Peter Pears could be heard playing and singing in the garden.

Today's interest in Cedric and Lett is at least in part inspired by their values. In the very conformist era following the end of the Second World War they challenged prejudice and helped the less fortunate. By vouching for gay men in trouble when same-sex relationships were illegal, Lett took risks. Cedric gave unemployed miners in the Welsh Valleys opportunities and self-esteem by helping to set up art and practical skills classes. He was an environmentalist and conservationist in the 1930s before the concept had entered the public consciousness. In the 1950s he protested against the use of harsh poisons on the land. Writing this book made me realize that the freedoms of expression and social norms we now enjoy, and the important issues we prioritize today, didn't just emerge fully formed. Cedric Morris and Lett-Haines, with their clear determination and devil-may-care attitude, helped change the way we live and think.

Such is their resonance in the twenty-first century that their Suffolk farmhouse is now run by the Benton End House and Garden Trust. The Trust's aim is to offer residencies for the gardeners and painters of today to absorb the creative spirit of Cedric and Lett. Matt Collins from the Garden Museum has discovered some of Cedric's plants that

have lain dormant over the years and thinks there are more to be found and nurtured. Others will be added. Sarah Cooke, former head gardener at Sissinghurst, has been collecting the bearded irises Cedric bred, all prefixed Benton in their name. Parts of the house will be restored to give a feel of the past and an exhibition space will be created to show work by Cedric and Lett and pupils of the East Anglian School of Painting and Drawing.

Thanks to a recent bequest, Gainsborough's House in Sudbury, Suffolk, has a rotating permanent display of Cedric Morris's work. There are over 240 Cedric Morris paintings in public collections across England and Wales, not all on display, but they can be viewed at www.artuk.org.

My special thanks, in alphabetical order, to the following, who have all assisted me with great generosity in my quest: Jennifer Andrews, James Birch, the late Ronald Blythe, Julia Boulton, Cathy and Peter Bullen, Lucy Cavendish, Mirabel Cecil, the late Beth Chatto, Matt Collins, Sarah Cooke, the late Mary Cookson, Robert Davey, Ashe Eriksson, Simon Finch, Jason Gathorne-Hardy, Diana Grace, Georgie Grattan Bellew, Maggi Hambling, Wenonah Harwood, Lawrence Hendra, Nathaniel Hepburn, Gideon Koppel, Jo Lawson Tancred, Rod Leeds, Laurie Lewis, Gail Lynch, John Lys Turner, Jim Marshall, George Miller, John Morley, Richard Morphet, Philip and Catherine Mould, Francie Mount, Conor Mullan, Emma O' Bryen, Eddie Oliver, Twig O' Malley, Diana Parkin, Bridget and Rob Pinchbeck, Hugh Tempest Radford, Lucy Redman, Anna Sanderson. Lucy Skelhorn, the late Tony Venison, Rosie Vizor, Felicity Wakefield, Peter Wakelin, Chris Grey Wilson, Jo Witcher, Christopher Woodward and all the staff at the Tate Gallery Archives and Library.

Hugh St. Clair
2023

1.

SONS OF WALES
& LONDON

C EDRIC MORRIS WAS BORN IN SOUTH WALES ON 11 DECEMBER 1889. TWO
younger sisters followed: Nancy, born four years later, and Muriel,
six years after that. Arthur Lett-Haines was born on 2 November 1894
and his sister Oenid in 1896. Cedric's father, George Lockwood Morris,
who inherited the baronetcy from a distant cousin and became the 8th
Baronet at the age of eighty-eight, lived at Sketty Lodge, then known as
Machin Lodge, near Swansea. He did not receive any large inheritance
from his forebears, but there was enough private money to enable him
to play rugby for Wales, at a time when rugby was still exclusively a
sport for amateurs. The handsome, wiry George was known as 'Morris
the football' and to his army of fans he was a great hero.

Off the pitch George enjoyed the country pursuits of riding to
hounds and bird-watching. His father might not have managed to
persuade Cedric to play rugby with any great enthusiasm, but he
certainly imbued him with a love of nature. Father and son would
ride horses all over the Gower Peninsula and walk along the coastline
around Swansea. Cedric recalled his father as a kind, gentle and
sensitive man. On many occasions the two of them would spend the
day in the reeds along the Severn and the Bristol Channel, watching
the seabirds.

Nancy Morris, in a television interview years later, recalled how she and her brother were allowed to roam freely around the Gower, poking around the beaches and fields looking for shells, insects, wild animals and birds. 'He was very bad at school, hopeless, but he believed in his gifts and his life around him.' She recalled that even from childhood he was the freest person she had ever known.[1] Nancy and he were never close, even when they were young, and never really became so in adulthood. In later communication between them she seems resentful and jealous. They saw each other infrequently. Perhaps as a middle child between a boy and a younger sister she felt overlooked by their parents. It cannot have helped that their sister Muriel died when Nancy was nine and Cedric thirteen.

Originally landowners from Shropshire, the Morrises were a prominent family in the Swansea area. In 1724 Robert Morris decided to sell his small estate and move to the Swansea Valley, hoping to make money from the burgeoning industrialization of South Wales. Known for his financial acumen, he was called in to value the assets of Llangyfelach copper works as part of bankruptcy proceedings. Seeing a business opportunity, he raised capital from London to form a partnership to take over the works at the same time as acquiring shares in the company. This proved a wise investment. His marriage to heiress Margaret Jenkins from Machynlleth enabled him to buy two estates in Tredegar Fawr and Penderi in the Tawe Valley. The couple had twelve children, though only six survived. One daughter, Margaret, moved to London, married Noel Desenfans, and became a part of fashionable town society. She was painted by Reynolds and helped to found the Dulwich Picture Gallery, the first public art gallery in Britain.

An over-abundance of money, of course, can lead to dissipation, and Robert's grandson, also called Robert, felt no need to work in industry. He eloped with the fourteen-year-old daughter of Lord Baltimore and got through his inheritance quickly, ending his days in India. It was his younger brother John who diligently expanded the business. At the age of just twenty-three he planned and financed the new town of Morriston for his workers on the outskirts of Swansea. He also invested in a new, bigger Swansea harbour. A man of culture, he purchased

paintings by Hogarth, Gainsborough and Romney and enlarged his house, Clasemont, on the edge of Morriston to display them. Cedric used to tell people that John was given a baronetage in 1806 for raising a band of Welsh labourers to defend the coast against a possible invasion by Napoleon Bonaparte. Ever restless, in old age John decided he did not want to live in Morriston amid workers' houses and factory fumes, so he had workmen move Clasemont brick by brick to the seaside village of Sketty on the Gower Peninsula, naming the reconstruction Sketty Park House. Over the next fifty years Sketty grew into a smart Victorian town with members of the Morris family building a number of substantial red-brick villas with huge gardens.

Less monied members of the family took respectable jobs in Swansea, becoming lawyers, bank managers and civil servants. However, in the 1850s Henry Morris, chairman of a Swansea bank, blotted the family reputation for probity due to his part in an accounting fraud for which he was sent to prison for two years. Robert Morris, Cedric's uncle, was a philanderer on such a grand scale that family members wondered how many people in South Wales were directly related to him. While his wife lay ill upstairs at home, Robert kept a mistress on the ground floor. On his wife's death his mistress raided the jewellery box of the recently deceased and wore as much of the jewellery as she could for the funeral.

The 4th Baronet Morris was keen to trace his noble pedigree and spent a lot of time poring over genealogical papers hoping to establish kinship to King Edward III of England. Cedric's cousin Robert Armin Morris lived a high life of leisure, running through a considerable amount of money organizing race meetings at Newbury race course. As a young man in the early 1900s he managed to get through his £10,000 annual allowance in one month. He invested money made by his forebears in unreliable ventures, including a poorly run whisky distillery.

When George Lockwood Morris married Cedric's mother, Wilhelmina Cory, a renowned beauty known as Willie, two important local industrial families were united. Wilhelmina was the daughter of Thomas Cory, a director of the Bank of Wales, and her relatives were shipowners and coal exporters. The Morris family money was older,

but the Corys were newly rich. In 1883 Willie's uncles John and Richard Cory, known professionally as the Cory Brothers, helped finance the Barry Dock scheme and became the largest shareholders in this impressive project. As his fortune increased, so did John's philanthropy throughout South Wales – in the 1900s he donated nearly £50,000 per year to the Salvation Army, Dr Barnardo's Homes, hospitals and sailors' and soldiers' retirement homes. He bought the Dyffryn Estate in the Vale of Glamorgan and in 1893 began to rebuild the house in a late Victorian eclectic style. Thomas Mawson, a well-known landscape architect and first president of the Institute of Landscape Architecture, was commissioned to remodel the landscape and design an impressive garden to match. Such was the scale of the project, it took fifteen years to complete. John Cory died in 1910, and his third son, Reginald, inherited. Reginald was a leading figure in the Royal Horticultural Society and a keen horticulturist and plant collector, who co-sponsored several worldwide plant-hunting expeditions in the early 1900s. Now accorded a Grade One listing, Dyffryn is described by its present owners, the National Trust, as possessing the grandest and most outstanding Edwardian gardens in Wales.

Willie had studied painting and needlework and, when Cedric was asked about early influences on his work, he would open a cupboard in his house in Suffolk and produce pieces of elaborate floral needlework his mother had sewn to her own designs. He credited her for his love of flowers, but her interest was not in names of plants or gardening; she only saw flowers as a subject matter. She enjoyed having flowers around her but took no part in growing them. She would visit her cousin Reginald at Dyffryn, who had grown the most wonderful plants that would become inspirations for her needlework and painting. Cedric recalled that his mother was charming and beautiful and, although little interested in ideas, highly visually literate. He saw her as a positive, determined, practical person, who would pursue to the end a course of action she had decided on. Although Cedric never later told anyone, he probably was taken to Dyffryn too. He used to joke that his future interest in plants came about as a baby when his mother would give him a flower to stop him screaming. He remembered noticing his maternal

grandmother's love of speckled flowers, particularly the purple-blotched *Lilium candidum*, which she had acquired from Dyffryn. Cedric came to believe that he had inherited the best of both sides of his family. In a dream later in life he wrote, 'I passed the ghost of my grandmother, she said I had the best of my family concentrated in me, I think I am more concentrated Morris than all of them and Cory too.'[2]

While Cedric was enjoying the perfect privileged childhood on the Gower Peninsula, Arthur Lett-Haines spent his early years in a much more modest home in an area of north-west London comprising mid-nineteenth-century terraced houses built for local business owners and professionals. His mother, Esme, had married architect and surveyor Charles Lett in 1882 and Arthur was born two years later in the recently built Walterton Road, Maida Vale. Shortly after his birth the family moved to a similar property in Mortimer Road, Kilburn. Arthur's father was an unreliable sort and Esme left him shortly after the birth of their daughter, Oenid, obtaining a divorce to marry Sidney Haines in 1900. Sidney was a more reliable man, a financially secure shipping agent, who lived in the more affluent area of Kew, near the Thames. Esme added Haines to Oenid and Arthur's surnames. Divorce was uncommon and frowned upon then and to new friends in Kew Sidney Haines was in all but blood the father of Oenid and Arthur. In the 1901 census Esme listed her son's name as Arthur Haines, omitting his father's surname altogether.

Charles Lett moved in with his sister and led an insecure life until his early death in September 1912. Arthur never really knew his father; he was only six when his parents separated and his mother did not encourage them to meet thereafter. Esme wanted to forget all about Charles Lett. When angry with her son, she would compare him to his father, saying 'your father was a fool and so are you.' Charles Lett died when his son was in his teens and Arthur dropped his Christian name and called himself Lett in acknowledgement of his departed father.

In Kew the young Lett led a quiet life. His mother and stepfather did not often go out or entertain. Their neighbours and few friends were conservative in attitude and, although later in life Lett became very gregarious, he had few childhood companions. His mother and

stepfather did not mix with arty types, although, judging by her enjoyment of Lett's friends later, she would probably have liked to do so. A memorable occasion in Lett's early life was a visit to the 1908 Olympic Games in London thanks to tickets from the Games' organizers (Sidney Haines was an official representative of the Amateur Wrestling Association). In the same year, fourteen-year-old Lett became a day-boy at St Paul's School in Hammersmith; the school that Duncan Grant and Paul Nash had attended some years earlier. The school had moved to new premises created by the architect Alfred Waterhouse in the popular terracotta brick and iron municipal Gothic style that was designed to project an image of rigour, discipline and modernity. The reforming headmaster Frederick Walker had added science and maths to the curriculum, although he personally still favoured the Classics as the only way 'a boy's mental definition and precise expression could be brought to any task'.[3] Lett was no scholar. School reports in those days were brief and to the point. In science he was 'moderate', in maths 'weak'. He was 'backward' in French, Latin and Greek. His best report was drawing: 'fair and improving'. In the class order he came fourth out of twenty in art, whereas in the other subjects he was in the bottom half of the class.[4] A fellow pupil of the school at that time was the author Ernest Raymond, who so movingly wrote in his novel *Tell England* about school friends who went to fight and die in the First World War. Lett was not in this group.

In Britain throughout most of the twentieth century attendance of a particular private or public school was a mark of social as well as intellectual stature. Edwardian society, with its minutely stratified social hierarchy, set much store by the 'right' schools. Eton, Harrow, Winchester, Rugby, Westminster and a handful of others were for gentlemen. Oxford and Cambridge universities took most of their students from them. Other private establishments were known rather dismissively as 'minor public schools'. In the late nineteenth century St Paul's was considered one such and headmaster Frederick Walker did not dare to presume otherwise. Indeed, he advised his staff against emulating the great public schools of Eton and Harrow.

Cedric's educational destiny was to attend a preparatory school

A LESSON IN ART & LIFE

for a top public school. He was sent far away from home at eight, as was the norm then, to St Cyprian's in Eastbourne, Sussex. This school was run by a young couple in their twenties who wished to widen the narrow intake of Eton, Harrow and Westminster. Headmaster Lewis Wilkes provided school places at significantly reduced fees for deserving cases, in the hope that these boys would attain scholarships to these public schools. His success rate was high. The appearance of children from poorer backgrounds can only have had a beneficial social effect on the shy, unconfident Cedric, who was unsure how he could follow his birthright. These boys would not have the swaggering arrogance and sense of entitlement found among pupils from the more traditional and exclusive prep schools for the British upper classes.

St Cyprian's was located near the South Downs, where Wilkes would take the boys on walks and picnics, giving them lessons in natural history. He also allowed them to run wild. For Cedric this was home from home. The atmosphere of the South Downs was very similar to that of the Gower. In those days the aristocracy were often remote from their children, giving over the running of their lives to a nanny or nursery maid; when they went away to boarding school, the matron or headmaster's wife took their place. Mrs Cicely Wilkes, called Mum by her charges, was a young woman with a fiery temper, whose moods flipped between firm discipline and generous indulgence. By former pupils' accounts, she was the boss, in total control of the school.

Cedric might have been surrounded by competitive and hard-working scholarship boys, but their studiousness did not rub off on him. He did not achieve high marks and it was decided that he should try for Charterhouse, whose entrance exam was less testing than Eton's or Winchester's. Charterhouse, the school to which he was indeed admitted, ran with the prevailing ethos which had typified private education since the time of Thomas Arnold of Rugby: much emphasis was placed on developing self-reliance and integrity of character through sport, especially cricket, athletics and rugby. Pupils memorized Sir Henry Newbolt's poem 'Vitaï Lampada' (the torch of life) in which a future soldier's selfless commitment to duty is born at school cricket matches. 'Play up! play up! and play the game!' it exhorted

future servants of the British Empire. Cedric certainly was not going to be a soldier or civil servant, the careers his father had considered for him. Cedric found one sympathetic teacher who, on learning of his love for riding, took the boy out hunting the following weekend.

Surrounded by a culture of male toughness, Cedric was sensitive and self-conscious. He hated his yellow curly hair; he wanted black locks. He felt unmanly and longed for hair on his chest to make him appear more masculine. He would rub in Vaseline every night to try to encourage its growth, but his upper body remained stubbornly smooth. He also singed his long eyelashes to darken them, even in the holidays, much to his mother's disapproval. In a blue notebook he confessed, 'I soon discovered that I possessed the kind of body that people liked to touch. I have always hated being touched except by someone I liked. As there was no one there I liked very much at either of my schools this was very awkward but it had its uses.'[5] He survived bullying by other boys by making them laugh. 'This predilection for yellow hair and long eyelashes plus my power to make people laugh I learned gradually that in art the of self-protection it was better for me to disarm the enemy to avoid a pitch [sic] battle.'[6] Perhaps it was a desire to achieve greater manliness that prompted him to take up boxing at Charterhouse. Survival meant distraction, then disappearance, in his case for a walk in the woods. Despite being crammed for the entrance exam, he failed to get into Sandhurst Military Academy.

Lett's mother had an idea that her son might become a farmer after leaving school, so the sixteen-year-old was sent to work on the farm at Poslingford Hall near Clare, Suffolk, but Lett showed no inclination for this rural career. He quickly returned to London, preferring to explore the landscape of the West End. He was more interested in the literary and artistic revolution that was occurring in London than in the natural world.

In 1909 the Italian poet, art theorist and magazine editor Filippo Marinetti published the Futurist Manifesto. Later Lett would cite him as a strong influence on his art and reproduce typically Futurist shapes and arrangements in his paintings of the 1920s. In 1912 the Sackville Gallery in London's West End held a Futurist exhibition. It was heady

stuff for an impressionable boy. He studied with great interest the newspaper reports, particularly the comments about the thirty-year-old Wyndham Lewis, who had produced large-scale, elongated pen drawings for a show at the Albert Hall in 1912. Lett appreciated the colourful geometric and rhythmic element that critic Roger Fry saw in Lewis's work.

Lett, as a prematurely sophisticated boy now on the loose in London, had no difficulty acquiring female admirers. Indeed, gossip many years later among those he instructed in art suggested that at seventeen he married a woman who died soon after, although no official record of this exists. Lett would write later in his biography for exhibition catalogues that he travelled in the Far East and the New World in his late teens, although he never said where.[7] He attended the Royal Military Academy in Woolwich and by 1913 he was a professional soldier. He enlisted and served in the Royal Field Artillery, becoming a Second Lieutenant. He was wounded in 1915 fighting in the British offensive against the Ottomans in Mesopotamia and was sent back to England.

Cedric's failure to gain admission to Sandhurst meant that an alternative plan had to be found for him. University was not an option. He agreed with his parents that he should see more of the world and the seventeen-year-old was given a boat ticket to Ontario, Canada, by his father and told to find work. He was first a farmhand, but then travelled to New York to be a waiter and lift-boy. A sheltered, naive and trusting boy with no real idea how much money he needed to live on, he was often paid less than he should have been. Much excited by the bars and clubs of Manhattan, where he heard Italian ballads and Dixieland jazz, he decided he wanted to be a singer. At nineteen he returned briefly to Swansea and in September 1911 enrolled at the Royal College of Music in London. His voice was a light baritone, and his Italian tutor, Signor Vignotti, attempted to raise it to a tenor to give him the strong singing voice he wanted. Much effort was expended, but the results were negligible. By the summer of 1913 Cedric had lost interest in singing and instead decided to try his hand at painting.

He returned to Wales and began painting and drawing what he saw around him. In 1898 Richard Glyn Vivian, whose family money

also came from copper, had become the Morris's neighbour when he purchased Sketty Hall. Glyn Vivian filled the place with early Italian drawings and Welsh and European oils and watercolours from the sixteenth to the nineteenth centuries. Cedric would go and look at the pictures at the house and his early watercolours, with their strong washes of colour, are in a classical English tradition. He was yet to discover what critic Desmond MacCarthy called 'the art quake'.

In 1910 paintings by Cézanne, Van Gogh, Gauguin and Matisse were shown for the first time in London at a post-Impressionist exhibition at the Grafton Gallery organized by the artist and critic Roger Fry. The older generation was horrified by these artists' ideas, but this made this new Continental style of painting and drawing all the more exciting to the young. The show drew huge crowds: in all, 25,000 people visited. Whether Cedric or Lett managed to see the pictures is not recorded, but they are likely at least to have known people who did. Cedric also made short trips to France to learn more about post-Impressionism. In April 1914 he decided to take painting classes at the Académie Delécluse in Paris's Montparnasse district. The Delécluse was one of a number of academies set up by artists in the late nineteenth century in reaction to the conservative state-sponsored École des Beaux-Arts. At these informal art schools there was no need to commit to a structured academic year. The Delécluse did not teach classical art history. Students were able to rent studios and receive informal instruction from established artists. The Delécluse particularly encouraged women artists to enrol, although in separate studios. It had been one of the leading ateliers in Paris in the late nineteenth century, but had not kept up with modern art and by the early twentieth century its influence and ability to attract students were waning. Cedric did not find the teaching satisfactory. He was discouraged by the what he called 'the arid and antiquated theories' they hammered into him there.[8] At his lodging house in Paris Cedric met Cuthbert Orde, who later became famous for his portraits of soldiers and airmen. The two got on well and shared a studio. Their painting friendship lasted for the rest of their lives.

Their time in France, however, was cut short. In August Cedric returned to Paris from a painting trip in Brittany with Orde to find a

telegram advising him to return to England. Britain had declared war on Germany. Back in London, Morris met up with an old school friend who persuaded him sign up with the volunteer regiment the Artists' Rifles. He was not to see active service. At the point of embarkation for France a final medical examination revealed he had mastoid problems and was not considered fit enough to join the army. In the doctor's opinion he could be rendered deaf by the sound of an explosion. Cedric was advised to play his part in some other way. As a keen horseman, he was directed to the Army Remounts Service. The Remounts' job was to train new horses sent from Canada for military duty. Horses' death rate on the battlefield was high and they needed replacing with increasing frequency. Cedric worked under Cecil Aldin, a horse painter acquaintance who was in charge of Lord Rosslyn's Remount Depot at Caldecott Park, Reading.

Cedric was responsible for eight horses at a time, and to get them battle-ready he rode one horse and led the other seven. He became a strapper (groom) as well, restoring them to health, which included scratching the horses' backs to test them for mange and applying foul-smelling ointment. Working alongside him was Alfred Munnings. They were not drawn together as friends; they were only similar in that they both had an occasionally cranky disposition. Their outlooks on the world were diametrically opposed. Cedric had a social conscience and socialist views inspired by the working conditions of the poor he had seen in the Welsh valleys. Munnings grew up the son of a miller in Suffolk, sheltered from such distressing sights. He held conservative views and liked to mix with country gentry.

Morris was excited by the new modern art coming from France; Munnings, only six years older, behaved like a blimpish Victorian squire and had no time for it. Cedric did, however, respect Munning's resolution to become an artist, and in 1916, when the Remounts became part of the British army and Munnings and Morris were replaced by enlisted soldiers, they both headed separately for Cornwall to paint.

Cedric first went to Zennor in North Cornwall, then moved south to Newlyn, where he stayed in a sail-loft, before renting Vine Cottage

from a Mrs Tregurtha. Next door was sculptor Frank Dobson, who had been invalided out of the war and later married Mrs Tregurtha's daughter Cordelia. Frank Dobson was learning stone carving from a monumental mason and also casting in bronze. Cedric helped him in his studio, casting and modelling, and also took flower painting classes. He later said that the Tregurthas offered him the perfect sanctuary when he needed to get away. He found refreshing 'their house of coarse emotions and crude thinking, people ruled, I think, almost entirely by physical things'.[9] His rather rough gouache portrait of the penurious New Zealand-born artist, forty-five-year-old Frances Hodgkins, who was spending time at St Ives, certainly shows a debt to Matisse. Hodgkins in a purple dress sits in front of a matching patterned wallpaper.

Lett took some army leave to pursue his painting. In 1916 he produced *Poems of Orissons of Sunnars*, an extraordinary work of escapist fantasy for a young English artist that shows the influence of Picasso and Aubrey Beardsley. In the same year he married Aimee Lincoln, whom he had met in London, at Hailsham in Sussex. She was from a Sussex family; he was twenty-two and she was twenty-three. By 1918 Aimee and Lett were living in Carlyle Square in Chelsea and on Armistice Day the couple gave a party to celebrate. This party was to change the direction of both their lives, and it was a guest, Cedric Morris, brought by a mutual friend, who did it.

A LESSON IN ART & LIFE

2.

A COUP
DE FOUDRE

CHELSEA HAD BEEN A CENTRE FOR ARTISTS SINCE JAMES MCNEILL WHISTLER and fellow artists formed the Chelsea Arts Club in the 1890s. By the beginning of the twentieth century, some thirteen hundred studios which included a living space had been built in and around Chelsea for would-be professional artists. After the First World War the next generation, including Wyndham Lewis and Jacob Epstein, joined the older Charles Rennie Mackintosh and Augustus John in renting studio spaces in the borough. The writers Ezra Pound and D. H. Lawrence also took up lodgings in Chelsea's artistic community. Lett later described society there as having 'an ambience of post-Impressionism and Futurism, which passed for avant-garde in those days'.[10]

In 1915 the dancer Margaret Morris (no relation of Cedric) had opened the Margaret Morris Club and Theatre in Flood Street, Chelsea. She was married to J. D. Fergusson, one of four artists known as the Scottish Colourists, who painted in the intense colours of the French post-Impressionists. Margaret Morris had several extramarital affairs, including one with John Galsworthy, author of *The Forsyte Saga*. Her animated manner attracted excitable young artists and writers. Lett met J. D. Fergusson at the club and took some art classes with him, later citing him as an important influence on his work.

One of the spontaneous parties celebrating peace on 11 November 1918 was thrown at 2 Carlyle Square, Chelsea, by Lett-Haines and his wife, Aimee. Into this throng of artists, painters and dancers stepped Cedric Morris. It was a revelation to the bashful young man whose London social life had been around the earnest types at the Royal College of Music. He immediately knew he had more in common with these jolly young people in colourful clothes. At the centre of the room stood an imposing figure, 6 feet 2 inches tall, with dark eyebrows, grey eyes and domed head crossed with a scar he claimed was caused by a rifle butt. (The scar became increasingly noticeable as he started to lose his hair.) Lett looked up from his circle of admirers for a second and glanced across at the self-conscious, crinkly-haired young man and decided to go and talk to him. Cedric was immediately taken with Lett's acerbic wit and what in future he would refer to as his intellect, sometimes in admiration, sometimes sarcastically. As their conversation progressed, the gregarious and inquisitive Lett recognized the strength in Cedric's quiet determination to become an artist. Cedric made Lett feel he would like to help him realize his ambitions and Cedric responded to Lett's interest. Lett encouraged his new friend to let go of any artistic inhibitions. In an introduction to a later exhibition catalogue of Cedric's paintings, Lett would declare, 'it was borne on him in Chelsea the complete freedom that would allow him to study art without having to draw from the plaster cast for three years before being allowed to give the imagination run.'[11] He also responded to Cedric's droll humour. Within a few weeks, Carlyle Square became Cedric's London base.

Cedric later told Lett that before meeting him he had been asleep and now he had 'sprung to life'.[12] He also analysed their differences in a letter to Lett eight years later, when their relationship hit a rocky patch. He called him 'a hopeless romantic with a head full of Russian novels, while I was very English, terribly shy, but had never felt like that before and my emotions were all bottled up, in fact only half awake. In spite of my age I translated them I know crudely, because I was terribly in love.'[13]

Lett told Cedric his plan to emigrate to America with his wife and

asked him to join them for a few months. Keen to do some painting before he left for the United States, Lett had sublet a studio from Frances Hodgkins in Eldon Road, Kensington, while she was working in Cornwall. As the February 1919 departure date approached, it became apparent Cedric was not well enough to travel. Earlier in the year he had contracted the often-fatal Spanish influenza, which swept Britain in the aftermath of the war. Cedric was lucky; in the care of a friend he got better despite being at the most susceptible age for this terrible illness. Lett then made a momentous decision. At the last minute he chose to stay behind to be with Cedric. He told Aimee to go on ahead.

As his health improved, Cedric knew he did not want to stay in London, so he decided to return to Newlyn to attend classes at one of the town's art schools. The clear, magical light had drawn artists since the late eighteenth century, including J. M.W. Turner. In 1884 the artist Stanhope Forbes moved to Newlyn, where he set up a small art school to teach the growing colony of artists and became known as the father of the Newlyn School of Painting. Equally influential was fellow artist Samuel 'Lamorna' Birch, who on the advice of Forbes adopted the soubriquet Lamorna after an area close to Newlyn, to distinguish himself from fellow artist Lionel Birch. The two Birches had arrived in Newlyn shortly after Stanhope Forbes. Lamorna Birch had taught Laura and Harold Knight in the first decade of the twentieth century.

Alfred Munnings took lessons from Lamorna Birch after the First World War, but a new wave of painters looking to develop a modern style were not satisfied with learning from Forbes or Birch. Cedric and sculptor Frank Dobson joined a young breakaway group which included Ernest and Dod Procter. Morris was not impressed by the tuition at the Forbes School, which he felt was all about painting landscapes and figures in the Victorian tradition. Dobson, too, found Forbes's teaching unsympathetic and Forbes was shocked at Dobson's modernism. Cedric was more interested in what the Procters could tell him. They had studied in Paris at Académie Colarossi and were familiar with Impressionism and post-Impressionism and had met Degas at an art class.

When Lett joined Cedric in Newlyn a few months later (having sold 2 Carlyle Square to Osbert Sitwell and his siblings Edith and Sacheverell), he fell in love with a row of fishermen's cottages on Newlyn quay known as the Bowgies and impetuously decided to buy a pair with the small amount of family money he had inherited. He wanted to join them together to make a suitable residence for two artists. He enlisted the help of the beautiful widow Mary Jewels to decorate the place. Mary was Mrs Tregurtha's other daughter; she had been widowed in the war and was now keen to become an artist. She was much encouraged by Cedric, who one sunny day placed a brush and canvas in her hands, giving her an order to come back with a painting by the end of the day. He was impressed with the result. It was in no small part Cedric's support of Mary Jewels that later gained her the attention of Augustus John, who then championed her work. At the Bowgies she painted the walls a deeply saturated blue, later known by artists as 'Newlyn Blue', and decorated lampshades and furniture with seagull and other beach motifs. The interior design was certainly eclectic: a coloured-glass rolling pin and a Persian pot were displayed alongside a terracotta-coloured fabric armchair draped in a sheepskin. Lett was a great collector of sea shells, pebbles and other jetsam from the beach, which he placed next to piles of finished and unfinished paintings, an interior style later adopted by Jim and Helen Ede at Kettle's Yard in Cambridge.

Frances Hodgkins, a frequent visitor, described the Bowgies as 'their futuristic abode'.[14] When she ran out of money for her rent in St Ives, she moved into the Bowgies, ostensibly to teach Cedric and Lett. In 1910 she had been one of the first female teachers at Académie Colarossi, but her hosts were not impressed by her unwillingness to instruct them. They both agreed she made no attempt, 'although we were her children'. Gladly relieved of the responsibility, she was able, as Lett said, 'to find new horizons in the gaiety and freedom of life'.[15]

The quiet and calm atmosphere of Newlyn was certainly disturbed with the arrival of Wyndham Lewis, Edward Wadsworth and Augustus John in the spring of 1919. Besides painting they were all keen to drink, argue and discuss the latest ideas in literature and art.

A LESSON IN ART & LIFE

Cedric, Lett and Frances found them vital forces creating new art to reflect the times. The work of Surrealist Wadsworth and Vorticist Lewis was to have a great influence on the work of Lett. Much as Cedric enjoyed the company of his new artist friends, he was not interested in incorporating any of their ideas and visual style into his painting. He preferred the French Cubists he had seen and met in Paris and their way of interpreting the world. Frank Dobson, who had been ill in hospital in London in 1918 with a duodenal ulcer from which he was slow to recover, decided he wanted to spend the summer of 1919 in Newlyn. Over the previous nine months he had worked on a Ministry of Information commission to draw his memories of the war. He lodged with his mother-in-law Mrs Tregurtha and wanted to work on something less harrowing than re-creating the trenches. He made a sketch of Cedric Morris in chalk and gouache. After posing for the drawing, Dobson asked Cedric if he would allow his torso to be cast in lead. Dobson gave the sculpture the title *Cedric* and exhibited it at his first one-man show at the Leicester Galleries, London in 1921. Cedric Morris and Frank Dobson shared similar tastes in art. Both admired Gauguin and the French post-Impressionists.

The shy Cedric was becoming more sociable, thanks in part to a new-found confidence Lett gave him. Both men were keen to dress up and host and attend parties. A photo from their time in Cornwall shows them both looking relaxed, with happy, contented expressions, lolling in front of the camera at a gathering of their friends. Cedric is wearing a long, flowing, patterned scarf and Lett is dressed in a seventeenth-century artist's smock, complete with beret, Peter Pan collar, foulard and velvet breeches. These young Francophile and Vorticist painters whose company Cedric and Lett enjoyed rarely mixed with the other group of Newlyn artists. The traditionalists, who had been to the Slade or other English art schools and exhibited at the Royal Academy, included Alfred Munnings, who strongly disapproved of the antics and the work of Cedric and his friends. Not only did he dislike French modern art, he also felt that the modern art lovers were disturbing the atmosphere of the small fishing town. Munnings had set up his studio in nearby Lamorna Cove. Munnings was keen to associate with good

English families and befriended the ambitious British artist Hannah Gluckstein, or Gluck as she liked to be called. She briefly had an affair with Cedric's sister Nancy, who had rented a cottage in Newlyn and spent time there over the next thirty years when, as Cedric put it, 'she was having the nerves'.[16]

In the summer of 1919 an atmosphere of creativity emanated from the Bowgies. Lett was writing poems and prose and Cedric and Hodgkins were painting portraits full of colour. In between flitting between London and Cornwall, Cedric painted a self-portrait in oil, a medium he had rarely used before. He depicts himself dressed in brown and orange against a yellow wall and a landscape painting probably by him. His expression is solemn. He also completed a portrait of Lett as a debonair man-about-town with his wide-brimmed felt hat, red spotted bow tie and matching handkerchief. In the same year Cedric attempted his first landscape in oils, *Landscape at Newlyn*, which was followed by *Landscape at Penalver* in 1920, shown at an Allied Artists Exhibition at the Grafton Gallery later that year. *The Times* critic Frank Rutter saw it as full of charm and rich in promise. Lett and Cedric also showed their work in a small gallery in Newlyn and Cedric began to be referred to as 'the Cézanne of Newlyn' by those in the local art scene who had managed to see reproductions of Cézanne's work. Like Cézanne, Morris painted landscapes by deploying a similar use of planes and blocks of colour and a variety of different brushstrokes to build up a picture, although Cézanne's work is considerably more accomplished, subtle and sophisticated. The comparison between Morris and Cézanne might have been reinforced at a later date by the art critic T. W. Earp's article in *Drawing and Design* magazine reviewing a Cedric Morris exhibition at the Arthur Tooth Gallery in 1928.[17]

Earp devotes half the text to Cézanne and his architectural forms, lamenting that Cedric Morris was one of the few English artists who could be as innovative and interesting as the French painter. 'The lessons of Cézanne were repeated texts of ritual, which are repeated to monotony,' he opined. He then goes on to praise Cedric's 'high degree of technical accomplishment, his landscapes distinguished by a remarkable sensitiveness, a real understanding of the moods of

nature'.[18] He never states that Morris is directly influenced by Cézanne, merely pointing out the colourful modernity of the two artists.

Cedric had now realized he wanted to become a professional artist with a London reputation, and he began making trips to the capital in search of artists' associations to join for career advancement and galleries prepared to sell his work. Thanks to the novelist Leo Myers, whom he had recently met in Newlyn, he was given an introduction to the Allied Artists Association, founded to give exposure to artists who did not want to show at the Royal Academy. The independently wealthy Myers would sponsor him over the next few years. In the summer of 1919 Cedric had also produced some pictures of London prostitutes, including *Alex Schlepper*. 'The prostitutes enjoyed doing something different from their normal line of work,' he later joked. He was also invited to paint a portrait of Anita Berry, whom he had met at the Margaret Morris Club. In the same year Anita and other members of the club had an idea to found an organization called the Arts League of Service, its name an allusion to the recently created League of Nations. Its declared aim – spreading the importance of the arts to provide enjoyment to everyone in the land – was an ideal close to Cedric's heart. Anita Berry was instrumental in encouraging up-and-coming artists and writers to join, including illustrator Edward McKnight Kauffer, Vorticists Frederick Etchells, Edward Wadsworth and the Nash brothers, Paul and John. Paul called the Arts League a 'national necessity'. Cedric would show there a number of times in the 1920s.

Lett spent most of 1919 in Cornwall, pondering his decision to leave his wife for a man. In the circles they moved in nobody cared, but in the wider world the trial of Oscar Wilde barely twenty years earlier still reflected the disdain in which homosexuals were held. But in a nation that was trying to rebuild its spirits after the terrible war the public and the police had no appetite for pursuing them, providing they were discreet. Lett drafted a frank but friendly letter to Aimee which he never sent. He told her he wished to dissolve their union. 'I desire you to have happiness and that I realise with all my faculties you cannot have this with me.' The rest of the letter explained and justified his love for Cedric, who he believed 'was the most romantic painter the United

Kingdom has produced since the Impressionists'.[19] He then went on to moan about Cedric: 'However much I willed it, the only card or message I got for my birthday was a phone call from Cedric. Cedric has been in London for some weeks and apparently is going to stay there, he is a dear boy and a very good friend and would send his love to you if he were here. He is fast climbing the ladder to fame (though he doesn't know it) as everyone in town is talking about his work – he has the advantage of money – indeed I often have not enough to eat.'[20]

Lett had been subsidized by Aimee during their marriage; now they were apart, the money had ceased. He was keen to impress upon her that he was working hard. 'I hope to get my book published this Xmas and have already started a new one and my book of poems is nearly complete. There are enough pictures for a show of my own when I can afford it. They are so different to what you have seen. It would make you laugh, I expect.'[21]

Lett's fears that Cedric might stay in London and not return to Newlyn to be with him were unfounded. During 1920 both men continued to draw and paint and travel round England. Lett had put away his poems and started to paint in earnest. His *Brighton Railway Station (Plate 2)*, would have made the Futurists proud in its depiction of machinery and modernity. Although Lett does not go quite so far in elongating shapes as some Futurists did, it is a dynamic picture that uses curves to express speed and movement. He never painted in this style again.

Cedric was painting works from nature that would impress the art-buying public and fellow artists. In 1921 he produced a selection of pen-and-ink drawings of birds. Anita Berry chose two of them to illustrate a chapter about form, pattern and space for a pamphlet for the BBC's Education Service in 1928. The following year she used Morris's *Greenland Falcons* in the *Studio* magazine's book *Art for Children* to show how the birds lived, where they nested and how they fed their young.[22]

T. W. Earp described Cedric's bird paintings in the 1928 Arthur Tooth catalogue as 'delightful decorations which give full opportunity to the delicate brilliance of his colour and sensibility of line'. *Birds of*

A LESSON IN ART & LIFE

the Barbary Coast (1920) was in rich blues with hints of yellow and, according to the *Daily Express*, stood out 'because the colour scheme would make an admirable decoration for a modern room'.[23]

But his bird pictures are certainly more than just decorative. Cedric does not paint birds with the accuracy of Archibald Thorburn or Audubon, in whose work every feather shines. Cedric dabs on paint quite crudely, but the overall impression is of vital beings with strength and power. It is the form and colour of the birds such as *The Jay* (1928) that interests him rather than birds represented as feathered, floaty things. Cedric rarely painted a bird against a white background but preferred birds in action, hovering and swooping. Richard Morphet, curator of a 1984 Cedric Morris retrospective at the Tate Gallery, wrote that 'his use of spiky impasto in his bird paintings enlivens them and gives them actual physical presence.' In 1926 the Welsh newspaper the *Western Mail* observed his technique when creating a painting of a bird: 'Morris has adopted an unusual method over his bird paintings, making colour compositions of the detailed colour and natural designs before he builds up the finished picture.'[24]

In 1928 Cedric was interviewed for the magazine of the Arts League of Service. He responded to a question about the accuracy of his bird paintings: 'If I paint a bird because I do not happen to see it with Mrs Jones' [presumably Mrs Jones was everywoman] ugly vision, must you accuse me of not being real and find my imagination at fault? It is my vision and very real to *me*. Realism is not Reality.' Birds were an expression of freedom for Morris.[25]

Cedric and Lett's stay in Cornwall lasted just two years. At the end of 1920 they concluded that they needed stimulation and instruction that could only be found in the French capital, the world centre of culture and freedom of expression that drew writers and artists, particularly from the more conservative United States and England. They put the Bowgies up for sale and set sail for Paris.

3.

PARIS: FINDING THE LOST GENERATION

H AVING HAD HIS TIME IN FRANCE CUT SHORT BY THE WAR, CEDRIC WAS NOW keen to return, this time with Lett. His friend Frank Dobson had also gone to Paris at the same time. Dobson introduced him to the influential British art critic and writer Roger Fry, who later wrote to his lover, Helen Anrep, 'I met a really interesting man, a young English artist, Cedric Morris, he really charmed me, very uneducated but ever so spontaneous and real ... He was all temperament and sensibility and genuine stuff, and très fin, and not at all a fool. I liked him.'[26]

Cedric was keen to immerse himself in all Paris had to offer. He became acquainted with Rupert Doone, the last premier male dancer in Diaghilev's Ballets Russes, and painted his portrait in 1923. Through Doone he met artist Nina Hamnett at one of the many parties held by the members of the English and American expatriate art community. After Armistice Day Paris had attracted American and British artists, writers and socialites and rich women looking for inspiration and inexpensive fun away from conventional families at home. Nancy Cunard and Peggy Guggenheim were rich and well connected but felt stifled by family expectations. Paris was a refuge for gay men and women too and couples in same-sex relationships could live much

more openly than in England and America. France had decriminalized sodomy in the French Revolution.

In Paris Lett could put his brain to something he enjoyed. He managed to become a good enough French speaker to translate some short stories by Guillaume Apollinaire and wrote his own poems in French. He was also keen to teach himself Italian and wrote notes on its grammar and vocabulary. Between 1923 and 1925 he wrote on a variety of topics for his own satisfaction rather than for publication. These included short stories, poems and literary and art criticism. He worked at poems which illustrated his fascination with eastern subjects. 'Art is the Supreme Manifestation of Human Activity,' he declared in capital letters in his notebook.[27]

Lett and Cedric first rented a flat in Montmartre on Rue Lepic, then moved to a first-floor apartment overlooking the courtyard on Rue Liancourt in Montparnasse. Montmartre was a more mixed area than Montparnasse, which by then was very much the quarter of French and foreign artists and tourists, where American and English newspapers were sold and English rang out across the tables in many bars. Montmartre was a more inexpensive, working-class neighbourhood, but a transvestite cabaret club, La Petite Chaumière, had opened recently, as well as a women-only club, Monocle, where ladies in gentlemen's suits and monocles met and took their girlfriends. By night, pleasure seekers of all types and classes flocked to the area.

Like every other artist working in Paris, Cedric sketched the characters he saw. In *The Brothel* (1922) there is no unhappy solitary absinthe drinker, but a couple of women, possibly a madame and her girl dressed in furs, but Cedric does not portray them as pitiable or depraved. One of his favourite cafés was another meeting place for poor artists, La Rotonde, whose proprietor would take paintings as collateral for bar bills. Cedric's watercolours *Le Bon Bock* (*Plate 3*) and *Café La Rotonde* (1924) did not seek to depict a tragic drunk. The pictures have an unjudgmental intensity. The women with their cloche hats and painted mouths and the men in their straw boaters seem to be enjoying themselves. Edward Burra, who stayed a number of times with Lett and Cedric in Paris, watched closely how the two artists worked, and visited

the bars with them. Influences can be seen in his own café scenes from his use of colour and instinctive response to his subject matter.

Most of the new art schools were situated in Montparnasse. Although the Académie Delécluse had closed as an art school on the death of M. Delécluse, its large painting studio was available to rent and Cedric decided to take a corner of it. Other artists occupied other areas and on occasion after a day's work Cedric and Lett might have a drink with Juan Gris, Fernand Léger and the sculptor Ossip Zadkine, who would become a good friend and visit them in England. In the evening, writers Ezra Pound and Ford Madox Ford, among others, would come by and often a party would develop. Cedric joined many would-be artists both male and female for *croquis libre* (freehand life drawing classes) before a live model in the warm rooms of the Académies Colarossi and Julian. Previously women had only been able to paint nudes from cast sculptures. At Colarossi anyone could purchase tickets for hour-long life drawing sessions. The impoverished artist Henry Moore found this within his budget. The newest venue, very popular with foreign students, was the Académie Moderne, founded and backed by a wealthy American who wanted to give opportunities to artists from the United States to learn more of current developments in French art. Fernand Léger and Amédée Ozenfant were on the teaching staff. Cedric and Lett dipped in and out of all the academies.

No young artist could avoid the fascinating new ideas about both subject matter and form swirling round Paris during the 1920s. Cedric was certainly influenced by the Cubists. His work also owes some debt to the previous generation of French artists, particularly Gauguin, in his use of similar dark outlines. Morris was praised in the *South Wales Daily News* for his use of an outline which, it said, 'forced the attention on the design'. However, the reviewer, referring to Morris's inclination to flatten his impressions on the canvas, 'worried that wilfully ignoring the third dimension might cause his work to slip into flimsiness'.[28] Lett embraced the literature and paintings of Surrealism in Paris and would travel an hour out of the city for weekends at the home of painter Hiler Hartsburg, where he would always find a gathering of intense, earnest Surrealists.

Morris and Haines were never offered an exhibition in the city. In 1922, on the invitation of Filippo Marinetti, they submitted work to the Casa d'Arte Bragaglia, a gallery in Rome run by the Futurist photographer Anton Bragaglia. Marinetti, the founder of Futurism, whose manifesto called for art to represent dynamic modern technology, was a wealthy man with good publicity skills. Cedric and Lett travelled to Italy to paint in preparation.

The catalogue compiled by Bragaglia and Marinetti tells readers that the exhibitions represented 'not the usual clique of know-it-alls but shows new trends in art without prejudice'. Lett-Haines offered drawings and watercolours including a drawing of Café Rotonde, a view of the Sea of Galilee and a rather dark work (in all senses of the word) entitled *Amusement*. Cedric put forward a total of twenty-seven paintings, a mix of flower studies and landscapes including *The Italian Hill Town* (*Plate 4*). Lett is described as a sculptor, whose black and white drawing 'shows symbolic meanings under modern structures'; the catalogue goes on to mention the macabre quality of his work.[29] Indeed, in Lett-Haines's *The Power of Atrophe* (1922) human eyes are placed in overwhelming inanimate objects, which oversee a tiny man at the bottom of a staircase. Lett agreed with the exhibition catalogue interpretation, calling his own sculptures and paintings at the Bragaglia 'nightmarish, spiritualistic and morbid'. Cedric's catalogue entry for the show is less alarming to the reader: 'Having completely distanced himself from the orthodox and protestant schools of his country, he has dedicated himself to free studies and modern experiences of technique, managing to give his work a sincere and personal character ... Cedric Morris is a very passionate lover of nature. A particular consideration should be given to his delicate sensibility for colour, the exquisiteness of which is easily noticed.'

Cedric received very favourable reviews from the Italian press. *La Tribuna* in Rome wrote: 'Morris with great economy manages to convey the atmosphere in his landscapes without allowing the one to interfere with the other, achieving at the same time noteworthy freshness and beauty. The works proclaim the aristocracy of the artist's materials, his paint is different from common paint, constituting a new sensibility.'

La Tribuna also picked up on an aspect of his painting that revealed his way of working and influences: 'the light dances among the waves of the paint flickering brightly so that the whole work takes on the appearance of a mosaic tapestry or precious enamel.'[30]

The exhibition opened on 1 November 1922, a few days after Mussolini had marched his Fascists into Rome. The Fascists did not approve of the art on show and closed down the gallery a week later. Fortunately, before Cedric and Lett were ejected from the country as 'undesirables', they had time to see the Rome exhibition of Giorgio de Chirico, who had founded the School of Metaphysical Art, the style which became Surrealism. On returning to Paris Cedric immediately started work heavily influenced by De Chirico. In *Golden Auntie*, completed in early 1923, Lett stands by a post-box waiting for an inheritance, while above the ghost of the dead aunt is at prayer, having risen from her coffin. Lett meanwhile was painting the brightly coloured but faintly erotic *Boy Mounting Lion*. He had a show at the Wanamaker Department Store in New York for his drawings, which showed strong Surrealist influences.

Cedric was painting abstract works and his *Experiment in Textures* (1923) predated Ben Nicholson's *1924 (first abstract painting, Chelsea)*. But these two artists differ in their approach; Nicholson's first piece has a patchwork feel of cut-out, flat, inanimate colourful shapes, similar to what Matisse would do in the future, whereas Cedric plays with texture and shape and colour, creating what could be distortions of three-dimensional natural forms. In *Experiment in Textures* he is playing with paint, applying it thick and thin in strong tones. This technique of applying paint in heavy dabs and making marks in all directions all over the canvas became typical of his work during the 1920 and 1930s, whether abstracts, landscapes or flowers.

For artists and writers living in Paris, winning the approval of two particular couples was a mark of success. Gertrude Stein and her partner Alice B. Toklas, along with Romaine Brooks and Natalie Barney, made very significant contributions to the artistic and cultural life of the city by providing somewhere for those with a creative bent to meet and exchange ideas. Every Saturday night Stein and Toklas would hold salons in rooms whose walls were covered in Cézanne

and Matisse paintings. Among the visitors were Ernest Hemingway and F. Scott Fitzgerald, seeking Stein's literary advice. A larger and less intimidating salon was run by the painter Brooks and writer Barney on Sunday afternoons at their house in Rue Jacob. Guests entered through a tiny door off the narrow street and found themselves in the wild and overgrown remains of a seventeenth-century garden, complete with a Doric temple. A hundred or so people, including on occasion Cedric and Lett, Peggy Guggenheim, Jean Cocteau and the writer and poet Mary Butts, would nibble delicious pastries made by Brooks's cook.

Mary Butts, recently hailed as the English Chekhov for her short stories as well as being considered an original and mystical modernist writer, became a good friend of Morris and Haines. She was certainly one of the most free-spirited and outrageous denizens of the city's expatriate scene. She received visitors wearing only a purple bedspread. All her clothes and underclothes were scattered across the floor and paintings by Cedric Morris and others were propped against the walls. Every surface, if not covered with books of prose and poetry that were required reading of the avant-garde, had lit candles on it. When the young Quentin Bell visited her in the late 1920s, he was greeted by a drug dealer wanted by the police jumping out of the wardrobe. As other guests dropped by and the absinthe bottle and opium came out, Bell made his excuses and left. In 1924 Cedric painted a striking portrait of the flame-haired, pale-skinned Mary Butts against a sun-orange background, wearing a dress in the same tone. Lucian Freud studied this picture very closely, calling it 'amazing'.

Gertrude Stein called the artists, writers, hedonists and dreamers in Paris 'The Lost Generation'. While the Americans called the decade 'The Roaring Twenties', to the French they were 'Les Années folles'. Drugs and drink were a part of the bohemian scene and some people drawn to Paris lacked any sense of purpose besides pursuing pleasure. Cedric and Lett were not seduced by opium or the 'green fairy', as absinthe was called; they preferred the company of those who indulged but left the party before conversation turned nasty or boring.

Morris and Haines were seen as the English gentlemen of the Paris art scene and they played up to the impression. The artist Kathleen

Hale, described by writer Antonia White 'as the most amusing person and best letter writer she knew, with an Elizabethan sense of humour', remembered her first encounter with them: 'They were like gazelles coming towards us, both of them extremely handsome and elegant in their lightly coloured socks.' 'Paris was a dream,' she wrote in her diary, 'we didn't go to bed for a week, we spent all our money on binges.'[31] Mary Butts recalled a party she attended with Cedric: 'The last thing I remember before I left was supporting myself on Cedric Morris' ears.'[32]

The antics of Cedric and Lett – what they wore, where they went – were eagerly reported in English-language newspapers and magazines. The *Paris Times* wrote in 1924, 'The Prince of Wales might be responsible for a vogue for blue collars but Cedric Morris instigated the fashion for wearing Fair Isle sweaters. This artist is famous for his swaggeringly disreputable attire.'[33] The *American Review* described Cedric Morris as 'an heir to a baronet who is a best seller in England yet whose life in Paris is as simple as that of the poorest and most unknown painter'.[34] He was photographed by Man Ray and his protégée, the young American Berenice Abbott. Lett had told the same newspaper he was an Irishman. Its reporter Arthur Moss wrote, 'I know no lad more languid than Lett-Haines.'

Seen as *boulevardiers anglais* by the English and American press, they were asked to show journalists and friends the exciting and edgy bars of Paris. Lett titillated them by recounting stories about the disreputable characters and intellectuals who inhabited them. Kathleen Hale was taken to a cellar bar called the Boule de Cidre just off the Boulevard Saint-Michel where the seats were cider barrels. 'It had been the hang-out of Verlaine and Rimbaud twenty years earlier. We didn't stay long as Lett said a fighting gang called the Apaches were on their way ... We went next to another bar, Lapin Agile or Lapin Gilles. Here poets recited their work, showed pictures, political groups plotted and philosophers struggled to define the meaning of definition ... Anyone could stand up and pontificate.'[35] Lett was asked by a journalist from the *American Review* to take her to the Boule de Cidre, where cigarette smoke wreathed guitar players, singers and guests alike. The journalist loved the mix of people, gazing wide-eyed at the 'men of the lower world in high-necked

jerseys, old donkey jackets, fedoras or caps over one eye mixing with artists and their models'. Lett had shown her a place with the whiff of danger she required. 'Sometimes someone gets shot or stabbed and people get crushed in the rush to get out before the police arrive,' he whispered into her ear. 'Cover your pearls. I am no good with knives.'[36]

Ernest Hemingway would include Cedric and Lett in his novel *The Sun Also Rises*. They appear as rather camp companions of the heroine Brett Ashley, who was based on one of their friends, Lady Mary Duff Twysden. Lett is described as the tall, dark one and Cedric as the wavy-haired blond one in a gang of men dressed in jerseys and short sleeves who go to a dancing club in the Avenue Montaigne. One of the men in the group sees Georgette, a prostitute, and announces, 'There is an actual harlot, I am going to dance with her, you watch, Lett.' Hemingway has Lett reply cautiously, 'Don't be rash.'[37] The author was never a friend of Morris and Haines; they were very different characters. The hard-drinking macho and sometimes doleful American writer lacked their social ease and charm and was jealous of their friendship with Lady Twysden. He was unnerved by what he called their 'superior, simpering composure' and failed to appreciate Lett's intelligent and perceptive side and ambitions to write or the stylistically diverse and original paintings Cedric was producing in France.

In 1924 Hemingway had become the assistant editor of the *Transatlantic Review* and for their art supplement in the March issue Cedric was asked to contribute drawings, along with Braque, Gwen John and Man Ray. Morris submitted two, one a drawing of reclining buffalo and the other entitled *Nursemaids in the Borghese Garden*. The form of these accomplished works shows the influence of Picasso and the confident use of line owes something to Cocteau. Hemingway forcefully expressed his dislike of Cedric's drawings. In November Cedric submitted drawings to the English quarterly magazine *Artwork*. Hemingway may not have given his stamp of approval, but an American collector's reaction to Morris's work had been positive. In 1923 the Société Anonyme, founded by Marcel Duchamp and Man Ray and backed by American patron Katherine Dreier, sent Cedric an invitation to show his work in New York. The exhibition was held in Dreier's Upper East Side

A LESSON IN ART & LIFE

brownstone home in Manhattan. The Société Anonyme was one of the first organizations to show contemporary art in New York and Dreier believed that the personal experience of viewing modern art would be enhanced in an intimate domestic surrounding. 'The experience should induce the viewer to treat art as a part of everyday life, not merely as a temporary exhibition,' wrote critic Richard Meyer.[38] The *New York Herald* agreed, admiring Morris's pictures of birds for their decorative possibilities and also the 'sensitive appreciation of their inherent qualities'.[39] The *Christian Science Monitor* in Boston described him as a painter of much charm: 'He is a young painter whose work is of that decorative quality which so well finds a place in the modern home.'[40] The *American Review* was more enthusiastic about the artistic merit of Cedric's work: 'His work is modern but without being exaggeratedly so, while he paints the same flowers others paint, his are real, the other men and women only succeed in executing a painting.'[41]

In June 1924 Cedric exhibited forty-four paintings at another private home, that of Mrs Judy Wogan, at 60 Gower Street, London, in her capacity as an organizer for the Arts League of Service. Morris's work was on display alongside William Staite Murray's stoneware bowls and pots glazed in rich mauve and purple, persimmon red and lapis blue. Among Cedric's paintings were ten abstract works that hung alongside his portraits, landscapes and animal drawings.[42] The critic R. H. Wilenski admitted that his drawings were 'at first a little strange . . . and make no concession to nineteenth-century realism or beauty, but looked at without prejudices, these drawings are seen to be full of whimsical observation, sly humour and fine feeling for pattern on the page, and since Gaudier [-Brzeska] no artist whom I know has drawn animals with finer synthesis and observation.'[43] *Good Housekeeping* magazine recommended his enchanting line drawing *At the Zoo* 'as one type of modern work that might appeal to the intelligent child'.[44] His images of birds were certainly arresting. A pair of drakes with their wings at full span take up most of the painting in *Ducks in Flight* (1924). There is nothing in the background to distract the viewer.

The Arts League of Service gave Cedric a second exhibition with Staite Murray in 1925, this time in Edinburgh. The resulting success and

publicity from both, Cedric later said, provided the breakthrough he needed. R. H. Wilenski's write-up for the exhibition catalogue accorded Cedric an accolade: 'Morris, I like to think, is on the threshold of a great career and he has already done enough to show himself an artist of unusual talent, energy and humour – three factors quite sufficient to make his pictures well worth laying down.'[45]

Lett wrote his rather grandiose appreciation of Morris for interested buyers in an essay entitled 'Pioneers'. 'The appearance of a pioneer in the world of art is not so much a frequent occurrence. Mr Cedric Morris' appearance, coinciding as it does with the first utterance of the British Prime Minister, shows him to be alive to the fact that Art is the supreme manifestation of human life and that the nation cannot live by the bread of commercial enterprise alone.' Cedric, he explained, 'is a new original, who owed no debt to Futurism, Cubism or Vorticism.'[46]

Cedric himself did not find it easy to talk to the press about his work. As one critic put it, 'he is an unusual personality. He is rather silent with his fellow creatures but in full sympathy with forms of animal life.'[47] He did allow Anita Berry to interview him for the 17 August 1924 edition of the Argentinian newspaper, *La Nación*, which was much more well disposed to modern art than British publications. Cedric wanted to talk about abstract art. 'Every picture is an abstraction whether it represents the objects of the external world or not,' he announced. 'A portrait, just as a landscape, is simply an arrangement of forms, lines and planes. In a good painting the lines and planes are related in this way. Therefore, it is impossible to copy nature in a photographic way. We have to reconstruct it, and to make a composition of an organised and vital drawing. To do this it is essential to give the forms the maximum expression, to discover the lines that can sustain the rhythm. In abstraction one exercises these essential points of the pictorial language.'[48] In the rest of the interview he stresses that none of his work from the most abstract to the easily recognizable landscapes was painted *en plein air*, none was a copy of what was in front of him. Morris wanted to get across the sensory appeal of the landscape and in reference to his pictures he observed, 'I hope they will transmit the emotion of the landscape or awaken the emotion of the landscape with its corresponding characteristics.'

A LESSON IN ART & LIFE

4.

TRAVELS IN EUROPE & BEYOND

A LTHOUGH LETT AND CEDRIC KEPT AN APARTMENT IN PARIS THROUGHOUT THE early 1920s, they spent much of their summers travelling around Europe and during the winter they visited North Africa in search of landscapes to paint. Cedric would continue to escape to the sunnier climes of southern Europe most winters until the last few years of his life, apart from during the Second World War. Like a number of British artists he needed to escape the endless grey days and scarce daylight of the British winter and see the uplifting light of the Mediterranean.

In locations round Europe and North Africa Cedric would position his easel in front of a landscape under sunny skies. Apart from being warmer and brighter than England, the cost of living on the Continent was far lower than at home. Cedric had another reason to travel abroad. His interest in unusual, non-British plants was starting to develop and he had met the noted ornithologist and plantsman Collingwood Ingram. Cedric would join him on plant hunting trips. The two men shared an interest in wild birds and on one occasion in Gibraltar Ingram took Cedric to see a forester who had a Bonelli's eagle that Ingram said must be obtained for London Zoo. Seeking out

the bird was a much lengthier process because neither Ingram nor Morris spoke Spanish. Eventually, after much sign language, the bird was acquired for five pesetas. Cedric frequently visited the bird when he was in London. The two men later fell out over the discovery of a white-flowered rock rose, *Cistus palhinhae*, on a trip to the island of St Vincent. Ingram claimed that he found it. Cedric always maintained it was him. What particularly galled Cedric was a picture of him in front of the plant many years later in Ingram's book, *A Garden of Memories*, captioned 'Cedric Morris examining a plant of mine'.[49]

In 1921, soon after their arrival in Paris, Cedric and Lett visited Algeria and Senegal. They would both spend time in North Africa over the following five years. Several early portraits by Cedric date from their first visit, including *Arab Woman*, painted in Algeria, and *Senegalese Boy* (1921). The latter painting, a pencil drawing of Lett and another of a Senegalese man were all done in the town of Tizi Ouzou. An Algerian garden, *The Jardin d'Essaie* (1921), is his earliest known drawing of a garden.

Cedric and Lett returned to Paris via Italy and the Dordogne, where Cedric painted a number of landscapes and flower pictures. In August Cedric and Lett attended the Margaret Morris Summer School in Normandy. Students were expected to play a musical instrument, sing, paint or design stage costumes and anything else that Margaret Morris thought relevant to unleashing their creativity. While Lett returned to Paris, Cedric continued to Berlin, but he was running out of money. He later told his friend Archie Gordon, Marquess of Aberdeen, that he had to take a job as a temporary assistant keeper at Berlin Zoo to restore his funds.

In the summer of 1923 Cedric and Lett were in the Pyrénées-Orientales, basing themselves in the town of Céret on the French border with Catalonia. Céret was an artistic colony favoured originally by Picasso and Matisse and by the 1920s it had become a mecca for Cubist artists. Cedric bumped into Alfred Cholerton, the British Moscow-based journalist, in the town and Cholerton sat for him. The picture, which he entitled *Portrait of a Political Extremist* (1923), was exhibited in The Hague to great acclaim. He also came across the

English Surrealist artist John Banting, who had been a fellow student at the Académie Colarossi. He was in a bad way, 'running around naked thinking he was Jesus Christ'. Cedric decided the best way to keep him still and under observation was to paint his portrait. Banting would have manic episodes throughout his life and spent time at Long Grove mental hospital in Epsom, Surrey. He always felt safe with Lett and Cedric and knew that he could confide in them and find support in what he called his 'mental adventures'.[50]

From Céret Cedric and Lett trekked across the Pyrenees into Spain, arriving in Barcelona tired and dishevelled. Their manual workers' attire drew the attention of the police, who under the military dictatorship of General Primo de Rivera had been ordered to arrest anyone they suspected of being a Communist. They were thrown into gaol. Other prisoners were brought food by the family, but Cedric and Lett were only fed due to the kindness of an American woman who looked after foreigners in the city. She managed to get in touch with the British consulate on their behalf and they were released on condition that they left inconspicuously. They boarded a boat bound for Majorca in the dead of night. There they stayed for a few weeks in the picturesque cliff-top village of Deia before slipping back into France.

By now, Morris was receiving very favourable press attention. The critic from the *Nation* newspaper felt that there had been an improvement in Morris's work over the last two years, in particular his landscapes. Following an exhibition at the Arthur Tooth Gallery in London in March 1923, he described Morris as having 'the hallmarks of an English painter in his sensitivity towards the atmospheric moods of the climate'.[51]

The mid-1920s found Cedric's work at its most experimental; indeed his painting *The Bird* (1924) incorporates some Surrealist influences that Lett had adopted. In this picture a lady is giving a man a bird, but all is distorted and both people have blank staring eyes. Lett wrote on the back of the canvas his alternative title, *Crème de Menthe*. Morris's *Halcyon* shows a nude lying by a lakeside in the pose of the *Sleeping Venus* by sixteenth-century Venetian painter Giorgione, with a kingfisher flying overhead. Maggi Hambling thinks that her head

and face closely resemble that of Lett. This kind of subject treatment was short-lived. After the 1920s he never painted full-length portraits and nudes again.

The year 1925 was very busy for both artists, although they spent much of it apart. Their personal partnership was starting to face challenges that would test their commitment to each other. Lett wrote retrospectively in his 1923 diary that this was the last year that he and Cedric would be exclusively together. Over the next few years they would produce an extraordinary variety of work. They had both been given an exhibition at the National Arts Club in Brooklyn under the umbrella of *The Little Review*, although they did not attend. They started the year in Morocco, where Cedric painted a good portrait of Lett, this time wearing a more serious expression, against a map of the country. Cedric then returned to France, leaving Lett to move on to Tunisia, where he reported back that he found the country and the culture artistically stimulating but was shocked by the pitiable life of women there. Lett typed out an essay called 'The Harem'; he somehow must have managed to enter one, as he describes the furnishings in great detail. In another piece of writing he described the desperate poverty of the Bedouin in the twentieth century.[52] He was also making sculpture: *Mud Pie* is a head of man made from dried mud with oil paint glaze on top. Another piece, *Deities of the Lake*, is sandstone carved in squares and rectangles on a plinth.

In the summer Cedric went to Bruges, where he painted landscapes including *Barges on a Canal near Bruges*, after which he went back to stay in Newlyn with the Tregurthas. In an untypical picture he turned his back on the sea to paint the new cinema, calling it *Heritage of the Desert* after a film of that name, a contemporary silent Western. The cinema is painted close up and not set in a landscape as are most of his buildings. In November Cedric returned to Deia, before moving on to Tunisia and basing himself in Gabès, taking excursions round the country including to the island of Djerba. Lett meanwhile was in Paris or staying with his mother in Sussex.

Their different plans were in part governed by a love affair. While in France in the early part of 1925 Cedric had fallen for a dark-haired

young man called Paul Odo Cross, who he thought might have had a bit of native American in him. Cedric was in the South of France at the request of Paul's mother, the formidable Mrs Florence Odo Cross, to paint her portrait. She was so aghast at the preliminary drawing that she forbade him to execute the portrait. Cedric's busy line drawing certainly captures a redoubtable woman of strong character. Mary Butts loved the story when it was told to her back in Paris and assured Lett 'that the business of art is to tell the truth'.[53]

By the spring Cedric could no longer keep his feelings for Paul to himself. It was as if he needed Lett's approval or disapproval. 'I can't fight against it, I have tried. I am not bored with you, I never shall be, but I am dreadfully in love.' he told him.[54] 'I am going with Paul to Bordeaux for a month ... Infatuations are all very well but they cannot last for ever. After all we have tried every known remedy except the obvious one, that is of seeing too much of each other.'[55] Cedric painted a rather startling portrait of Odo Cross with exaggeratedly arched eyebrows and hair that looks like a wig (*Plate 12*).

Throughout his affair with Paul, Cedric wrote to Lett, telling him his deepest thoughts: 'I cannot talk to you so must write as usual.'[56] Lett would reply to every letter, sometimes with weary reproaches, more irritated than angry, but never in a tone of high dudgeon. At no time did he ask him to choose between him and Paul. Cedric, in an attempt to absolve his guilt, urged him to look for his own love interest: 'I have the courage to say, find another lover.'[57] That is exactly what Lett did, taking up with a young man, their mutual friend Roy Martin. Lett told Cedric, who of course immediately felt jealous. In August he wrote from Newlyn in drunken melancholy to Lett, 'I love I love you. I'll die if I don't see you soon. In all the ways that people love one another, I love you more than anyone else in the world.'[58] Lett replied calmly with a hint of censure: 'Please stop getting drunk. It is the intoxication, not the drink, that is bad for you.'[59] Ever since Cedric had confessed his affair to Lett the correspondence between them, although interspersed with complaints and jealous barbs, also included news from one to the other, the ballet one had seen, the people the other had met and paintings both of them were doing. Soon after he confessed to his love affair with

Paul, Cedric wrote excitedly to Lett thanking him for helping with the composition of 'The Big One', which incorporated a dancing sailor beside grazing cows with boats on the sea in the background.[60] Indeed, *Dancing Sailor* (1925) at over 1 metre square was the largest picture he had painted to date. The picture remained unsold for many years.

In southern France Cedric painted *Vallée de l'Ouvèze* (1925) and wrote to Lett in Tunis: 'I think the landscapes are the best I have ever done, rather like the Newlyn ones, the colour suits me here.'[61] Each man had to know where the other was: Lett drafted a letter explaining his travel plans but never sent it. In the same letter he accused Cedric of vagueness: 'How I hate your stupid vagueness. Why can't you date your letters?'[62] Cedric wrote from the Gironde to Lett in Tunis in increasingly shrill tones when Lett did not respond: 'I feel rather anxious that I have not heard from you. How are you and where are you? I think of you most of the time in spite of everything. I don't want you to stay away from me unless you want to.'[63] 'Because the thing between you and me is so strong it has chained us together probably for always'.[64] In April Cedric was in Paris and sent Lett an invitation to join him. Lett replied, 'I should love to join you in Paris or anywhere else you like if you have finished roosting with Paul.'[65]

A few months later Cedric again invited Lett to join him in Paris. 'Will you come with me to Paris in September? I won't contemplate sharing you with anyone. If you prefer him [Roy Martin] to me, please say so and I will go away to cure myself of you'[66] 'You will find in him [Roy] all the things you wanted in me, the reverse of all the crudeness and rudeness, so it will probably be a success.'[67] The affairs probably fizzled out because both Paul Odo Cross and Roy Martin began to realize that they were not receiving the full attention of Cedric and Lett, who were too busy communicating with each other. As Kathleen Hale observed, the pair may have had affairs but they were inextricably bound together for life. Back in England in July 1925 Cedric wrote Lett a long letter to try and clear up the misunderstandings and resentments he had held towards him: 'You lived with your wife at the same time as you did with me. I wasn't jealous, I was shocked.'[68] He endeavoured to explain his moods and tantrums and the crudeness for which Lett

had criticized him. 'You intellectualised and analysed everything especially sexual things, which made me shyer and cruder and you laughed at me.' This analytical attitude, he went on to write, made him feel rejected and bad-tempered: 'I took it out of you in temper during the day and bottled up my emotions more and more in the evening.'[69] But at the end of this unburdening he declared his undying love for Lett: 'You seemed to understand and always helped me and this kept us together, I have become dependent on you. Personally, I can never be content without you and probably never with you.'[70]

Throughout the summer they were still spending time in different places but continued to write to each other practically every day. In August Cedric stayed with a Mrs Oates in St Just, Cornwall, and the men's correspondence included a frank discussion about their respective painting styles and approach to their work. Lett had accused Cedric of preventing him from developing his oil painting skills but Cedric replied his oils were bad because 'you were too damn lazy to learn your medium properly.'[71] He continued: 'I have always believed in your work and tried to make you work. You have ten times the brains and ability I have and a much better understanding in every way.' While admiring of his brain, Cedric was frustrated that Lett did not use it to best effect: 'I should like to know in the bottom of your heart you have the ideal for action (not necessarily art) or that of the leasured [sic] classes a little dilletantism, a little pretence at work or a little or lot of sensuality.'[72]

Nancy Morris, in an attempt to reunite Lett and her brother, suggested they all share a house and a little car in the West Country, with Lett and her looking after the inside and Cedric and her looking after the outside. But they all knew that this could not really work. However, by the winter Cedric and Lett were back together again and decided to travel to North Africa. To celebrate and commemorate, Cedric painted a portrait, *Arthur Lett-Haines* (1925). The handsome sitter, whose dark hair has become more golden, is placed in front of a map of northern Morocco.

Lett enjoyed travelling in French North Africa, a playground for British gay men where the offence of buggery was not enshrined as an

offence under the Napoleonic code. It was while Lett was in Sousse the following year that he met a twenty-year-old soldier, Jack Macnamara, awaiting trial for importuning an Arabic policeman. Lett took to this young man, he felt that he didn't deserve to be convicted for misreading signals around a sexual encounter. He wrote to the Editor of *The Times* and the British Council in London vouching for Macnamara's good character and innocence. Jack told his mother that he had been arrested for spying for the British government. She passed on his letter to the Foreign Office, who came to his defence on this accusation, and the charges were dropped.

In January 1926 Cedric submitted landscapes to a group show of the London Artists' Association. The Association had been set up in the previous year by Samuel Courtauld and John Maynard Keynes at the instigation of Roger Fry, for the purpose of assisting young artists. Located in New Bond Street, the aim was to have exhibitions backed by financial guarantors so that artists could show their work at minimal cost and be guaranteed a small income to allow them to keep working. Guarantors were given the option to purchase work exhibited at prearranged prices. In February Cedric was part of a group show at the Claridge Gallery. The *Morning Post* critic singled out his *Spanish Landscape* and his bird oils *Green Plovers* and *Cormorants* and remarked on 'the sinuous lines of his silverpoint drawings of leopards and camels'.[73] The *Western Mail* said his work expressed true Celtic temperament and that, as a close observer of animal life, he had reproduced the creatures 'with striking faithfulness'.[74] The *Leeds Mercury* was more cautious, asking for an opinion on his *Floral Abstractions* under the headline, 'Queer New Kind of Art. What do you think of this picture?'[75]

Cedric's flower pictures have a density of colour applied in thick brushstrokes. *Poppies* (*Plate 8*) depicts a riot of purple and scarlet poppies set against a brick-red background. Tony Gandarillas, the lover and sponsor of the young painter Christopher Wood, whom Cedric was acquainted with in Paris, talked about Cedric's work as having a 'spectral feel'. 'Cedric Morris' painting style is animistic not humanistic. I mean one would not be surprised if some of his places grew in the

night, as if by magic,' he told Wood.[76] Cedric never saw flowers as floaty and ephemeral but as intense and determined things, symbols of strength portraying the eternity of existence. 'Flower painting was not merely just struggle and achievement but a crystallisation of past apprehensions,' he elaborated. Colourful, densely packed flowers full of life became a hallmark of Morris's paintings. Richard Morphet, Keeper of the Modern Collection at the Tate Gallery in the 1980s, felt that Cedric 'saw a kind of life in the plant world which was oddly parallel to the world of humans and was constantly amused by the erotic analogies'.[77]

Other work had a surreal feel. Cedric's *Celtic Twilight* (1924) has a naked lady in front of a cross draped in a climbing plant. Possibly it is a humorous comment on the Church's teaching on morals. He also decided to condemn the hypocritical moralizers of America. *The Entry of Moral Turpitude into New York Harbour* (1926), painted in the manner of Sienese artists of the fourteenth century, depicts a ship full of people entering the harbour. Cedric was angered by a newspaper article describing the refusal of the United States immigration authorities to allow an Englishwoman on the ship to enter the country on her arrival at New York because she was guilty of 'moral turpitude'. Her offence was travelling with the man cited as the co-respondent in her divorce proceedings. The picture inspired by this puritan stance was exhibited in a group show of the London Group, which was run by artists for artists. Among the thirty-two in the group were Robert Bevan, Henri Gaudier-Brzeska, Jacob Epstein, Duncan Grant, Wyndham Lewis, Lucien Pissarro and Walter Sickert. The picture was bought by Vita Sackville-West's husband, the diplomat Harold Nicolson.

At the same time as painting imagined scenes, Cedric was also turning his attention to his everyday surroundings. There is a scene against a winter sky in *View from a Bedroom Window, 45 Brook St* (1926), which achieved a rich, detailed surface through the application of thick, opaque layers.

London galleries and independent art organizations had begun vying for Cedric's work and critics approved of his more figurative direction. Later in the year the Little Review Gallery in New York,

which prided itself on attracting the latest in 'sculpture, painting, machinery and constructions from all over Europe', gave Cedric a show of drawings to complement sculpture and drawings by Lett and Gaudier-Brzeska. The show was entitled 'English Moderns'. The *New Yorker* told its readers, 'Cedric Morris and Lett-Haines are both naughty boys and you will enjoy them if you can stand any of this modern fooling. The show will not shock you, Lett-Haines often goes for pure designs of high order.'[78]

At the end of 1926 Cedric was pleased with his efforts in Paris and Cornwall; he sent the resulting pictures to London, where he had been invited as a guest artist of the Seven and Five Society at the Beaux Arts Gallery in the first week of 1927. He submitted oil paintings, *Shipping* and *Newlyn*, and watercolours, *Café Scene in Paris* and *Plovers*. The Seven and Five had been founded in London by seven painters and five sculptors immediately after the First World War with the intention of making art for those with conservative and traditional sensibilities and in so doing distance themselves from the tumultuous developments in Europe. The Seven and Five wished to take a stand against obvious Continental influences. Indeed, the first exhibition catalogue declared, '[we] feel that there has of late been too much pioneering along too many lines in altogether too much of a hurry.'[79] Christopher Wood and Ben Nicholson were fellow exhibitors at the Beaux Arts Gallery; *The Sunday Times* hailed them as seeking 'to stimulate us by some novelty of arrangement, while Cedric Morris and Winifred Nicholson seek to charm or fascinate us by their notation of the thing seen'.[80]

While Cedric was being asked to join and show work at practically every art group in town, Lett received no invitation to join either the London Group or show with the Seven and Five Society. The Seven and Five ideals certainly did not appeal to Lett-Haines. While the Society viewed the new Surrealist painting style in Europe with horror, Lett embraced *The Surrealist Manifesto* published in Paris in 1924 by André Breton. Lett had become enamoured with artists Jean Arp, Joan Miró and Yves Tanguy while in Paris. Looking back at Lett-Haines's work from the 1920s, Conor Mullan, a director of the Redfern Gallery in London, remarked that he was one of Britain's first Surrealist

painters. According to Maggi Hambling, he always referred to himself as an English Surrealist.[81]

Cedric was wooed for an exhibition at the Claridge Gallery at their premises in Bond Street in March 1927 along with Paul Nash, Kit Wood and William Roberts. Clive Bell, writing for *Vogue* magazine, singled out Paul Nash and Cedric Morris as important artists to watch. In his review he highlighted Cedric's *Plovers*, which he had recently seen at the Beaux Arts Gallery, stating that the picture signified a change in Morris: 'And if now he distorts his forms because he has become aware of a subtler significance which can be rendered only by distortion, all well and good. I fear that his object is not expression but decoration.' He added that 'his bird forms remind one of a Japanese bird screen rather than of a picture by Cézanne.'

In the summer of 1927 Cedric, Lett and Frances Hodgkins decided to take a painting trip to Brittany, stopping at the little fishing port of Tréboul, which Cedric had visited with his classmates from Académie Delécluse before the First World War. When Hodgkins produced her first finished landscape painting on the Brittany excursion, Cedric was surprised and excited, declaring how much he admired her originality, courage and wit. He and Lett agreed that it was far more modern and challenging than anything she had done in Newlyn. It was to be the start of a campaign by Cedric to gain her greater recognition, which he and Lett pursued up to her death twenty years later. Through his influence Cedric got her admitted to the London Group and the older New English Art Club, to which he had been recently elected. In the spring of 1928 Cedric painted a portrait of her looking very serious and stern – or, in the words of her biographer Frances McCormick, 'looking like a sharp-eyed pouter pigeon ready to soar but if needs be to peck'.[82]

When Christopher Wood saw Cedric's paintings from the 1927 trip to Brittany, he wanted to know more. He loved Cedric's *Breton Landscape, Corner in Tréboul* and *Seagulls at Douarnenez* and decided he must travel there himself. Morris further fuelled his enthusiasm with legends of a submerged city from fifteen centuries ago and reminded him that before the Ice Age Cornwall and Brittany were the same landmass.

Cedric and Lett kept a professional distance from Wood. Although they bought one or two of his pictures, they certainly did not champion Wood, who was twelve years younger than Morris, as they did Frances Hodgkins. They had met in Paris and originally moved in the same circle and painted superficially similar, colourful café scenes. However Wood, who called himself by the first name Kit, had become an opium smoker along with Jean Cocteau and they did not approve. Wood valued Morris's opinions greatly and certainly took inspiration from him. When an invitation from Wood to paint with him in St Ives was proffered in the autumn of 1928, they declined. For his part Kit felt that Cedric was not professional in his attitude to his art, partly because of his private income. In Wood's eyes this allowed galleries not to pay painters a proper income for their work. He had very little money and needed loans or advances on pictures to survive. He told Winifred Nicholson that he needed a steady salary and commissions to be able to devote himself to painting: 'Cedric between ourselves has not much ambition and he told me he wanted £400 a year to be happy, with me it's not a question of money but if anything, I need £4,000.'[83]

Both men were attracted to the landscapes of Cornwall and Brittany although they were never there at the same time, and their work shows similar views, colours and composition. The paintings Kit Wood produced in Tréboul during his visit in 1929 have many debts and similarities to Cedric's interpretations of landscape and sky. He told his patron, Lucy Wertheim, that he learned how to depict skies from Morris's Tréboul paintings. They both painted in a naive colourful way which gave an immediate reality to their pictures. Their application of paint was slightly different – Wood's paintings have a smoother, more colour-saturated appearance, whereas Morris's paint is more layered, the brush strokes more visible. Both use strong coloured backgrounds in their portraits. Christopher Wood's background orange behind a portrait of his patron and lover Tony Gandarillas is similar to the colour Morris had used in his portrait of Mary Butts two years earlier.

At the end of 1927, at Ben Nicholson's suggestion, the Seven and Five Society asked Cedric to join. Christopher Wood, whom Cedric had introduced to Winifred and Ben Nicholson, became part of the group

shortly after. Morris was a well-liked member and was nominated to the picture-hanging committee in 1928. He proposed Frances Hodgkins for admission to the Seven and Five the following year.

By now it had become apparent that Cedric's success and offer of regular exhibitions in London required them to move back to England. Lett knew that Cedric was no good at promoting himself or organizing the return to London. He bravely wrote to Cedric's sister Nancy, 'I cannot emphasise too much the necessity for your brother to make himself more accessible to his clientele and the public in general. Instead of travelling Europe and Africa looking for cheap facilities he should obtain a permanent and adequate studio in a good corner of London.' He stressed in the letter that he felt that Cedric would not consider approaching an outside person and that a modest outlay from his family would be 'by no means a foolish investment'.[84]

Nancy was not moved to contribute, but his cousin, the wild-living Robert Armin Morris, agreed to pay the rent for the year 1927 on 32 Great Ormond Street in Fitzrovia, London's bohemian quarter north of Oxford Street, so that Cedric could prepare for three London exhibitions. As a show of the artists' commitment to each other, both their names head their Great Ormond Street writing paper. Lett's former lover Roy Martin wanted to come and see them there. Cedric was not keen on this but conceded that he had to subsume his feelings of jealousy towards Roy. 'You will not make me unhappy if there are temporary atmospherics, it will not be caused by you, but my familiar demon – Mr Lucifer having a game with me,' Cedric reassured Lett.[85] He was certainly more confident that Lett would give up Roy Martin after he discovered that they had had a big argument.

In Fitzrovia Cedric and Lett were to become very close with Kathleen Hale, who had taken a studio flat with her husband in nearby John Street. She was married by now to a doctor, Douglas Maclean, but she was not of the inclination to sit quietly in the evenings while her husband read. She wanted the live the more unconventional life of a London artist and her salvation came in the form of her neighbours Cedric and Lett. She was invited to drop by any time and Cedric offered to share his painting studio with her. She felt honoured and touched

by his generosity. 'I didn't see much of Lett but I remembered him one morning, pink nude and handsome, emerging from his bath flashing an inadequate towel.'[86] Now back in Britain she got to know the two men better and later wrote in her autobiography, *A Slender Reputation*, 'Both men had same sense of values. Art was sacrosanct, and hard work the climate.'

By the end of the 1920s Cedric Morris had formed a distinct style that he would pursue with minimal variation for the rest of his life. Landscapes from his foreign travels, portraits, flower and bird paintings and still lifes were his preferred subject matter. No longer would he paint abstracts or imagined scenes. For the following decade his landscape paintings show an appreciation of Gauguin, Cézanne and elements of Cubism in the way blocks of colour are juxtaposed at right angles. But they also have a fineness that is unrelated to Cubism. When describing his landscapes, art critic R. H. Wilenski remarked, 'It is not hard to appreciate the delicate atmosphere of Provence, the silver tones of olives, the rare light of Italy and the rich contrasts of the Pyrenees.'[87] The American press on their tour of London galleries liked 'his something of the romance of the continent'.[88] The *Christian Science Monitor* spoke for many Anglo-Saxons when it remarked in 1924 that, although Morris had made excursions into Cubism and Futurism, the English critics preferred his flower and landscape paintings.

5.

BOHEMIAN LIFE
IN FITZROVIA

In February 1928 Gaudier-Brzeska, Morris and Wood shared a drawing exhibition at the Claridge Gallery in London. Cedric wrote to Lett, who was at his mother's house, 'I do realise how much depends on them [the upcoming shows] both from your point of view and mine. I realise how much you resent being eternally tied to me and that the only way of altering that is making these shows a success.'[89] Cedric confessed that he had been unhappy for a while, but blamed himself for his situation. 'The cause of it, as you have often said, is entirely my fault,' he told Lett in an assessment of their relationship and his attitude to life. He explained that he did not agree with Lett's assertion 'that it is no good kicking against the pricks'. 'After all perhaps my hatred of certain things is my way of conquering that same thing in myself. If only you would let me rave when I feel like it instead of getting annoyed and taking it personally you would save such a lot of unpleasantness. Surely by this time you must have noticed that you can't do much where I am concerned. You will never change me so what's the good of trying?'[90]

Wood sold nothing, Gaudier-Brzeska only one drawing, but Cedric sold five (which were compared favourably to Jean Cocteau's work) at the Claridge Gallery show. Christopher Wood told his mother rather resentfully that Morris's friend Lett-Haines had policed the exhibition,

making sure that Cedric's friends spent money on the right person's pictures. *Apollo* magazine wrote that 'Cedric's drawings were not quite so spontaneous as Gaudier-Brzeska's but very attractive.' The magazine critic even went as far as to say that he thought Morris's drawings were more convincing than his paintings.[91]

Cedric painted another portrait of Lett in 1928 in which he is now slightly balding and looks more serious in suit and tie. Cedric's star was in the ascendant and he was becoming increasingly well known thanks to press coverage of his social life as well as his exhibition reviews. Lett, who had appeared as a good-looking Englishman-about-town and interesting artist in Paris, was not widely sought out by the press in London. He was giving less attention to his own work and had less to show gallery owners. His personal ambition seemed to be faltering and he showed little interest in associating with any of the burgeoning and diverse group of British Surrealists that included Eileen Agar, John Banting, Paul Nash and Henry Moore. He was not invited to submit to the 1936 International Surrealist Exhibition in London which was in part organized by Surrealist poet David Gascoyne.

A Seven and Five Society show including Morris's work opened a few weeks after the Claridge Gallery exhibition. It was attended by the important art patron Eddie Marsh, who was becoming a collector of art and also of artistic types. He had been the poet Rupert Brooke's landlord and edited his memoirs; now he was cultivating the company of a new generation of painters including Stanley Spencer, Paul and John Nash, Christopher Wood and John Skeaping, as well as a theatrical, mainly homosexual, crowd including Ivor Novello, Noël Coward and John Gielgud. Marsh had recently bought Cedric Morris's *Breton Landscape* from the artist's time in Tréboul. At the Seven and Five exhibition he bought a number of Morris's bird pictures. The *Daily Graphic* interviewed him about his recent purchases and remarked, 'I always think I shall come home and find those ducks have flown away. They are literally in headlong flight.'[92]

Marsh was an enthusiastic promoter of Cedric; he brought his paintings to the attention of Winston Churchill, for whom he worked as a private secretary. The two became friends and whenever seeing

the other in London at a gallery opening they would be keen to discuss painting techniques. Marsh later bought two Morris pictures, which he donated to public collections: *Ducks* (1924) to Halifax Art Gallery and *Mottled Irises* (1931) to Leamington Spa Gallery.

There were only two months for Cedric to recover before the launch of his third exhibition of 1928 at the Arthur Tooth Gallery in London in May. He displayed the breadth of his subject matter in his paintings, which acted as a visual diary of his travels over the past few years. In the show were a huge flower painting (182 x 152 cm) and a tiny one (12 x 9 cm) as well as the beautiful *English Spring Flowers* and *Poppies*. Alongside them were landscapes from England, France and North Africa: *Landscape near Tréboul, Church Knowle Dorset,* as well as *Mohammadan Cemetery* and *Djerba Flowers.* Only one portrait was on show – *Senegalese Soldier* – and no abstracts. It was practically a sell-out with forty pictures sold, including *Birds of the Barbary Coast* (1926), bought by Winston Churchill. R. H. Wilenski wrote a revealing article on 9 May in the London *Evening Standard* entitled 'A Left-to-Right Painter'. He told readers that Morris painted his pictures 'from the top-left corner without any preparatory drawing on the canvas, proceeding inch by inch until he reached the bottom-right corner'.[93] He was not quite correct in every case. In 2017 art dealer Philip Mould found an unfinished and undated iris painting with clear outlines of its subject lightly painted on the canvas. London's other esteemed critic, T. W. Earp, was intrigued by 'Cedric Morris's unconventional art education and his ability to teach himself. He has the wisdom to allow his subject its own share, but he has also the essentials of design, composition and colour.'[94] Frances Hodgkins reckoned that Cedric was 'on the wings of almost incomparable success'.[95]

On a high following the exhibitions, Cedric and Lett decided to give an all-day-and-night party on 30 May with the theme 'The End of the World'. Dress code was 'Positively Judgment Day, BYOB'. The invitation was edged in black. Some guests went in mourning clothes; others decided to go in outfits copied from artworks depicting Judgement Day. A few weeks later Cedric left for The Hague to see an exhibition that included some of his pictures. On the way back to

London he passed through Paris and was shocked to discover that Duff Twysden had fallen badly into debt following her divorce from Roger Twysden two years earlier. Cedric gave her some money, writing to Lett, 'she looked so ill and depressed I couldn't help it.' He also saw Christopher Wood, who, he said, 'looked just as bad'.[96]

By the autumn of 1928 Cedric was exhausted. He later recalled to *Country Life*'s gardens editor, Tony Venison, 'There was too much of a social whirl, I couldn't get any work done and there weren't any landscapes out of the window.' He was now forty and his priorities were changing. He wanted to spend time somewhere he could indulge his love of birds and plants. He was tired of discussing his paintings. His reluctance to talk to journalists was becoming apparent. The *Daily Express* told readers that 'he will discuss horses and dogs more readily than he will talk about art.'[97]

Cedric decided to look eastwards to Suffolk, near enough London but affordable. 'It is where everyone goes who thinks they are going to be an artist. We knew the scenery would keep us busy,' he later remarked to a friend. East Anglia has often been compared to Cornwall from an artist's perspective: both have clear, open, blue skies where the banked white clouds flatten the land and highlight the light and dark. In Suffolk Cedric appreciated the similarities and when he started to paint there he used blocks of colour applied in thick brushstrokes. In its October 1928 issue the *Studio* magazine valued Morris as 'indubitably one of our most interesting landscape painters'. The magazine goes on to say, 'his paintings show a remarkable response to the English spirit of place, emphasising the Englishness of his work.'[98]

One winter weekend Morris and Haines went to look at a house that they had heard through artist friends was for rent. Hidden away in a fold in the Suffolk landscape down a tunnel of elegant elms they found a timber-framed, plaster-fronted farmhouse called The Pound, named because it had been adjacent to a cattle pound. Originally Tudor, with Queen Anne additions, the long house was only one room deep, with four double bedrooms, two smaller bedrooms accessed by a narrow, winding staircase, a sitting room, a dining room and a

hall with a basin with a hot tap in the corner. The kitchen scullery overlooked an overgrown garden of over two acres.

The view down the valley through ancient trees towards the River Stour was much as John Constable would have seen it. For a gardener previously used to growing things in small pots and tins, this offered the possibility of making a beautiful, romantic garden where woodcock swooped in winter and nightingales sang on summer evenings. The property was owned by the artist and wood engraver Vivien Gribble and her husband, Douglas Doyle Jones, and rent was reasonable; there was no electricity, but the men decided to take it and moved in early the following year. They certainly did not cut themselves off from London, keeping the lease on Great Ormond Street, then moving to nearby Charlotte Street. Just before Christmas their studio at Great Ormond Street was burgled. Nothing of value was taken, only Cedric's dress clothes, wine, gramophone records and a Parisian book on mixing cocktails. The break-in did not, however, diminish their love for London and the exciting cultural shifts that were taking place there. Two books, Radclyffe Hall's lesbian novel, *Well of Loneliness*, and D. H. Lawrence's *Lady Chatterley's Lover*, about a cross-class love affair, both published in 1928, were sending shock waves through polite society. But for some of the more liberal aristocrats and bohemians in London it was a licence to *épater les bourgeois* and throw off their inhibitions. Cedric and Lett, despite their new Suffolk life, could not resist invitations to extraordinary parties held by these hedonists.

Sculptor John Skeaping wrote in his autobiography, *Drawn from Life*, 'According to your inclinations you could have your wine sweet or dry, your company, "B.M." [Bloody Manly], homosexual and camp, cultural or extraordinarily grand.'[99] There were parties in swimming pools, circus parties and dressing in costume was almost always required. Parties were set round a theme: Indian and Byzantine were popular at parties held at the Chelsea Arts Club. Sometimes the dress code was undress. Guests had to be unclad either from the waist up or from the waist down. The most outrageous party-goers stripped altogether. Cedric and Lett enjoyed parties with theatrical types. The Charleston was their favourite dance. On some occasions choreographer Frederick

Ashton would provide the cabaret, which included the dancer Billy Chappell, who often designed fabulous costumes for the event.

In the years before the lives of Hollywood film stars were reported to their readers, newspapers put artists, aristocrats and authors on their gossip pages. Fox Studios press photographers covered a fancy dress party Lett and Cedric gave at Great Ormond Street. Cedric and Lett were very willing to allow them in. It all helped publicize the paintings. Cedric appeared in The *Daily Chronicle* under the heading 'Chic Cactus', which credited him for making the North African cactuses 'the thing' for home decoration.[100] Cacti and succulents were to be the subject of many of his still lifes and a grey-green succulent he discovered in the wild and painted frequently was named after him: *Cotelydon orbiculata* 'Cedric Morris'.

Cedric and Lett also attended society parties where aristocrats and wealthy young heirs dined on wild swan and drank to excess. Lett and Cedric were among the most beautiful and cleverest members of society, according to the *Dundee Courier*, at a party hosted by camp socialite Stephen Tennant, which included the aesthete and art collector Harold Acton, composers William Walton and Constant Lambert, actor Ernest Thesiger and theatre set designer Oliver Messel.[101]

Cedric's mother, Willie Morris, had got wind of their London lifestyle and blamed Lett, who was moved to write an (unsent) letter to Nancy in October 1931 'to remove a few misapprehensions of which your mother seems to be the principal author'. He proceeded to list her accusations and opinions. 'I have no intention of bumping your brother off to inherit his vast wealth (principally because I am rather attached to him). We are not dissolving our partnership, principally because we are rather fond of each other. I am not a drunkard, nor is Cedric. He is not going bankrupt nor ever can while he is with me. Cedric does not pay more than a half share in our mutual expenses.'[102]

In February 1936 Cedric and Lett gave a memorable Byzantium-themed party at Charlotte Street. It was attended by the cream of artistic and intellectual London: actors Ernest Thesiger and John Gielgud, *Vogue* editor Madge Garland, writer Rosamond Lehmann, Augustus John, Allan Walton, man of letters, gossip and wit Peter Quennell, John

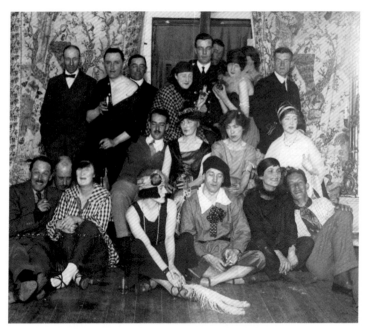

1. Fancy dress party in Newlyn, 1919. Cedric Morris (*bottom row far right*), Lett-Haines (*bottom row fourth from left*); other guests include Frank Dobson, Cordelia Dobson, Gertrude Harvey, Gladys Hynes, Sheelah Hynes and Dicky Holmes.

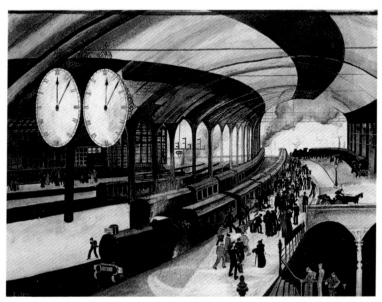

2. *Brighton Railway Station*, 1920, by Arthur Lett-Haines, ink and watercolour, 47.5 x 62.5 cm (18¾ x 24½ in).

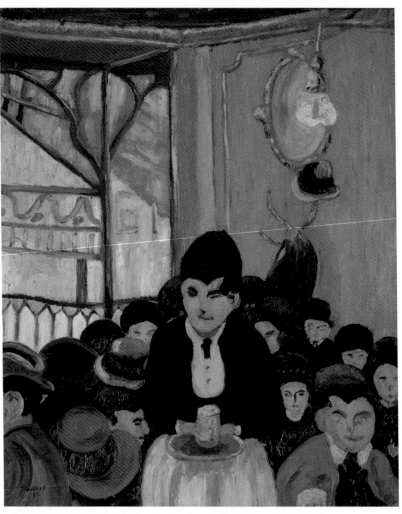

3. *Le Bon Bock,* 1922, by Cedric Morris, oil on board, 45 x 54.5 cm (18 x 21½ in).

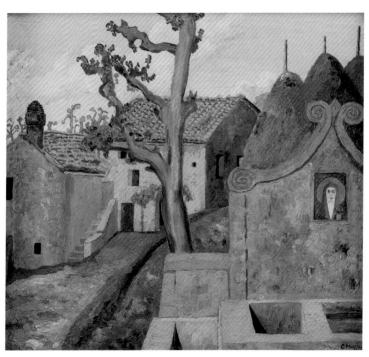

4. *The Italian Hill Town*, 1922, by Cedric Morris, oil on canvas, 55 x 60 cm (21½ x 23½ in).

5. *Composition*, 1922, by Cedric Morris, oil on canvas, 50 x 60 cm (19½ x 23½ in).

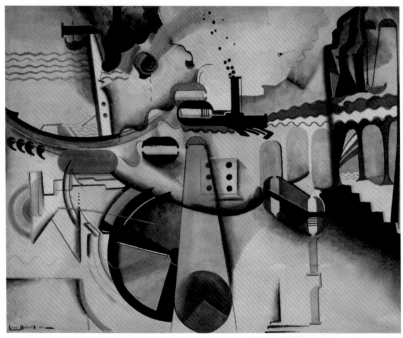

6. *Fantasy Landscape,* 1922, by Arthur Lett-Haines, pen, ink, watercolour and gouache on paper, 48 x 60 cm (19 x 23½ in).

7. *From left to right:* Nancy Morris, Cedric Morris and friend, The Pound, 1930s.

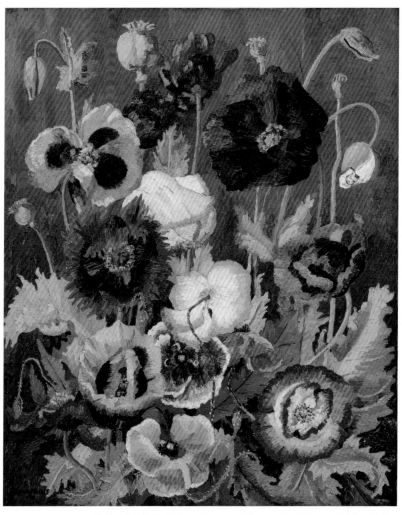

8. *Poppies*, 1926, by Cedric Morris, oil on canvas, 61 x 50 cm (24 x 19½ in).

9. View of the The Pound, Higham, with Cedric Morris's studio (*left*), 1931.

10. Cedric Morris looking fashionable in Paris, 1920s.

11. Kathleen Hale in a Paris café, 1920s.

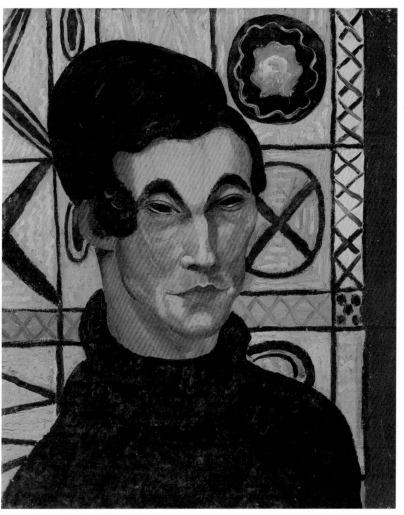

12. *Paul Odo Cross*, 1925, by Cedric Morris, oil on canvas, 61 x 51 cm (24 x 20 in).

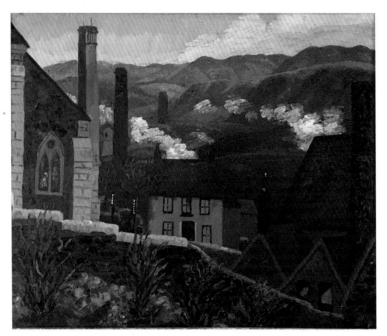

13. *Dowlais from the Cinder Tips Caeharris*, 1935, by Cedric Morris, oil on canvas, 59 x 72 cm (23 x 28¼ in).

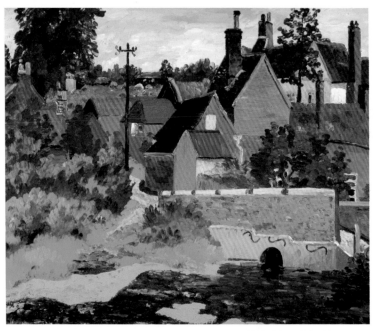

14. *Polstead, Suffolk*, 1933, by Cedric Morris, oil on canvas 67.5 x 80 cm (26 x 31½ in).

Banting and Shell Oil's publicity director Jack Beddington. One member of the Bloomsbury Group was invited, the psychoanalyst and Freud expert James Strachey, brother of Lytton. They had much in common; Vanessa Bell and Duncan Grant were producing furnishing fabric designs for Allan Walton, a friend and fellow student of Cedric's at the Académie de la Grande Chaumière in Paris, who was commissioning Cedric too. But the relationship between Cedric and Lett and the Bloomsbury Group was not straightforward. Lett extended invitations to Bell and Grant; sometimes they accepted, but they never returned the invitation, which irked Lett. In his diary he would write the dates of parties given by David Garnett or other members of the Bloomsbury group and pencil against it 'not invited'. Indeed, it became a standing joke between him and his friends. It seemed that the Bloomsburys did not rate the Morris family's intellect. Nancy Morris, who had had a short affair in 1927 with Alix Strachey, wife of James, was regarded as positively backward by the Bloomsbury families, the Stracheys, Bells and Woolfs. Alix Strachey told her friend Eddy Sackville-West, music critic, novelist and cousin of Vita, that she was pursuing 'a woman of somewhat limited education called Nancy Morris, the daughter of a baronet. She can hardly write a letter and she is 34.' When Sackville-West was invited to meet Nancy, Alix writes, 'I hope you will like her [Nancy] when you meet her, I have become very fond of her. But she is absolutely uncultured and will remain so, I think. You may not get on at all with her. She loves dogs, I even sometimes think she can't distinguish clearly between them and human beings, except that she prefers them.'[103]

The snobbish in-jokes, intellectual competitiveness and what he saw as the mannered behaviour of the Bloomsbury set did not interest Cedric. Lett, however, was in awe of them, both intellectually and as members of an upper-class elite with liberal attitudes in their romantic lives. It mattered more to him not to be included in their parties. Cedric would often poke fun at 'intellectuals', as Welsh friend Esther Grainger would later recall. 'He would make lists of who was in and who was out with no explanation. Nazis, Jews, Blonds and Intellectuals were randomly on the list, not from any personal prejudice but more an

observation of public attitudes. He would read the list out loud from time to time while giggling. Pretentious people, extremists and those who were opinionated and discriminatory were to be mocked to reduce their power.'[104]

When in London, the morning after a party or a night out, Lett and Cedric would often take breakfast at Madame Buhler's café in Charlotte Street. It was a good place to meet students and teachers from the nearby Slade School of Art. It was also the favourite morning spot of William Coldstream, Rodrigo Moynihan and Frederick Gore, those denizens of Fitzrovia who needed a strong morning drink and would go on to a lunchtime tipple at the Wheatsheaf or the Fitzroy Tavern. Cedric and Lett would join occasionally, athough their need for an early tipple was not so pressing. They liked to go to the Fitzroy Tavern to hear painter Nina Hamnett regale the assembled gathering of young artists and writers with tales of well-known and notorious people she thought would shock them, peppered with an inexhaustible supply of bawdy jokes. Lett's energetic, free-flowing line drawing of her at the bar captures her wild spirit. For an artist such as John Skeaping, whose family was conservative in outlook, the artists of Fitzrovia were vital and stimulating: 'I had been brought up in a sheltered way but none of these people's avant-garde ways shocked me, simply because they were so nice.'[105]

The places to dine were L'Étoile in Soho and the Eiffel Tower and later the White Tower in Percy Street, Fitzrovia. The more affluent bohemian was likely to be found at the gloriously opulent gold and green mirrored *fin-de-siècle* Rococo palace, or the Café Royal in Regent Street, which had been made notorious by Oscar Wilde. On any evening Cedric and Lett might encounter the occultist Aleister Crowley, Virginia Woolf, D. H. Lawrence, Winston Churchill or Augustus John. Most restaurants and pubs, thanks to the 1921 licensing law influenced by the increasing power of the Prohibition movement, were only open from 11 a.m. to 2.30 p.m. and from 6 p.m. to 10.30 p.m. No such restrictions applied to the Café Royal, where an alcoholic drink and a snack could be consumed at any time of day. Absinthe was legal in England and it was the favourite tipple of more serious drinkers at the

Café Royal. Conversation flowed, lewd and loud, effectively drowning out the music played by the small orchestra. Skeaping recalled that 'the room was so thick with tobacco smoke you could hardly see the Toulouse-Lautrecian figure of the woman bandleader.'[106] Lett was one of the founder members of the Gargoyle Club on the upper floors of 69 Dean Street in Soho, set up by wealthy David Tennant, Stephen's brother. Social formalities were here dispensed with; the place became a haven for struggling artists and writers, who were encouraged to express themselves freely and directly. The club was reached by a very small, rickety lift, which opened on to a very large ballroom, bar, coffee room and drawing room. The interior was Moorish and mirrored with pieces of eighteenth-century glass; and some of the contemporary wall decoration was executed by Henri Matisse, a member. His painting *Red Studio* hung in the club until 1941. The Gargoyle was a meeting place for aspiring and famous artists and painters, film stars and eccentric aristocrats. The Mitford sisters or the Sitwell siblings might be in the same room as a member of Hollywood royalty; Fred Astaire could bump into writer Graham Greene.

Vogue and the *Transatlantic Review* and other magazines loved to titillate their readers with the goings-on of London's artistic set, although they avoided reporting on the more louche and drunken behaviour of the wild members of Fitzrovia for fear of offending their readers. Attractive and smiling artists and poets with an original dress sense and mildly eccentric habits were the limit of press coverage of bohemia. Cedric was photographed confidently posing in a flannel shirt, Arran sweater, corduroy trousers and cocked felt hat. He was deemed by the *Daily Mail* to be 'not typical of those London Bohemians, nor does he look like so many modern artists trying to look like a successful businessman. His weather-beaten face is clean shaven, his hair close cut and his lean form clad in a perfectly ordinary lounge suit. You would probably take him for a gentleman-farmer enjoying a day out in town.'[107] The *Southwark Echo* ran an article on artists' pets and was much amused that Morris kept a pet rabbit in London named Maria Marten, with which he dutifully posed. The journalist reckoned Maria Marten would go down in posterity 'in some bewitching form',

as would Augustus John's Siamese cats and George Belcher's canaries.[108]

At weekends there were house parties. Stella Gwynne often asked Cedric and Lett to her country house, Wootton Manor in East Sussex, when she was married to her first husband, MP Rupert Gwynne. Cedric and Lett were invited to leaven the company of her husband's hunting and shooting friends. For Morris and Haines these weekends were a strain, as their fellow guests were not often to their taste. After Rupert Gwynne's death in 1924 the country sportsmen and their wives were replaced by more artistic types: actors, painters and musicians, including their mutual friend Allan Walton, whose paintings Stella collected. Stella, a keen and original painter of flowers, had created a much-admired garden at her Sussex country home. She sought out unusual plants and had a gift for juxtaposing seemingly unrelated ones. She treated her garden as a refuge where she could escape, ponder and find peace. Cedric was beguiled. At Wootton Manor he met William Robinson from Gravetye Manor, the author of the extremely widely read book, *The English Flower Garden*, and Lawrence Johnston, who created an extraordinary garden at Hidcote. The food served at Wootton was better and more experimental than at most English country houses of the time and the Continental flavours did not escape Lett's attention. His burgeoning interest in food and cooking was observed by Stella's daughter Elizabeth David, although when asked about their first meeting David recalled that she was rather intimidated by his large presence.

Weekend invitations also came from Paul Odo Cross, who was now in a steady relationship with country gentleman Angus Wilson. Cedric spent a good deal of time in Wales in the early 1930s and on the way back to Suffolk or London he would often stop off at their home, Tidcombe Manor, near Marlborough, Wiltshire. Angus Wilson was a keen gardener and propagated and cross-pollinated irises. Wilson had acquired two American irises known as plicatas. The term describes an iris which is stippled or covered in tiny dots or spots of another colour. In the 1930s plicatas were rarely seen in Britain and Angus Wilson was very excited to breed his first one, a cream flower speckled with purplish maroon. He named the plant Odo. He was astonished to

discover that the French were selling plicatas at 20 US dollars a root (equivalent to $368 today).

Cedric had a new garden to fill and was keen to extend his knowledge of plants. At Tidcombe he would follow Angus Wilson round and on one weekend in 1934 when the irises were in bloom he became entranced watching Wilson delicately using tweezers to cross-pollinate his irises. Detecting a fellow enthusiast, Wilson offered him some seedlings to take home to The Pound, where Cedric began to experiment for himself. He started to spend many hours sifting, refining and eliminating rhizome rot in susceptible plants to achieve colours he was looking for. It was a slow process. An iris takes three years from seed germination to its first flowering. As the seasons passed and his confidence and abilities grew, he was eventually able to take the colouring a step further and create an iris in which the contrasting colour completely covered the lower petals: such specimens are known by breeders as 'fancies'. It was the start of an obsession and a passion.

6.

A GARDEN IN
THE COUNTRY

THE POUND WAS A PROJECT. BEFORE ANY PLANTING COULD COMMENCE A THICK tangle of brambles and impenetrable nettles had to be cleared. When it came to gardens, Cedric's enthusiasm was somewhat greater than his knowledge. Fortunately, advice and plants were forthcoming from a highly esteemed gardener, the no-nonsense Mrs Gwendolyn Anley, who had a printed message on her mantelpiece telling visitors, 'if you have nothing to do, don't do nothing here.' She was an iris grower too and later wrote a book on them, *Irises and their Selection*. With her encouragement Cedric started to grow the Spanish xiphium variety. Neighbours with cottage gardens and the local gentry were very generous with plants too. Cedric favoured delicate-petalled flowers and with his painterly eye he created a planting plan using colour combinations which balanced strong colours with soft ones. He planted scarlet multi-petalled anemones, white-flowered chives (*Allium tuberosum*), delphiniums, pink daisies, tall white asphodels, alstroemeria, foxgloves, orange poppies and lilies with small bells (*Lilium martagon*). Box balls in pots framed the old oak front door.

The countryside was largely unknown to Lett. His mother had moved to Eastbourne in Sussex when he was in his late teens, but he had never really lived in the country before. But as Cedric's manager

and promoter, Lett realized that in order to get good work out of him, escaping London would provide total immersion in his subject matter.

The plants and animals soon became Cedric's new friends. His red notebook is filled with accounts of the behaviour of flora and fauna, especially his pintail and mallard ducks. 'Worked in the garden all day, heard cuckoo, gladioli showing, the spring is so strong it is impossible to think of anything else.'[109] He became very familiar with the day-to-day routines of the waterfowl and and the dangers they faced from foxes. He was excited by his delphiniums and tulips and regretted digging up the foxy-scented crown imperials by mistake, enthusing that 'their smell excites me more than any other.' 'I am afraid for my Japanese irises – temperamental sluts.'[110]

The move to the country had reconnected him with the vital strength and character of birds and flowers. The reviewer from the *Manchester Guardian*, having seen his paintings *Peregrine Falcon, Greenshanks, Gold Finches, Golden Plovers* and *The Green Beetle* at the Arthur Tooth exhibition in 1928, praised his ability to create 'living, breathing, flying birds, not coloured reproductions of stuffed carcases'.[111] What impressed the reviewer was Cedric's ability to depict birds sympathetically in a way that no modern photograph could match. He compared him to the Chinese masters of bird painting.

At any opportunity Cedric could be found digging the rich clay loam of Suffolk, but he still had to wield a paintbrush. He would set out on foot with a folded easel and a bag of paints to find suitable landscapes in preparation for two more exhibitions in London. He was fortunate to have a large, secluded studio in the garden of The Pound. In 1929 he painted *Wood Pigeons*, a brightly lit canvas with birds set against the gently undulating Suffolk landscape. In 1932 he painted the outside of his studio, naming it *The Black Studio*.

In 1928 he had been asked to illustrate the book *Herbs and Salads* by his French friend Marcel Boulestin. Boulestin's eponymous restaurant in London's Covent Garden, which imaginatively combined English and French food, was one of the most fashionable, and expensive, of the time. Interiors were by painter Allan Walton, who went on to print fabrics designed by various artists, including Cedric, at his factory in

Manchester. Boulestin's cookbooks and restaurant were to influence Lett (and Elizabeth David) considerably. Cedric presented seventeen drawings with a beautiful economy of line much influenced by Henri Gaudier-Brzeska, whose work he admired. However, on receiving a published copy of the book he was less than delighted, writing in his journal on 10 February 1929: 'Marcel's book arrived, not bad printing, too big and thick for my drawings, also some badly placed. This sort of thing is hardly done perfectly in England.'[112]

The year 1930 was to be a very busy one for Cedric and Lett, and the work they were producing was received with great critical acclaim. In January Cedric extended his contract with Tooth to produce two pictures a month. In February Cedric and Lett decided not to renew the lease on the Great Ormond Street studio and instead took a flat at 39 Gloucester Road, South Kensington. This coincided with the opening of a gallery at Heal's department store, the Mansard Annexe, and both men were invited to contribute work. The aim was to showcase a diverse range of contemporary British art and included were still lifes by Duncan Grant and Matthew Smith, but also haunting cityscapes by Christopher Nevinson and the Surrealist John Banting. *The Times* reviewer singled out Morris and Lett-Haines, praising Morris's beautifully painted *Pheasants* and Lett-Haines's *Blue Trousers*, which the newspaper's critic wrote were 'rich in its sombre tones of red, black and blue', also commenting that 'his watercolours have great originality and imagination.'[113] Cedric received a congratulatory telegram from fellow Seven and Five artist John Aldridge, who had moved to Great Bardfield on the Suffolk–Essex border in the early 1930s, where Eric Ravilious and Edward Bawden had also decided to settle. The Great Bardfield artists lived thirty miles from Hadleigh and Aldridge became a friend of Cedric's; he would always tell enthusiastic horticulture students, 'If you want to see a good garden, look at John Aldridge's.'

On 29 March 1930 Cedric's second solo exhibition at Tooth celebrated the flowers from The Pound, Suffolk landscapes and local birds. *Langham Mill* illustrates his trademark paint-laden brushstrokes. Three flower pictures on canvas, *July, August* and *September*, are densely packed and intertwined, multicoloured arrays

of flowers against a dark ground, which creates a slightly surreal and crepuscular atmosphere.

The press was full of enthusiasm. 'Cedric has suddenly become the rage, there has been no one-man show more important than this of Morris' for the last few months and this is saying much,' wrote the critic for the *Scotsman*.[114] In total, he sold fourteen pictures for between £60 and £75 each. *The Times* commented that his work 'is attractive because it proceeds from a disinclination to conceal imperfect knowledge behind technical cleverness. Mr Morris has an extremely personal vision, with something of the child's wonder at ordinary things.'[115] Cedric, though, was not in a very good mood at the private view. He was tired and depressed, and wrote in his notebook, 'I met dozens of people, abominable and otherwise, made myself pleasant but otherwise talked complete balls.'[116] Though acknowledging that it had been a successful day, he felt that he had not spoken one word of sense. Three months later he decided to end his contract with Arthur Tooth. His resignation letter complained of their 'lack of policy in their modern picture dealing', adding, 'there appears to be a tendency to eliminate the more unusual and the technically interesting.' They were not pleased by his behaviour, but agreed that when there was an opportunity the gallery would take his paintings and give him a percentage of sales.[117]

He was not short of offers from other galleries to show on an ad hoc basis. He was part of the British contingent at the Venice Biennale in 1930 and 1932, showing *The Black Tulips* and *Storm Prelude* respectively. He continued to exhibit in mixed shows in London over the next few years. He sent a couple of paintings to the Arts League of Service in 1931, four paintings to the Leicester Galleries in 1932 and two to the Arthur Tooth Gallery in 1934.

Both Lett and Cedric were keen for their artist friends to come to work in their new-found tranquillity in Suffolk. Frances Hodgkins was an early guest. Critics were by now praising her as an 'extremely original and impressive artist' but Cedric knew she was still struggling financially and had no place to work. He had rescued her from her poor living accommodation in London by asking his sister Nancy if

she could stay in her London flat for a while and at the same time asked Nancy for a loan of £1. She agreed, reluctantly. Not long afterwards he received a terse reminder note asking for repayment. Furiously he paid her in one penny stamps and they did not communicate for two years. The infrequent correspondence between them was often about money; she often seemed to be very short of it.

Cedric's benevolence was a lifesaver for Hodgkins. On 24 February 1930 she wrote to Lucy Wertheim from Nancy's flat: 'The fact that I am working here in a state of comparative independence I very largely owe to the friendship of Lett and Cedric.'[118] In the summer of 1930 she decamped to Suffolk from London, lodging in a pub near The Pound. She had been given the use of a studio at Flatford Mill to prepare for an exhibition at St George's Gallery in London. On 8 August she reported to Lucy, who had recently had another spat with Lett over showing one of Cedric's paintings to a client, 'so glad to hear your news, which I read to Lett. He is quite his old self again and his plumage smoothed down, you two must not ruffle up again.'[119] Lucy Wertheim was the daughter of a Manchester industrialist and a tireless promoter of young artists. She has been called one of the most determined and charismatic figures of the gallery scene in the 1930s. Walter Sickert described her as a 'plumpish, fresh-coloured woman, like a Renoir with an expression of gentle obstinacy'.[120] But she did rub people up the wrong way in her wish to be needed and Cedric and Lett sometimes found her behaviour tiresome.[121] Hodgkins produced a colourful picture, *Man with a Macaw* (1930), which depicted Cedric Morris with the cursing scarlet-green-blue bird, Rubio, that had been brought back from Jamaica by Stella Gwynne.

In the summer Cedric invited the sculptor John Skeaping to live with him and Lett at The Pound and bring his mare Jenny too. They had met in the early 1920s through Eddie Marsh. By the end of 1930 John Skeaping's marriage of five years to Barbara Hepworth was disintegrating. Their son Paul had been born in 1929 and much against Skeaping's wishes Hepworth immediately hired a nurse for him. 'She was determined that nothing should interfere with her sculpture and her progress to her final goal, the top,' he said bitterly.

But really, they had lost interest in each other and had started love affairs: she with Ben Nicholson, he with accomplished horsewoman Eileen Friedlander. Skeaping gave his version of their break-up: 'Barbara was very unsexy and I was just the opposite.'[122] Cedric had always liked Skeaping but disliked Barbara. 'Barbara loved talking about analytic portraiture,' Cedric recalled years later, 'but generally I didn't really care for her.'

In a brief attempt at reconciliation Hepworth and Skeaping revisited The Pound for two days in April 1931 and Cedric painted her portrait. There is unhappiness in her almond eyes as she gazes blankly into the distance. She and Skeaping were finally divorced two years later. Cedric was to continue to provide a refuge for Skeaping at The Pound over the next few years while he was trying to extricate himself from his girlfriend, the spendthrift Eileen. Cedric lent him money. He eked out a small income teaching at the Central School of Art in London and gave private classes at Dedham in between hunting foxes and chasing the local women Cedric introduced him to. He did not treat them well. Cedric was amused by his stories about characters in the local hunt, particularly Alfred Munnings, who Cedric thought was becoming increasingly pompous and blimpish. Skeaping made Cedric laugh when he described Munnings as looking like 'a sack of potatoes on his overfat thoroughbred mares'.[123] Skeaping honed a shiny larger-than-life black marble torso, which was placed in the forecourt of The Pound. Lett named the figure Tarquin.

Making a garden was exhausting and time-consuming and all help was welcomed. A gardener, Mr Stiff, had been hired, but Cedric was delighted when friends lent a hand. John Banting was a frequent visitor and helped dig a rectangular pool on three sides of a catalpa tree. It was home to Cedric's tree frogs and deep enough to swim in. This part of the garden was the subject of a painting by Camden Town Group artist Charles Ginner. Lett's contributions were terracotta gargoyles and Arabic script, which he set into the pink plaster of the house. A greenhouse was restored and Cedric used it to house all number of cacti and geraniums. Other exotic birds joined the household: a peacock and a pair of parrots which flitted between the trees.

The Pound also gave shelter to poets and writers. Mary Butts and the eccentric modernist poet Anna Wickham stayed on a number of occasions in the mid-1930s. Wickham was reeling from her falling-out with Dylan and Caitlin Thomas, to whom she had given her encouragement and support. Both women were more inclined to stay inside talking to Lett than help in the garden. Lett painted the watercolour *Rites of Passage, Panganay*, a surreal interpretation of one of Butts' poems, when in 1937 she published her autobiography, *The Crystal Cabinet*. Cedric was peeved that she eventually chose a portrait drawing by Jean Cocteau for the frontispiece over his.

On 23 August 1930 the shocking and upsetting news reached Cedric and Lett that Christopher Wood had fallen under a train at Salisbury station. The question of whether it was suicide was never established. He had threatened to kill himself if Lucy Wertheim refused to give him an annual stipend of £1,200, but general opinion was that this was just a threat. Cedric was convinced that the Guinness family had hired private detectives to track Wood because of their disapproval of his association with Meraud Guinness. Wood had been in a distressed state for a while and asked Lett if he might be able to live with them at The Pound. Cedric told him he could only come if he gave up his liking for opium. Ben Nicholson was more tolerant and allowed him to live with him and his wife Winifred. It took a while for Cedric to express his condolences to Nicholson, but eventually some months after Wood's death he wrote to him: 'I have been meaning to write but all I had to say seemed so banal, so I didn't say anything.'[124] Wertheim was of course devastated too, but in her grief and confusion behaved very ungraciously to Kit Wood's mother, who was in discussion with Jim Ede, champion of contemporary art at the Tate, about holding a memorial exhibition at a private London gallery. Wertheim refused to loan any pictures, contending that she had given Wood a large advance for him to complete the paintings and wanted recompense before releasing them. Both Winifred Nicholson and Cedric took a dim view of Wertheim's behaviour. 'I was delighted to hear that Winifred had told off that old cow Wertheim. I did too, and so did Lett,' Cedric wrote to Ben Nicholson.[125]

The memorial exhibition was staged later at the Burlington Gallery by Rex Nan Kivell, director of the Redfern Gallery. Meanwhile, two months after Kit Wood's death, Lucy Wertheim opened the Wertheim Gallery, showing artists of very different styles. Cedric had a whole wall to himself, as did Frances Hodgkins, Walter Sickert and Matthew Smith. Russian-born Surrealist Pavel Tchelitchew was exhibited in another area. Cedric felt that this show had at last established Hodgkins's long-deserved reputation. The gallery was decorated like a comfortable modern drawing room in a soft creamy yellow with furniture in Queen Anne walnut. Sofas and chairs were postioned adjacent to the art. A recent book by Dorothy Todd and Raymond Mortimer, *The New Interior Decoration*, had declared that good art must be a seen in a room. An article in British *Vogue* entitled 'Picasso the Decorator' told its readers that the Spanish artist was an exemplar of a considered and significant arrangement of form that had similarities with interior decoration but was far more meaningful.[126]

On display at the Burlington Gallery were some of Cedric's latest landscapes. His atmospheric *Llangennith Church* perfectly captures the watery light of Wales and was hung alongside Christopher Wood's *Boats in the Harbour. Apollo* magazine reviewer Hubert Furst singled out Wood and Morris in his review, writing that 'Christopher Wood's striking painting complemented the two admirable landscape works by Morris.' Morris himself told Ben Nicholson he considered Wood's last work to be 'a real advance'. Visitors to the exhibition included Jack Beddington, art director of Shell Oil, and the young painter Francis Bacon. Beddington very much admired Morris's immediate style and he was one of a number of contemporary artists commissioned to illustrate an advertising campaign. The artworks of Morris's selected for 'Artists Prefer Shell' were a painting of red admiral butterflies flitting round a petrol pump and 'Gardeners Prefer Shell', a poster decorated with a profusion of brightly coloured flowers which was displayed across Britain in the summer of 1934. It was rather ironic that Cedric had no cause to fill up with petrol for he never learned to drive. Maggi Hambling says that he could not tell one model of a car

from another and would often get into a different car from the one that Lett was driving.

The lack of distinction between the decorative and fine arts had been a principle of the Omega Workshop, founded by Roger Fry in 1913 with the support of the Bloomsbury Group artists. It was Fry's idea to set up the London Artists' Association in 1925 to give as much respect to fabric design as to painting. It had two very important patrons, economist John Maynard Keynes and the textile magnate Samuel Courtauld, who set up the Courtauld Institute of Art in 1932. Freddie Mayor, who opened the Mayor Gallery, organized exhibitions of printed cloth with patterns by Duncan Grant, Vanessa Bell, Frank Dobson and Allan Walton throughout the 1930s. Cedric certainly believed their designs for fabric were of equal value to an oil painting. The creation of repeatable designs and advertising posters brought Cedric Morris to a wider audience.

In 1930 Tom Heron of Cresta Silks, who later worked with Paul Nash on printed fabrics,, had asked Cedric for flower designs to print on to dresses and scarves. Lett, as Cedric's agent and manager, set terms: 'Cedric will supply a number of designs from time to time from which you will select six per season. You will pay him £50 each quarter regularly and without demand. He asks for a two-year contract from 1930–32. You will have no fear of not getting good value.' Heron did not take up the offer but was always very open to seeing Cedric's ideas and putting them into ad hoc production. Cedric was very gratified to be offered the chance to paint two large flower murals to complement the art deco interior of Cunard's luxury transatlantic liner, the *Queen Mary*. Duncan Grant, Vanessa Bell, John Skeaping and Edward Wadsworth were also invited to submit work. Cedric filled a large vase influenced by classical Greek motifs with a profusion of poppies, lilies and thistles among greenery twisting skywards.

Cedric supported his friend Allan Walton by attending his inaugural textile exhibition at the Mayor Gallery in 1932, following the formation of Allan Walton Textiles by Walton and his brother Roger in the previous year. On display were fabric designs by Duncan Grant and Vanessa Bell. Cedric's presence was much appreciated and Walton

invited him to produce some fabric designs. His white iris design printed in 1934 and a pink and grey lily print design from 1935, both on cotton and rayon, sold well.

In 1932, much to his surprise, a gift had fallen into Cedric's lap. The widowed Mrs Vivien Doyle Jones, owner of The Pound, left him the house and grounds in her will. This good fortune was to boost his confidence and ground him. Around this time Cedric was also developing a love for poppies. He was pleased with the paintings he produced that year, particularly *The Blue Poppy*, depicting a variety still rare at the time, *Meconopsis betonicifolia*. He was also pleased with the painting *End of August*, depicting a collection of sunflowers, irises, alliums and lilies. 'My stock as a painter is better than ever but that nobody seemed to want my work.',[127] he told Lett. He did acknowledge, however, that no galleries were selling much due to the American Depression. Lett meanwhile was in full Surrealist mode, producing excellent work. *The Escape*, in pen and ink, depicts black and blue silhouetted figures cavorting in a mythical landscape. He also painted *Piscatorial*, a collection of fish, which appears more like a study for a wall panel.

In the garden at The Pound, Cedric would lay a canvas flat on the ground and kneel down to paint. His *Paysage du Jardin in 2* (1931) is crowded with nicotania, verbascum, lobelia, sunflowers and a seed head of a giant lily in a dark autumnal jungle. *Proud Lilies* (1931) sets the noble pink and yellow flowers against a muddy background. Both this and *Dragonmouth* (1933), with densely packed pink and purple flowers against a brown background, have a magical, slightly surreal feel. However, the large *Floreat*, painted in the same year as *Dragonmouth*, is much more open, fresher and brighter in appearance. A large blue and white vase is filled with a profusion of twisting blooms set against a bright sky. It was sent to the Carnegie International Exhibition in Pittsburgh. Roger Fry and Duncan Grant also represented Great Britain. Maurice Utrillo, Maurice de Vlaminck and André Derain were in the French area and Karl Hofer in the German. Morris was praised for his beauty of texture and harmony by the *South Wales Daily News*, but the newspaper, aware of a wave of change sweeping through the

art world, remarked that 'this self-taught artist remains outside the modernist styles current at the time.'

Cedric was feeling the pressure of commitment to galleries and artists' collectives and decided to cut back his obligations. In the summer of 1931 he resigned from the London Artists' Association. He did, however, accept the chairmanship of the Seven and Five Society. As chairman he was keen to advance the reputations of Frances Hodgkins and Christopher Wood, among others. But there was another faction in the society headed by Ben Nicholson trying to steer the Seven and Five towards exponents of abstraction and away from the naive, figurative work of those artists who had joined in the 1920s. Claude Flight, Jessica Dismorr, Frances Hodgkins and Cedric Morris represented a form of art which *Sunday Times* reviewer Frank Rutter described as 'seeking to charm and fascinate us by the things seen'.[128] In 1931 Claude Flight and Jessica Dismorr felt they did not fit in with the abstract trend and resigned from the Seven and Five. Cedric Morris resigned a year later. Frances Hodgkins would follow him shortly. Their departure allowed Ben Nicholson to take the society in the direction he wanted. Barbara Hepworth, Ivon Hitchens and Henry Moore gave the society a new name, the Seven and Five Abstract Group, but this new incarnation was short-lived and in 1935 the Seven and Five held its final exhibition.

Although Paul Nash's short-lived Unit One Group was founded in 1933 to represent and promote abstract artists Henry Moore, Edward Burra, Ben Nicholson and Barbara Hepworth, the British art establishment and the public were not receptive to their avant-garde style. In establishment circles the Bloomsbury painters were regarded as representative of modern British art. When Picasso wished to visit a contemporary artist in England immediately after the First World War, he was disappointed that he was shown the work of Duncan Grant rather than something more radical and expressive. 'Why', he asked Wyndham Lewis, 'when I ask about modrn artists in England am I always told about Duncan Grant?'[129] Twelve years later Duncan Grant still represented modern British art among much of the British public.

The English attitude to art in the 1930s was summed up by the art critic R. H. Wilenski, who opined that pictures were to be attractive

and unthreatening. For so many people, critics included, pictures were interior decoration, not independent statements. 'The English have always regarded pictures as wall furniture,' said Wilenski. 'Good English painters have always painted pictures that look their best in rooms. Only bad English painters paint pictures that have their maximum meaning in exhibitions.'[130] It was not a criticism of modern art per se, only an observation that good art might follow fashions in decoration. A later critic pointed out that 'it had become quite fashionable to have a Cedric Morris let into the wall of one's room as a panel, which certainly adds to the prevailing style of furnishing.'[131] Many magazines, including the *Studio*, saw painting and decorative design as equal forms of art and covered exhibitions of both applied and fine art. This magazine continued to be an enthusiastic supporter of Morris and in May 1942 he contributed an article on flower painting.

In 1935 the very wealthy and well-connected politician and art collector Sir Philip Sassoon backed young art enthusiast Derek Rawnsley to set up Picture Hire Ltd, a subscription service enabling hotels and service flats to borrow works by contemporary artists. Cedric lent *Ibis among Cacti*, *The Orchard* and *Shells*. The pictures could be bought too. Shortly after the opening of the Picture Hire Gallery in May, which was decorated like a smart drawing room with tasteful green walls and elegant furniture, Cedric had a very positive conversation with Derek Rawnsley, who was keen for him to lend work on a regular basis, particularly his flower paintings. The Picture Hire was inferior in standing to Tooth and other more established galleries, but he was pleased that at the Picture Hire there was someone he liked and trusted. 'I don't think he is a crook and I would rather be cock of my own dung heap than being bundled in with a lot of mediocre painters,' he said. Cedric also felt that Rawnsley would work hard to make the venture a success, unlike 'the other London galleries who don't do any work all day and are lukewarm to clients'.[132]

At the inaugural private view Cedric sold well and was happy – so were the reviewers, curious about this new London space. 'Cedric Morris manages to share out his bread and narcissus in happy proportion. His landscapes and flowers seem to grow out of his instinctive use

of paint. It gives his work a natural and spontaneous felicity,' wrote the *Evening Standard.*[133]

Cedric's reputation was riding high and he was enjoying himself in the garden, but he found himself drawn back to Wales. As a young man he had returned there rarely. Now in his early forties he began to spend more time near his birthplace. He had a reason to go back – to paint – but he also wished to help working people so badly affected by factory and mine closures.

7.

THE DRAW
OF WALES

D URING THE EARLY 1930s CEDRIC WOULD SPEND EVERY SUMMER IN WALES
while Lett looked after The Pound, went to London or visited
his mother in Sussex. Lett would visit Cedric in Wales every three
weeks or so. The men spent spring and winter together in Suffolk
and London; while Cedric worked outside, continuing to expand the
garden, Lett painted pictures and walls and carried out improvements
to the house. Their relationship was much calmer than in the previous
decade. Other people still excited their amorous interest, but they did
not swap jealous remarks. Communication between them when apart
was affectionate, intimate and less dramatic. Cedric liked to hear news
of developments at The Pound, what work the gardener, John, was
doing, what the restored fireplace looked like. He would write to Lett
about his painting trips and what he was doing in Wales. Cedric did
feel guilty about leaving Lett to manage The Pound: 'I am concerned
I have put you in a horrible position, turning you into a sort of cook
and bottle washer. It was the last thing I wanted to do,' he wrote in a
covering letter with cheques to pay the bills.[134]

But neither man rejected advances from others. Cedric was being
pursued by Loraine Conran, later director of Manchester City Art
Gallery. They had met in London in 1932 and the striking young

man with dark glossy hair and large, wide mouth accompanied him to Wales later that year, where Cedric painted his portrait. Lett wrote at the back of his 1932 diary that this was the last year that he and Cedric were completely together in an exclusive relationship. Cedric's paramour was no secret; indeed, he was keen to tell Lett that the affair with Loraine really was only a brief fling: 'I have been getting snappy notes saying Loraine wants to see me and that I must go back to Oxford with him. I can't say no and I am horrified by the idea,' he wrote from Solva, Pembrokeshire, in 1933. 'Loraine is a hard-boiled devil and will soon tire of me.'[135]

Morris's love of Wales was visceral. 'Pa must have had some dirt out of the garden on his thing the night he made me,' he joked in a letter to Lett from 1928 written from his mother's birthplace, Llangennith. 'I always said this was the loveliest country in the world and it is, it's so beautiful that I hardly dare look at it. I realise now that all my painting is the result of pure nostalgia and nothing else. I thought I was homesick for England but not at all – that dirty smug little market garden. It was this I wanted and now of course I know I shan't be able to paint it. There's too much to do, everywhere is paintable and it all looks like my landscapes but twenty times better, the colour is marvellous and so is the shape.' Feeling that the country might not live up to his ecstatic worship of it in Lett's eyes, he added, 'but you may be disappointed when you see it'.[136]

In the *Western Mail* in 1926 he had been described as a rising and important Welsh artist devoted to the most minute studies of nature. But the newspaper was keen to add that that he was not pursuing what was expected of him as a Welsh gentleman: 'In the early days he was never able to understand the appeal of hunting and some of the more energetic forms of outdoor sport nor in consequence were his family able to understand him.'[137]

Cedric was not drawn to Wales to live a life similar to his parents'. Indeed, there is no mention in any of his letters to Lett that he visited his parents while in Wales. If he did see them, it was not worth mentioning. He viewed himself as outside the establishment and the class structure. At the same time he saw being Welsh as different

from being English, with its own distinct sensibilities. He singled out characteristics in himself that he perceived to be Welsh, seeing himself as strong, witty and bitchy, with socialist ideals. As a young man he had often referred to himself as English, particularly in reference to his shyness and inability to show his emotions, but now he began to call himself Welsh. Spending more time in the principality awakened an interest in politics too. He came to the conclusion that Wales was looked down on or ignored by London and many English people. In his opinion Wales was the noble, struggling nation, which gave so much to empower the Industrial Revolution but did not receive enough support from the British government in its industrial decline. Cedric was concerned about the increasing poverty and unemployment in Wales. Due in large part to a failure to modernize, Welsh factories, mines and steel works were closing at an alarming rate. The copper smelting industry that had enriched his family had largely moved abroad. In 1929 Britain's first Labour prime minister, Ramsay MacDonald, was returned to power, but could not agree how to deal with the fallout from the American Depression. He decided to form a National Government in coalition with the Conservatives under Stanley Baldwin. Their plan was to cut public spending and benefits. In 1931 government assistance to the unemployed was reduced by 10 per cent. Claimants were put through a rigorous and humiliating means test. For Wales these measures were particularly devastating. The country desperately needed financial aid to rebuild and compete with overseas industries. In 1934 the government was forced to reverse the cuts; it then passed the Special Areas Act, which identified South Wales as an area with special employment requirements. The Westminster government invested in a new steel works in Ebbw Vale, but this could only replace a fraction of the jobs lost. Unemployment benefit prevented most people from starving to death, but there was no system to help them find work. On a royal visit to the Merthyr Valley, South Wales, in mid-1936, Edward VIII felt that something needed to be done and announced, 'These people were brought here by these works, employment must be found for them.' Cedric was no royalist, but he always remembered Edward's comments and defended

him vigorously during the abdication crisis, perhaps as both men had chosen a different path from what was expected of them.

Cedric liked to attend Labour party meetings, but as a member of a well-known family his presence was not always well received. Labour MPs, many of whom had Communist sympathies, believed he had got rich from the sweat of the working man. On one occasion Labour MP David Grenfell, a Sketty resident, reminded him that his family were factory owners and in part responsible for the conditions the workers now found themselves in. In a conversation between them after one lecture Grenfell told him, 'South Wales is one of the worst spots and where there is a town bearing your name.' Determined not to be fazed, Cedric replied, 'I went there yesterday.' 'I was born there. I worked ten years underground,' Grenfell retorted pointedly. Grenfell was wary of anyone called Morris. 'Morris of Swansea had gone and Morris of Swansea has come back,' he said. Cedric was keen to show him that he was not like his forebears. 'Morris of Swansea is dead,' Cedric shot back. 'I don't think so,' Grenfell said with a shake of his head. 'We must have a change of values in everything.' Cedric felt embarrassed. 'I agree with him but it was like being talked to by a headmaster,' he wrote to Lett.[138]

As a show of solidarity, Cedric would attend Nonconformist chapels in Wales, although his church attendance in England was infrequent. 'I have nothing against Jesus Christ but it's the way he is presented I object to,' he once said in response to a question about his beliefs. The hell-fire and brimstone and hair-shirt sermons that were preached in the Welsh chapels did not move him, indeed as a party piece he would imitate them in his best Welsh accent. He was able to find common ground with his fellow countrymen in his distaste and shock at the neglect of absentee landlords and uninterested Church of England bishops that they all felt had alienated the Welsh poor.

Methodism, which saw helping the poor as an obligation, was a wellspring of the British Labour movement. Cedric found the Methodist form of socialism less severe and more palatable than Marxism. Cedric's socialism was to some degree paternalistic and may have been driven in part by a sense of *noblesse oblige*, but by those families affected by unemployment in the Welsh valleys his desire

A LESSON IN ART & LIFE

to help was accepted in good grace. He decided that diversions were necessary and pushed for the establishment of art studios in the most deprived areas. He believed the government in London was not giving enough hope to the unemployed and pleaded with local councils in the Merthyr Tydfil area to provide workspaces for local and visiting artists. He maintained that the proportion of young artists working in Wales during the 1930s was 'perhaps for her size higher than in any other area' and he felt they should be encouraged. He railed against the Welsh museums for their lamentable deficiency in acquiring contemporary painting. He was convinced that Welsh art should be celebrated for its uniqueness. England had a framework to promote the arts. Artists working in England who could afford the subscription could join the Imperial Arts League, which promised its members, including Morris, 'to protect and promote the interests of artists and to inform, advise and assist artists about business and lobby governments in their interest'. No such organization existed in Wales and Cedric and a few others were trying to do the League's job. Fellow Welshman Augustus John felt equally angry that the Welsh establishment seemed uninterested in contemporary art. Both Cedric and he were frustrated that 'the whole attitude towards the visual arts in Wales appears to be a mixture of apology and indifference.' Like Morris, John had left Wales as a young man, painted in the South of France and settled in England.

In 1934 Morris and John gave their support to an exhibition of Welsh contemporary art. Caroline Byng Lucas and her sister Frances were behind the idea and had persuaded the influential architect Clough Williams-Ellis to open the exhibition in Aberystwyth on 16 July. It then travelled to Swansea in September and Cardiff in October. The three men contributed work: John a portrait of T. E. Lawrence, Morris a Welsh landscape and Williams-Ellis architectural drawings. They were joined by Frank Brangwyn, Wyndham Lewis, Gwen John and Caroline Byng Lucas. The catalogue declared, 'Amid the turbulences caused by the rise and wane of great industries the creative instincts of our people have too often been thrust aside in the struggle for our daily bread. Man cannot live on bread alone. It is our endeavour to bring before the people of Wales the urgent importance

of art in our National development.' In a show of support Lett wrote a pamphlet extolling the nobility of the Welsh and the importance of Welsh contemporary art. He highlighted Cedric's contribution and his opinions to accompany the exhibition. Cedric was very touched, telling him that the pamphlet was being 'used all over the place'. He was very keen for Lett to deliver a lecture he had written, 'Pontypridd: Public Appreciation of Art, ditto of Artist' to unemployed men at a holiday camp, but Lett declined.

The show was a great success, with 2,000 visitors in the first week, in no small part due to the hard work of Caroline Byng Lucas and, Frances Byng Stamper, who lived at Manorbier Castle near Tenby. This formidable and determined woman had been given the position of secretary to the organizers. The sisters helped to push the idea that Wales needed a permanent organization to represent living painters. Their efforts were rewarded when three years later in 1937, with the public backing of Augustus John and support and patronage of Lord Howard de Walden, the recent owner of Chirk Castle, the Contemporary Art Society of Wales was formed. Part of the society's remit was to acquire work by young Welsh artists and present it to public bodies.

Following the opening Cedric went on a painting trip with fellow artist Tod Picton Warlow. They started in the Crickhowell and Amroth area, where Cedric found the countryside 'as having unearthly beauty that is Wales that I have been wanting last summer and mixed with it there is something grim and cruel and primeval, if only it were paintable. It would make good fabric print.'[139] He asked Lett for the measurements of Allan Walton's printing block so he could try do one or two designs to fit.

The trip ended in Laugharne. Cedric and Tod dined with Tod's aunt, Edith Picton-Turbervill, the social reformer and Labour politician, who lived locally. Like Cedric, she had aristocratic connections but no wealth (until she inherited a Glamorgan estate). As a young woman, she engaged in social and philanthropic work, which drew her to the Labour movement, leading her to conclude that 'fundamental changes in law were necessary to obtain better conditions of life for the people.'

Edith provided moral improvement by helping to set up reading rooms and encouraging church-going. Cedric and she got on very well and, due to her influence, he would finance a reading room at Penclawydd in 1935. He was very keen to paint a portrait of this woman whom he found 'quite a celebrity and fine to look at'. In his picture her expression is unsmiling and her face has a contemplative seriousness. She is wearing a simple open white shirt and necklace. Cedric never sold this portrait; he took it back with him to Suffolk.

In the summer of the following year, 1935, Cedric travelled around Wales supporting Augustus John in the promotion of the Welsh Contemporary Art Society. While there, he produced a picture, *House on a Welsh Hillside*, that confirms his status as a superb colourist. The farmhouse, a block of flat colour, is unimportant; it is the illumination of the landscape and the differing shades of green in the momentary tungsten light of Wales that he captures so well. John and Morris were staying at the George Hotel in Shrewsbury. Both had plans for a painting trip around South Wales. Cedric was charmed by the older artist and took it upon himself to be the hard-drinking John's nanny-cum-minder. He confessed to Lett that he had difficulty steering him past pubs, but congratulated himself that he had managed to keep him to four beers and two gins in twenty-four hours. 'He is half naughty boy, half wise', he wrote to Lett, adding that 'it was good thing he is not younger'.[140] Augustus John was a star in Wales and Cedric knew he would draw attention to the plight of Welsh art: 'John is popular among all classes, though they have never seen him, he is spoken about with the greatest of awe,'[141] he told Lett. Augustus John liked Cedric, but later remarked rather waspishly to Kathleen Hale, with whom he had a brief affair, 'If Cedric Morris thought a little less about Cedric Morris he would be a better artist.'

In July Cedric broke up with Loraine Conran but did not tell Lett until a month later in a letter just before coming to see him accompanied by Eleanor Hampden Turner. Lett had already suspected that the affair was over. He wrote in his diary when he was with them both at Manorbier the previous month, 'c'était la fin de l'affaire.' Cedric rationalized his feelings: 'I am not suffering from wounded vanity

nor a wounded heart, I never had any vanity about Mr Conran and I have no heart.' He moved to a hotel in Ponterwydd in the hills and Frances Hodgkins said she would visit to cheer him up. She was not impressed by the place and only stayed one day. He was, however, able to see his old friends Stella Gwynne and her daughters, Elizabeth, Priscilla and Felicity. Elizabeth had decided she wanted to learn the Welsh language, so the family had rented a cottage at Talybont. Cedric and Lett took them to visit Clough Williams-Ellis at the Italianate village he had built at Portmeirion. Elizabeth particularly adored this colourful Mediterranean-inspired village and was to return over the years to Wales in search of peace to write her cookery books.

While at Manorbier, he decided it offered the perfect opportunity to paint a portrait of Caroline and her sister Frances for a proposed exhibition at the Picture Hire Company in London. He never made a preliminary drawing for his portraits, rather working round the face in a very definite order. He started near the bridge of the nose on the corner of the eyebrow on the left, then moved to the top of the head working downwards to the eyes, nose, mouth, chin and neck.

He titled this painting *The Sisters* (1935). The women were depicted as stern and unsmiling, both wearing strong red lipstick and simple orange and red wool dresses. Their steely determination can certainly be read in this picture. Mrs Picton-Tubervill had not objected to her portrait, but the sisters certainly did. They thought it unforgiving in its directness. He painted his immediate conscious and subconscious impression of a subject; this picture is not a personal portrait but one that represented an attitude. Their faces show a born-to-lead pragmatic toughness but also a hauteur that he felt members of his class should reject. Artist Cuthbert Orde's daughter later expressed the view that Cedric's portraits of women were often very unflattering, especially when a woman married one of Cedric's friends. In his 1923 husband-and-wife portrait of her parents she felt her mother, Eileen, was made to look extremely disgruntled and sour-faced. Cedric later reflected, 'every time I paint a portrait, I lose a friend.'

The Sisters didn't sell at the Picture Hire show; prospective buyers wanted flowers, birds and Welsh landscapes. The reception *The*

Sisters received surprised Cedric and he told Lett he wished to look for new subject matter: 'I want to work among the factories if I can find somewhere to stay.' He found an out-of-work miner's cottage in Penclawdd and wrote to Lett, 'it's extremely uncomfortable, and filthy food but nice people, but I am getting on to do something I want. I am getting used to living with these people. It is really heart-breaking the way they have to live, I am not enjoying it.'

On 12 August 1935 Cedric visited Penclawydd and wrote to Lett full of outrage and a sense of injustice concerning the conditions of mining families. 'Went for a lecture by the Labour member of the district, who said things were by no means as bad in Glamorgan as they were going to be and that people must face utter destitution and that there is no hope, no escape, and they must face it and try and save the children – there was no solution from any party.' Cedric made these desperate people into heroic figures. He went to country fairs and admired their ability to throw off their troubles and enjoy themselves. But as his worship of Wales increased, so did his disdain for England and the English.

When requested, Lett wrote impassioned exhibition catalogue introductions extolling the excellence of Welsh art and the work of his partner, citing his 'unique vision, his intricate harmonies, and subtlety of colour techniques, based as they are on an unprecedented breadth of palette'. He gave equally effusive praise to Cedric's portraits.[143]

The situation in Wales was, however, making Cedric angry and upset. In a splenetic letter to Lett he wrote, 'I don't think I can go on living in England, there seems to be nothing left of me but shame, depression and a hatred of all the things I have always hated – I am ashamed of being an Englishman. I hate England but there doesn't seem anywhere to go, I wish there was something to tie oneself to, but there is nothing but complacency, perhaps a few half-starved frightened miners have got to be murdered to make way for more complacency.'[144] Lett lent a sympathetic ear but urged him not to get involved in politics and stressed his painting must a be priority. Cedric understood his point and admitted that he was getting too caught up in what he called 'the Welsh business'.

Cedric needed a distraction and decided he must work towards his long-held ambition of having an exhibition of his portraits. Lett, who felt Cedric's portraits were some of his best work, greatly encouraged him. Cedric and Lett knew many figures in the arts who had expressed an interest in his soul-piercing representations, but he was reticent about approaching subjects, worrying that they might be too busy. If Peggy Guggenheim would show his portraits, he thought they might be more willing to sit for him. Guggenheim, now divorced from the hard-drinking bohemian Laurence Vail, was living between London and Paris. He was aware that half the artists in London were running after Peggy for a show, but theirs had been a very close friendship in Paris; he was the godfather to Peggy's firstborn, Michael Cedric Sinbad, now ten. She had not yet opened a gallery in London, but was proposing to put on an exhibition in Paris for her protégée Djuna Barnes, author of the ground-breaking lesbian novel *Nightwood*. Gossip was that Djuna's paintings were not much good and Peggy was just doing it to help her make some money. Cedric met Djuna and author Antonia White for dinner while they were passing through London. He mentioned his plan to ask Peggy Guggenheim for an exhibition and hoped that Djuna might mention it to her. However, he found she was not helpful and rather proprietorial. 'Djuna was very defensive, in fact a complete bitch,' he told Lett. He also had tea with Ottoline Morrell in the hope of getting her to encourage her famous friends to be painted by him.

Cedric believed that he might make money from a portrait show. Precarious finances were a constant worry in many of his letters to Lett from Wales; he would reiterate his concerns about the upkeep of The Pound. In August 1936 he wrote from Manorbier, 'Can we afford to live there or can we afford to live anywhere? It's such a frightful amount of work for both you and me. Anyway, it will be easier after my show in October [at the Picture Hire Company]. If that is again a failure. I shall burn any work and start all over again, as it's only the doing it that is interesting, and it would do away with the necessity of having a fixed abode.'[145]

Cedric had to make a decision about his priorities. The obsession with Wales and the lot of the poor was beginning to take its toll on his relationship with Lett, who felt Cedric's personal suffering over

politics was not doing him any good and was getting in the way of his painting. Cedric was intransigent. 'This is me. I cannot change,' was his response. But he did admit that the enthusiasm and work involved to bolster the spirits of the unfortunate Welsh families were tiring him out. He accepted that he could not control their fates. It began to dawn on him that obsession and rants about Wales and England were something Lett tolerated, but found wearisome. He could sell The Pound and live in Wales full-time, but it would be very unlikely that Lett would want to come with him. He decided that they should sort out his attitude to Wales. 'Would you mind leaving Wales out of our conversations and in future treat it as a taboo subject? I have a special feeling about it and have perhaps inflicted this special feeling on you and other people. I shall not do so again,' he assured Lett.[146]

Pragmatically, Suffolk was a better place to live. He could produce good landscapes and flower paintings there. He was enjoying creating a garden and, most importantly, it was where Lett wanted to be. They were both making good local friends. It dawned on Cedric that he must make positive plans to keep the Suffolk house and merely be a visitor to Wales, which he continued to do throughout his life.

8.

LETT HELPS WITH INTERNATIONAL RELATIONS

WHILE CEDRIC WAS ABSORBED IN WALES, LETT WAS STARTING TO BECOME VERY engaged in the Anglo-German Society. He had become interested in Germany as a fertile land for exciting new art while he was living in Paris. The important Parisian art dealer Ambroise Vollard was keen to promote an exchange of ideas between French artists and German ones and offered exhibitions to Wassily Kandinsky and Gabriele Münter of the Munich-based Blaue Reiter movement. When outlining his career in art in a notebook, Lett wrote how much he admired the work of Russian-born Kandinsky, who had spent time in Germany.

Many English people still felt anger and enmity towards Germany. The Germans remained the enemy who had caused a catastrophe in Europe and there could be no acknowledgement that they were suffering too. They were to be punished and their culture ignored. The English ambassador to Germany, Viscount D'Abernon, was one of the first Englishmen to notice that this demonization of the Germans by the victors of the war was a factor for the rise of the Nazi party. In 1931 D'Abernon, in an attempt to calm tensions, founded the Anglo-German Society with the aim of encouraging understanding

and friendly, peaceful relations between the two nations through the sharing of culture (known today as soft power). D'Abernon was society president; board members included Harold Nicolson, Bertrand Russell and German consuls and politicians, including Konrad Adenauer, who would become the West German Chancellor immediately after the Second World War. The society rented 6 Carlton Gardens near St James's Park in London and equipped it with a library to enable British and German nationals to study the art and literature of both countries. The intention was to make Germans welcome in Britain and to furnish British members with introductions and assistance when visiting Germany. There were lectures, a library, film screenings and art exhibitions. British people could learn about German cuisine through demonstrations and attend beer and wine tastings. The society was strongly supported by British artists and the Tate Gallery. In 1932 an exhibition of contemporary British paintings which included works by Augustus John, Paul Nash, Christopher Nevinson, J. D. Fergusson, Charles Ginner, Stanley Spencer, Mark Gertler and Duncan Grant was staged in Hamburg to great local acclaim. Lett's interest in the project was piqued when Cedric was asked to supply three pictures, *Prelude to Spring, Flower Piece* and *Country Life*. The English disavowal of German culture had been brought to his attention by a letter from author and theatre critic Huntley Carter lamenting that no English publisher was interested in his book which, he explained, 'showed the importance of Germany as a highly cultured nation and the truly awful effects of the war and peace treaty on the population.'[147]

Lett's art was receiving acclaim at an exhibition at Fortnum & Mason in early 1933 which resulted in sales. The work was idiosyncratic, merging figurative, abstract and Surrealist features. *Birdlore* he described as 'an abstract painting in oils'. *Pastoral* is a slightly surreal landscape, *Tree of Knowledge* features people and a monkey, and *Dancing Sailors* and *Cows* are both lively figurative works. In addition to the pictures there were painted tables he had decorated with shells and sea-wrack. Prices ranged from £15 to £50. The success of the show encouraged Fortnum & Mason to take on his fabric designs to be developed in conjunction with Cedric and Allan Walton.

But on 30 January 1933, when Adolf Hitler became Chancellor of Germany, the dream of England and Germany as friends began to fade. His propaganda terror and programme of intimidation against Communists and Jews, which forced Jews out of civil service, university and law court positions, dismayed many in England who had previously supported him. News was trickling through that the arts were being censored and many intellectuals and creative people persecuted. But as the situation worsened in Germany, Lett was determined that artists from the two countries could still share their ideas. He was therefore very happy to receive an invitation for the post of honorary organizer of an Anglo-German Society exhibition to be staged in London just before Christmas 1933. Jack Macnamara, who was now a territorial army soldier seeking to be a member of Parliament, later elected MP for Chelmsford and becoming Lett and Cedric's neighbour in Suffolk, was keen to repay Lett for getting him out of a tricky situation in North Africa. He volunteered to be co-organizer and gave parties to promote the Anglo-German Society. He wrote to the Foreign Office saying he was keen to develop the club and give talks in Germany.

As the show date approached, Lett was taken aback when some of his artist friends decided they could not take part. Just before the opening, Frances Hodgkins wrote, 'I am most grieved to hurt you, this you must believe, but quite definitely I wish to withdraw my support from your exhibition for the clear reason I do not want to identify myself with a movement benefiting English artists when such atrocious cruelty and hardship has been shown to Germany's own cultured classes. I saw it for myself in Spain this year, the suffering and privation of exiled artists.'148

Jacob Epstein did not wish to be involved either, seeing the exhibition as tacitly accepting the German state's oppression and discrimination against its Jewish citizens. 'I can assure you that my activities are the reverse of the impression you have unfortunately been given,' Lett wrote back to him.149 Duncan Grant also declined Lett's invitation to supply pictures. Lett was aggrieved, and a sharp exchange of letters took place between the two men. 'I cannot help but be hurt by the attitude of some of your friends to the exhibition for which I am responsible. Your boycott of the exhibition can only serve to help jeopardise the success of

an ideal I believe to be mutual to both of us, that of pacific international and national relations.' In his letter Lett listed members of 'this non-political organisation', including a number of Jewish names.[150]

The exhibition opened at Carlton Terrace on 14 December and was attended by the German ambassador, members of the Anglo-German Society, politicians from all parties and British aristocrats and collectors. Paul Nash, Ben Nicholson and Edward Wadsworth represented abstract art. J. D. Fergusson, Augustus John, Cedric Morris, Matthew Smith and Edward Burra supplied colourful figurative work. Morris showed the soft and luminous *Flower Piece*. Sculpture was provided by Barbara Hepworth and Frank Dobson. R. H. Wilenski's catalogue offered a robust defence of the show and its aims: 'We know astonishingly little of what is happening around us because the press in all countries records only what the proprietors of the papers want the readers to believe and what the proprietors think the readers want to read. The English people as a whole know next to nothing of post-war Germany and the German people I imagine knows nothing of post-war England. This exhibition is an attempt to provide information.'[151] He went on to explain the English character: 'The English tradition in the arts, the English climate, the English restrictions on the consumption of alcoholic drinks, English prudery and the English personality of the painters have all played parts in works here collected.'

However, the critics completely failed to highlight the artistic exchange the society wished to promote between the British and the Germans. Instead they wrote about the English artists' differences from their German counterparts, stressing the qualities of the Englishness of the artists unsullied by foreign connections. Cedric Morris was singled out in a review as 'the only English artist who shows not the slightest Continental influence. This exhibition and its artist should kill the Continental fancy.'[152] Sadly, the newspaper coverage was the start of a destruction of the society's noble aims. As Hitler and Germany increased their aggressive behaviour, the Anglo-German Society was quietly wound down.

While Cedric dallied with Loraine Conran in Wales, Lett was amusing himself in the company of his friend Stella Gwynne, who

had recently moved to the Old Grammar School in Dedham and set up an antique shop. He was also seeing a good deal of Eleanor Hampden Turner. Charles Hampden Turner, Eleanor's husband, had originally sought Lett's company while he was going through marital difficulties. He was Lett's guest at The Pound during early 1933 and often stayed for a few days. Charles was an army man but in Lett he found a sympathetic ear. In June he brought his wife Eleanor to lunch with Lett. The strain in their marriage was palpable. They arrived and left at different times and were on edge in each other's company. The next day Eleanor called to thank Lett and they discussed her husband. Lett then received a phone call from Charles. He found himself in the invidious (and tedious) position of listening to them complain about each other and telling Lett not to repeat what they had said. He had to choose whose confidant to be; he chose Eleanor.

Eleanor Hampden Turner was fast becoming Lett's constant companion, as frequent entries for 'E' in his diary show. She stayed at The Pound with him, Cedric and Loraine Conran. The conversation between the four was entirely civil; indeed Loraine and Eleanor got on very well, and became good friends independently. Eleanor also accompanied Lett when he visited his mother, attended parties in London and went to the cinema with friends such as Paul Nash. Since leaving Aimee for Cedric fifteen years ago there had been no female to whom he had been particularly attracted. His renewed attraction to women puzzled him and he noted in his diary that he must read *Psychopathia Sexualis* by Richard von Krafft-Ebing, one of the first books on homosexuality and bisexuality. Also on his reading list was a book on African dances that he wanted to look at to inspire his work.

In February 1934 Eleanor told Lett she was having a baby[153] and on 29 September a son, christened Charles Michael, was born. Referred to as Michael by his family (he later called himself Charles), he was late arriving in the world. Eleanor had been in the nursing home in London for twelve days while Lett anxiously waited to hear, doodling the name Charles in his diary. He was at The Pound with Loraine and Cedric when he heard the news. Loraine rushed up to London to see the baby. When the baby was born his paternity was never mentioned by the

Hampden Turner family. He was Charles Hampden Turner's son, but circumstantial evidence pointed to Lett's being the father. It was not discussed by friends of Cedric and Lett either. Cedric had his suspicions and was in a state of shock, but there is no written evidence that he confronted Lett. Lett seemed – or chose – to be oblivious to Cedric's obvious distress, complaining in his diary that 'Cedric depresses me so much, he is always trying to pick a quarrel.' Lett visited the baby when he was four days old and was happy that all was well and stated that 'the baby is excellent.'[154] Lett was made his godfather and, although he did not attend the christening, he sent a mug.

That winter the relationship between Lett and Cedric had reached a very low point and Cedric suggested breaking up. At Christmas Cedric stayed at Manorbier Castle with the Byng Stampers. Lett's diary entry for Christmas Eve and Christmas Day reads, 'Dined and went to cinema alone, cleaned up Charlotte Street studio and drains blocked by rats.'[155] By 27 December Eleanor had fulfilled her family duties and came to London to dine with him. After New Year, she returned home to Cambridge and Lett went to stay with his mother in Sussex. He visited his mother frequently over the next two months, sometimes taking Eleanor, who charmed her with flowers and chocolates. In October he sold some farm buildings and cottages he had inherited at Wilmington, Sussex, which earned him £1,500.

Cedric meanwhile was writing him a flurry of letters explaining his financial concerns. 'I am sorry you can't tear yourself away from these absurd women to talk things out with me,' he wrote in February 1935. 'I have less than £250 a year living expenses or £5 per week, which we can't afford to live on. I have no prospect of making any money and have reconciled myself to it. I shall do my work and not attempt to sell it or to worry because it does not sell. We shan't be able to have John [the gardener] back and there is too much work for me to do on my own. I think it really might be the best thing to sell The Pound and to live somewhere with a smaller garden. Don't think this is a result of a mood, I realise though that I have spent too much money but what on God knows. It's no use bullying me for being selfish, that is my way of going to work and I am too old to alter now.'[156]

Lett did not rise to this. These outbursts were becoming familiar. He patiently told him not be so hysterical, but that he should address his spending. These were not the letters of jealousy and insecurity that they had exchanged ten years earlier. Their relationship had gone beyond the sexual and possessive. They had come to a greater understanding of each other. Quibbling and bitching were part of the way their relationship worked. They understood each other and needed each other as best friends. However, much to Cedric's fury, Lett did not divulge his whereabouts or what he was up to, despite Cedric sending him accounts of his daily activities.

Lett saw no reason to give up seeing Eleanor. He took her to fashionable restaurants, such as L'Étoile in Soho, where he would often dine with John Gielgud, and then take her on to the Café Royal, where he might meet Nancy Cunard and other artists and writers. At other times he would go with Cedric to gallery openings and dine with poets David Gascoyne and Dylan Thomas. On one occasion he wanted Cedric to meet Eleanor's brother-in-law Peter Hampden Turner for lunch in London. He duly obliged, but Lett was late, which infuriated Cedric.

The following year, 1936, was much like the previous one: the two men were like ships in the night, together and apart. Eleanor had separated from Charles and was requesting a divorce. She brought the baby Michael to see Lett in London, which cheered him up. Lett threw himself into his work, producing thirty-two paintings in watercolour and oil and sixteen drawings for a show at the Picture Hire Gallery in November. He gave inventive titles to his mysterious paintings, among which were *The False Banana*, *Drama of Masks*, *The Bad Queen's Magic Mirror* and *Betrayal*. These hung alongside traditional Suffolk landscapes and line drawings of nudes with a sculptural, French influence. Sales were reasonable, but Lett was not in celebratory mood. He was too preoccupied with his relationship with Eleanor and Michael. Cedric meanwhile was trying to ignore Lett and his agitated state of mind, and threw himself into preparing for his one-man show, also for the Picture Hire Gallery.

As the year drew to a close Eleanor was travelling in Europe with Michael and waiting for her divorce to be finalized. Fortunately, a friendship that Cedric was forming with Ian Brinkworth, a young man

who had just graduated from the Slade and was now teaching at the Westminster School of Art, would pull the two artists back together again and reinvigorate their relationship. Lett did not initially take to Ian Brinkworth, but it was Ian who was in part responsible for helping to form a plan that would enable Cedric and Lett to live and work together at The Pound. The proposal put together by Morris and Brinkworth was to found an art school in a village near The Pound which would be different from the rigorous and prescriptive London art schools and their formal instruction in art history and technique. The school was to be based on the French *académies* they had attended in the 1920s. Cedric would be principal, Lett honorary secretary and Brinkworth the art teacher. They decided to call the new venture the East Anglian School of Painting and Drawing. With minimum fuss and a great sense of purpose, in the new year they drew up a prospectus: 'The object of the school is to provide an environment where students can work together with more experienced artists to produce sincere paintings.'

Cedric believed that drawing classical sculpture could stifle the imagination and kill creativity. His preferred teaching method was to encourage students to look around them and observe the landscape, birds, animals and flowers. Instead of painting from a stone sculpture, a life model would be provided. 'The attitude of the student is that he has a clear idea of creative work and requires only help in its production,' the prospectus continued. 'We propose to work on this assumption, not an idea current in art schools, that the student is the depository for the theories of the master and guilty of impertinence in thinking otherwise. We do not believe there are artists and students; there are degrees of proficiency. The school is not just for those wishing to take up painting as a career, but for those who just have an interest and sympathy with painting.' The East Anglian School of Painting and Drawing was to be a community of artists who would be able 'to decrease the division between the creative artist and the public'.[157] Enthusiasm for the project was shared equally by Cedric and Lett, and they were keen to get going with it as soon as possible. In Dedham, a few miles from The Pound, they found a building that could be converted into an art school; and they set about attracting students.

9.

A LESSON IN
ART & FUN

O<small>N THE WEEKEND BEFORE</small> E<small>ASTER</small> 1937 <small>THE</small> E<small>AST</small> A<small>NGLIAN</small> S<small>CHOOL OF</small> Painting and Drawing was ready to receive its first pupil, at a rented studio in Dedham opposite the Marlborough Head pub. The student, however, did not arrive. This was perhaps fortunate, as the keys to the place had gone missing and were only found three days later. Cedric did not return from London until Good Friday. The first apprehensive students were Lionel Crossley from Colchester and an eighty-year-old lady whom Lett described as 'very washed-out'. Fortunately things improved. Two weeks later Kathleen Hale arrived with a male life model. By the middle of April young Denise Broadley, the subject of one of Cedric's portraits back in 1934, joined the group. Denise Broadley was escaping from her imperious grandmother and often in the early evening she would walk back, or get a lift in Lett's Austin Seven, the four miles to The Pound and have supper. A formidable Mrs Hellaby swept in, promising to bring her daughter Felicity in May. As the weeks passed, attendance picked up: four became five, then six and more.

Students had to be found lodgings in Dedham. Among the intake in the first few months was a young Joan Warburton, whose father had retired from the army and settled the family in Little Horkesley near

Colchester. She had been pestering her father to be allowed to learn to paint and eventually he reluctantly acquiesced. He had found out about the new school from their family doctor, a friend of Cedric's. Joan was from a class of women who were sent to finishing schools in Europe, in her case in Belgium. Like many other girls, she was expected by her parents to go to hunt balls and be presented at court as a debutante, in the hope of meeting a 'suitable' husband. She had other ideas and was keen to attend art classes and become a professional artist. At first, she was only allowed to take instruction three days a week 'as my mother insisted that the rest of the time I led the life that she considered normal', she recalled in her unpublished autobiography, 'A Painter's Progress: Part of a Life 1920-1984'. The art school, she said, 'was a complete awakening'. She was keen to absorb everything around her and seldom returned home until late at night. The first evening was no refined sherry party but a pub crawl with three men, Cedric, Lett and Brinkworth. She visited The Pound the following day and was bowled over by the beautiful garden, in particular the greenhouse full of geraniums and Cedric's collection of cacti and succulents. The old wash-house, now Cedric's studio, was full of scented and finely coloured irises in pots waiting to be painted.

As the daylight hours lengthened, more students arrived, among them Daphne Bousefield, David Carr and Bettina Shaw Lawrence. David Carr, a member of the Carr's Biscuits family, had been studying history at Exeter College, Oxford, when he decided to throw it all in and become an artist. On learning this, his father cut him off financially. Fortunately, his mother came to his rescue and paid the two guineas a week fee.

Every weekend and many Wednesdays during the first summer there were parties. Some were spontaneous: no reason was needed. Kathleen Hale came to many of them. Once, on arriving at the train station, she found Lett dropping pennies down Joan Warburton's cleavage, observing her body as they tinkled to the ground. According to Hale, the young girl with her peaches-and-cream complexion and golden hair pretended to be in a trance. Lett had renamed her Nordic Maudie after the Tennyson poem 'Come into the Garden Maud' and because he perceived her to be frigid.

Parties often began with screech from Ptolemy the peacock, parrots circling above and a few swear words from Cedric's yellow-crested cockatoo Cocky. The wind-up gramophone was brought out and the dancing began to the latest jazz and big band sounds and Latin American records. In an attempt to make the party useful for students, on some occasions local Royal Academicians Algernon Newman and Henry Rushbury would be invited to give encouraging advice. Then there were the more party-minded guests, such as Stella Gwynne, who came one weekend and left the next. For evening parties Bob, a manservant in white jacket, was hired to cook and serve. He would test visitors' mettle by making inappropriate comments. Joan Warburton later wrote excitedly about a sophisticated bohemian fancy dress party one weekend at which 'Lett kept away the boring and tiresome, Tony Butts was in sailor suit with gourds round his neck, Daphne Bousefield was wrapped in a leopard skin with bunches of grapes in her hair, John Banting wore a dressing gown and conical shaped hat made from newspapers. There was lots to drink and I arrived home at nearly 6am. I once found myself too close to some spikey aloe plants when dancing with a man called Boo.'[158]

There was one trip to the pub that was mandatory that term. Cedric and Lett had recently signed up as members of the Hadleigh Labour Party and had promised to bring a large gathering to hear their friend, the political scientist and philosopher George Catlin, husband of Vera Brittain and father of Shirley Williams, speaking at the Marquess of Cornwallis.

There might have been a party or an outing the night before, but hard work was expected the next day. Lett and Cedric insisted on professionalism and as time passed they became concerned that Ian Brinkworth was not taking his teaching position seriously. They thought that he should return to his cottage after the school day was over rather than spending the evening relaxing with the young pupils. Lett expressed his concerns to Eleanor in France. She was sympathetic, enclosing a picture of the child Michael: 'I do hope you can get rid of him and not be soft-hearted. You want someone dependable to whom you can delegate.'[159] Lett had little time for painting now; cooking and

administration were taking up a most of his time, even with the help of another servant, named Philip. To compound his stress Cedric became ill in August, saying he needed a break. Eleanor wrote supportive words to Lett: 'it is extremely hard on you and the school [for Cedric] to choose to take a holiday at this moment, but he thinks he has got an excuse. I can't think how you manage to carry on and deal with Cedric's ills at the same time, I am deep in my admiration but I must say you always seem to be "left nursing the baby".'[160]

The East Anglian School of Painting and Drawing may not have followed a traditional teacher-pupil arrangement, but there was a daily timetable to be followed. In the morning instruction was given in canvas preparation before painting began. Pupils were expected to learn landscape painting and life drawing. The landscape artists were sent on field trips along the river banks. Alternatively, there was an opportunity to work in the studio painting life models from London billeted locally. Both men expected full dedication to painting and decreed that students should carry sketchbooks at all times and use them wherever they were, on trains, buses and even in shops. At the end of the day Cedric and Lett would comment on their work – often, students reported, in complete contradiction to each other. Cedric tended to shoo Lett away while he was talking. 'Cedric was always himself and relaxed and instinctive, a very good and authoritative draughtsman. He didn't like to tell a student what to do. In his quiet voice he preferred to encourage, adding comments such as '"maybe a little more yellow there" or some similar vague guidance,' Joan Warburton recalled. 'Lett had a splendidly authoritative voice, which he used to advantage with his very original wit, sometimes verging on sarcasm.'[161] 'Ah, we have a Monet here,' he once said to pupil Gwynneth Reynolds.[162] While Cedric mostly taught by example, Lett had art lectures prepared which he could refer to. If Lett noticed a student was interested, he would pass on his knowledge of art history and theory. But 'Don't be bemused or fuddled by intellectual or professional opinions as to what is good or bad. Because what is good for Tom is often bad for William though both are equally inspired,' he told pupils.[163]

Other students recalled how much confidence Cedric gave them by his positive remarks. Denise Broadley remembered that 'Cedric would say very little and what he did say was quite vague.' Pushing his thumb at her work, he would declare, 'that's out of tone, it will only take five minutes.' She had more definite advice from Lett, who 'would show you a line or curve and it was always right'.[164]

When the East Anglian Art School of Painting and Drawing closed in October, sixty students had been to paint there during the previous six months. To celebrate, an exhibition of students' work was held at the Dedham School just before Christmas. Two hundred people came and the sale made the local press, who were impressed by the amount of work done in such a short period and commented on 'an appearance of liveliness and enthusiasm'.[165] Cedric Morris's exuberant flower and cuckoo painting *Go She Must*, was voted the visitors' favourite. In high spirits, Cedric left for Gran Canaria, which he decided would be a good place for a change of scene.

On his return in March 1938 Cedric received the good news that Peggy Guggenheim was going to give him a solo portrait exhibition at the Guggenheim Jeune Gallery in Cork Street, instead of the exhibition of flower paintings she had originally suggested. 'I loved Cedric Morris so much I couldn't refuse,' she said, though she condescendingly described him in her autobiography, *Out of This Century*, as 'a painter of flowers who had an iris farm and a school for painters in Suffolk'.[166] To show portraits for which Morris was little known, was a commercial risk for Guggenheim. To prepare, he rented a studio in Park Hill, Hampstead, and began to approach his considerable collection of friends and people of note to see if they would sit for him. He told Lett he had started by painting people he described as negroes and an Indian woman.

But Cedric was feeling depressed at the thought of dealing with the London art world again. Lett was firmly encouraging him to concentrate on his paintings and not escape into looking for plants for The Pound garden. He exhorted him to keep calm, telling him not to work himself up into a lather against the art system and the wrongs of the world. Cedric drily replied, 'I will endeavour to cut my spending

and deal with the rogueries of Guggenheim, placate dealers and art critics, simulate a sufficient respect for the present financial and social system and learn to cultivate geraniums and that decorum which is suitable to middle age – that is about the sum of your admonitions.'[167]

When she saw them, Peggy Guggenheim did not have a high opinion of the portraits, which included authors Antonia White, Rosamond Lehmann, Mary Butts, Loraine Conran and John Banting. 'The portraits in most cases were nearly caricatures, all of them on the unpleasant side,' she fulminated. She complained that Cedric had exceeded the agreed limit of fifty paintings. 'He covered the walls three rows deep, I think he must have hung one hundred of them. As well as sitters he knew, there were women he paid to sit for him, some of them prostitutes.'[168]

Guggenheim's trepidation regarding the portraits was well founded. At the opening party an architect, Mr Silvertoe, disliked the portraits so much he started to burn exhibition catalogues in protest. Cedric was most displeased and threw a punch at him. Joan Warburton said that one subject tore his portrait down and stamped on it, although she could not recall who it was. 'The walls were spattered with blood,' said Peggy Guggenheim. The next day Cedric phoned to apologize and offered to move his paintings. 'Of course, we did not let him,' Guggenheim recalled.[169]

This was a wise decision. The next morning the critics were effusive in their praise. The portraits had disclosed a hitherto little known aspect of Morris's talent. 'It could only add to his reputation,' wrote one of London's most respected critics, T. W. Earp in *The Times*. 'There is a downrightness about the portraits of Cedric Morris which makes them a welcome relief from the flatteries and evasions of ordinary portrait exhibitions. At the same time, they are not caricatures, nor do they suggest any conscious attempt by the artist to "interpret character".' The *Daily Sketch*'s critic, Eric Newton, singled out the portraits of Mrs Gorer, Mary Butts and Rupert Doone. Critic Raymond Mortimer wrote, 'they're not speaking but shrieking likeness.'[170]

For Cedric, this was a welcome reaction. 'I have always been against portraits being analytical. I don't want to hurt a sitter's feelings, but

I can't help how a portrait turns out. I nearly always do hurt their feelings by painting just what I see.' Kathleen Hale, however, thought them piercingly perceptive, describing his painting of her sister-in-law Mollie Maclean as 'deliciously wicked, malicious and funny, an uncanny likeness – typical of every portrait he painted'.[171] In Lett's opinion Cedric's portraits were unique and among his greatest works.

Cedric's determination to put on the exhibition and its success seemed to rekindle Lett's love and commitment to Cedric and his work. Shortly after the exhibition he broke the ten-year silence with his wife Aimee by suddenly asking her for a divorce. She replied very graciously through Lett's mother: 'I will do whatever he wishes, I have had not much of anything from him, not even my wedding presents. However, that matters very little. Nothing could make up for the loss of him. He did give me a great deal mentally and also by all means the happiest time of my life. I shall never cease to be grateful to him.'[172]

In early 1939 Eleanor Hampden Turner was killed in a riding accident in India, throwing Lett into despair about his future relationship with Michael. Although Charles Hampden Turner was now Michael's legal guardian, as the likelihood of war grew, so too did the possibility of Charles's enlistment in the armed forces. When he received a curt, businesslike letter from Eleanor's mother to say that Michael and his sister would become wards of court and then custody would be transferred to their aunt Lilian Mellish Clark, he did not know if he would be permitted to see the child. She wrote to Lett, 'I trust this is quite satisfactory, and Charles approves,' addressing him 'Mr Lett-Haines'.[173]

Lett turned to Kathleen Hale for support and advice and told her how he wished to see Michael after a letter he had received from the small boy. It was awkward to talk to Cedric about Michael and equally difficult to bring up the subject with their joint friends. Kathleen was not afraid to refer to Michael as Lett's son. She kept up Lett's spirits about the possibility of seeing Michael: 'I am so glad to hear about Michael, you will see him and I am afraid it will upset you. But you are an exceptionally courageous man, Darling. I hope so much you will have access to your small son despite the hopeless future you predict

for yourself. It is a marvellous five-year-old boy who can write a letter. My six-year-old is too bone lazy to write more than his name. Shall we take mine and him to the sea for a holiday?'[174]

Over the next few months she continued to boost his morale. 'I wonder if you have heard from Michael's guardians yet? They may relent [about the possibility of seeing him] if you continue to send him birthday and Xmas presents'.[175] Lett did continue to send him presents every year, recording in his diary Michael's age and what he sent every 29 October: 'a football and a greetings telegram', he noted in 1941.

The 'bedroom encounter with K' started on the last Friday of 1939, Lett wrote at the back of his diary for that year. Kathleen Hale (K) said she was advised by her psychoanalyst to have an affair to help save her marriage: 'Only a lover could release me from the chains that bound me to my imprisoning rock,' she wrote in her autobiography, *A Slender Reputation*. She didn't want to fall in love, but sought fun with 'a free spirit with such charisma and originality of mind that could never be owned or tamed'. Lett was the perfect choice because 'his relationships never lasted, except for his permanent attachment to Cedric,' she reasoned.

'When I succumbed to "Lett's tempting ambience" and joined his set, I earned Cedric's lasting disapproval. When we met face to face he would assume an expression of a disgusted camel,' Hale recalled.[176] Although wishing for a man with a free spirit, in reality Kathleen Hale found it hard to deal with Lett. 'Dear Old Beast, I am either extremely fond of you or excessively angry with you. It's not the months of idleness but the intrigues and beddings I hate you for.'[177] In November 1939 she tried to persuade him to write a book for her to illustrate, but he never obliged. Affectionate and teasing letters flowed between them. She tried to make him write poetry: 'do write a children's book of poetry so I can illustrate it, you won't of course, you will just drink of course and quaggle away your holiday and cast your sheep's eyes at every woman and emulate the hero at every lad.'[178] Both Eleanor and Kathleen seemed to enjoy casting Lett as a promiscuous rogue, a magnet to women who, given any encouragement, he would seduce. She teased him about and reprimanded him for his beer intake. What Kathleen

loved him for she also disliked him for. When they were apart she would tell him she hoped his bad temper was subsiding. She accused him of being quick-tempered, mischievous and sometimes wicked – and a bit of a drama queen. But she always found him magnetic, exceptionally patient and very unself-serving and longed to see him when they were apart. 'With Cedric and Lett, I was in a magic world that I had to abandon when I married,' she wrote, and described her doctor husband, Douglas Maclean, as 'Reason and Moderation'. At The Pound she threw herself into the fun. 'We all danced all night to records of Latin American music, the parties overflowing into the starlit garden. I loved the rumbas and sambas and preferred to dispense with the encumbrance of a partner and to parody, by myself, the gamut of human emotions, from romance to tragedy.'[179]

Throughout the war Kathleen continued to live with her husband in Hertfordshire, but she frequently visited Lett and Cedric in Suffolk, ostensibly to attend painting classes. Kathleen would say her affair with Lett saved her marriage and unlocked her painter's block and 'shook me out of myself and immensely widened my view of life'. Douglas Maclean seemed to give tacit approval to her affair, much to Lett's amazement. However, Kathleen did not want to parade their closeness in front of him and requested that Lett's letters should not be sent in envelopes marked Benton End. 'Douglas always wants to know what you say and sometimes it might be inconvenient,' she wrote.[180] She burned all his letters immediately on receipt; Lett kept all of hers. On 15 December 1947 he noted enigmatically in his diary, 'Kathleen Hale breaks away.' It is difficult to decipher this cryptic entry as neither party marked the end of the affair in more straightforward terms, but from around this time they began to see less of each other.

Lett always remained extremely fond of Kathleen and they kept in touch throughout their lives. She became a famous author and illustrator, depicting the adventures of Orlando the marmalade cat. Her first Orlando book was published in 1938 and she produced nineteen in all, the last of which was written in 1972. In *Orlando's Home Life* (1942) she drew Cedric as the dancing master and Lett as the Katnapper. Cedric was often asked by students if they could paint

his portrait and were almost always met with a refusal: he told them, 'you will never capture me.' Hale took this as a challenge and drew him a number of times. 'Cedric defied me to get a likeness, saying no one ever had, but when he saw the caricature he had to admit I had succeeded.' She was given the nickname Moggie by Cedric in homage to her Orlando books and often recalled Cedric's remark after the first one was published, 'Do you mean to tell me, Kathleen, you have hung your slender reputation on the broad shoulders of a eunuch cat?'[181] When Kathleen's husband died, Lett suggested that she come and look after him. She declined. 'I was too old to be a nurse.'[182]

Among the pupil intake of 1939 was a wayward young man, a keen horse rider and would-be artist. He had been expelled from Dartington for disruptive behaviour and then from Bryanston for dropping his trousers in the street in Bournemouth and directing a pack of foxhounds into the school buildings. He was recommended to Cedric by a mutual friend, Judy Goossens, a student from a famous musical family. His name was Lucian Freud, and Cedric and Lett were of course intrigued, proudly telling everyone that Sigmund Freud's grandson was joining the school. Lucian, with his shock of black hair and swagger, made a strong impression. Felicity Hellaby, a fellow pupil, was smitten and enjoyed a romantic attachment to him, kissing and cuddling but no more, while at the school. In her old age she recalled to author Geordie Greig that she found Freud 'very, very funny, incredibly charming, and there was something about him that made me think, even then, that he was going to do extraordinary things.'[183]

The East Anglian School of Art and Design at last gave Lucian some much-needed grounding. He remembered it later as 'a place where people were working and that there was a very strong atmosphere'. He was fascinated by the methodical way Cedric worked: 'I got a feeling of the excitement of the painting, watching him work because he worked in a very odd way, it was as if he was unrolling something from top to bottom that was not actually there.'[184] Lucian embraced all the school had to offer. Cecilia Dennis, painter Mark Gertler's model, posed for the students, giving him his first chance to paint a nude. At the East Anglian School of Painting and Drawing students could also design

textiles and Freud won a prize awarded by Allan Walton, now living in Suffolk on the Shotley Peninsula, for the best textile pattern.

For Joan Warburton, the summer before the Second World War was a magical time. She recalled the flower-scented evenings dancing to a young local accordionist, bicycling late at night through woodland and hearing nightingales sing. She helped in the garden and planted vegetables and flowers in long oblong borders enclosed by box hedges. 'To work with Cedric in his garden was a delight and made me feel in tune with all around. It was also an education and they were happy days.'[185] Cedric, an inveterate pipe smoker, decided to grow his own tobacco.

Students made painting trips to Ipswich docks and David Kentish, Lucian Freud and Joan Warburton were sent further afield in the autumn to Dowlais in Wales to stay at Gwernllwyn House. Formerly the ironworks manager's house, it was now an arts centre for the local unemployed run by Mary Horsfall and supported by Morris, who gave lectures and classes, and also criticism of the paintings by correspondence based on photographs. Cedric regarded it as important for his students to leave the cosseted world of the school in Suffolk. They were instructed to paint the slag heaps, miners' cottages and abandoned works and live with local families as paying guests. Freud painted a picture of a crate of apples with a Welsh landscape in the background and wrote mischievously from Betws-y-Coed to Cedric, 'I also painted a large monster and landscapes and a street at night and a tiny portrait of a woman wearing a pearl necklace. I am doing a great deal of drawing; my painting is getting much better.'[186]

Morris produced two very powerful pictures from Wales. From the window of Gwernllwyn House he painted *Caeharris Post Office*. There is little sign of life: leafless trees and smokeless chimneys dominate the landscape. In *Dowlais from the Cinder Tips, Caeharris (Plate 13)*, there is an equally depressing impression in muddy colours. Today the pictures are dated 1935, but when displayed at an exhibition in 1968 the date given was 1939. With the closure of the steel works in 1930, the area around the village of Dowlais near Merthyr Tydfil was one of the most impoverished in Wales; almost the entire male population was

unemployed. *The Times* reported that 'men and women are starving, not outright, but gradually rotting away through lack of nourishment.'

Back at the school, students Lucian Freud, David Carr and Bettina Shaw Lawrence were known by Lett as 'the infernal trio'. Carr would later recall stories about the goings-on at Benton End and his friendship with Freud; he told the art curator Bryan Robertson how Freud skinned a recently deceased cat from The Pound and wore the skin as a Davey Crockett hat before painting it as a still life. Carr and Freud often got into fights. Freud had taken a shine to Bettina, who was Carr's girlfriend. On the evening of 26 July 1939, having worked late, Freud and Carr were sharing a cigarette. They casually flicked their butt ends just outside and went back to the Marlborough Head pub, where they were staying. In the morning Freud was amazed to see brilliant orange and red flames rising from the black and white timbered school building. As Lett arrived, the roof fell in. Alfred Munnings, who happened to be driving by, stopped the car and waved a stick from the passenger seat of the car, roaring, 'Look what happens to modern art! At least you will have to paint out of doors for some time.' 'And that is exactly what we did,' Joan Warburton said later. Cedric instructed the students to join him in painting the smouldering building. The terrible fire did not deter the students from life classes either. On rainy days, they continued painting at the Marlborough Head, storing their materials in the bus garage. Paintings by Haines, Morris, Frances Hodgkins and Christopher Wood had been destroyed in the fire and the building was now damaged beyond repair. The cause, though never proven, was suspected to have been those unextinguished cigarettes falling on to turpentine rags.

On 3 September, when war was declared against Germany, Cedric was painting in Brittany with Cuthbert Orde. Back home an atmosphere of shock and uncertainty fell over the whole country. Students remained in Dedham until mid-October, but their return next summer was thrown into doubt. Cedric realized that plant-hunting trips to Europe or North Africa would not be possible while the war lasted. In October, he decided to spend most of December teaching at Dowlais, a far cry from the romantic environment of The Pound. He

explained to Lett, 'I have three classes, some of the results are interesting but it has been hard work in that they are so shy and inarticulate, three women have painted landscapes and a portrait of a Chinese woman.'[187] In another letter he was happy to report plans to resuscitate a couple of closed factories and a coal mine.[188]

Cedric was battling with conflicting thoughts about reopening the school in the spring now the country was at war. On one hand he felt 'a certain responsibility for the aesthetic welfare of young people by instructing them in painting, wallpaper design and fabric printing'; on the other hand he feared there was 'no place for aesthetics while this lunacy was going on'.[189] His work in Wales was unpaid and when an opportunity to earn £2 a week teaching at the Fitzroy Street Studios in London arose, he was pleased. He agreed to do two consecutive days a week until the following April.

The possible renovation of the East Anglian School of Painting and Drawing received encouragement from many sources. The Anglo-American magazine the *Artist* and the *Daily Herald* newspaper wrote to express their sympathies. The *Artist* offered their support by telling Cedric that they were not going to mention the fire 'because some people may think you are out of action'. The *Daily Herald* offered to publish the rebuilding plans. But despite backing from friends, Cedric and Lett received a blow to their plans when the landlord's solicitors informed them that Homeleigh, as they called the art school premises, would not be rebuilt and recommended they seek alternative arrangements.

Unexpectedly, some white knights came to the rescue. Angus Wilson, who shared Cedric and Lett's ethos for the school, wrote offering help. He suggested that with the inheritance his partner Paul Odo Cross had received he should buy a suitable house and let it to the school at a reasonable rent. Wilson's opinion was that 'it might be more practical than building at a time like this, labour and materials being difficult.'[190] Cedric was taken aback and reported to Lett, who was staying with his mother in Sussex, 'Paul has asked to help in any way we want, financially. I think he meant it. I, of course, was evasive. I think if we want his help the best thing to do is to use him as part-landlord and in some way purely as a business footing.'[191]

It was a gamble; wartime could have an effect on the numbers able to attend. Petrol was now rationed. There would be tiresome administration and regulations. A place needed to be found that required minimal work. Cedric felt they should strike while the iron was hot and advised Lett to write to Paul as soon as he had 'any kind of plan'.[192] He also passed on Angus's tip not to bother Paul with details, but as soon as something was formulated he was to contact Paul's solicitor.

The offer was a huge bonus and strengthened their belief in the school. They started to look for somewhere that had a good-sized garden with some outbuildings or a series of rooms that could be converted into artists' studios. They fell in love with a ramshackle, part-sixteenth-century farmhouse with an overgrown garden of two-and-a-half acres at Benton End on the edge of the market town of Hadleigh.

10.

WARTIME AT BENTON END

T HE FIRST, FREEZING WINTER OF THE WAR FOUND CEDRIC AND LETT IN LONDON for an exhibition of Cedric's work at the Fine Art Society. They were joined that January by Lucy Wertheim, Archie Gordon (later the 5th Marquess of Aberdeen), Angus Wilson, Paul Odo Cross and Kathleen Hale. Lett got very drunk and recorded in his diary that his mother had had to put him to bed.

The following week Paul Odo Cross placed a deposit on Benton End and Cedric, Lett, Stella Gwynne, Allan Walton and student Lucy Harwood drove the eight miles from The Pound to poke around the place properly. Joan Warburton recalled bicycling the journey to Benton End, laden with Cedric's garden tools and plants, and digging, hacking and scything to exhaustion. The house too was in a very poor state; electricity had to be installed, drains dug out and a schoolroom created. There were a few bedrooms for students, although some would have to stay in Hadleigh.

The refurbishment of Benton End was under the direction of Marion and Tom Davies from Gwernllwyn House in Wales and there was much to do before the school could open in the new premises. In the meantime, students of life drawing had to work either in Dedham pubs, the Sun Inn and the Marlborough Head, or at The Pound. Lett and Cedric would separately visit the classes. Committed and serious art students who returned from the previous year included David Carr

(a conscientious objector), Lucian Freud, David Kentish, Bettina Shaw Lawrence and Lucy Harwood. Joan Warburton managed to attend classes in between guarding the eastern seaports for the Women's Royal Naval Service. Millie Hayes, whom they knew from London, was a model for the term. Millie's life thus far had not gone well. She had been incarcerated in a mental instution for twenty years at the request of her husband and one doctor; this was, shockingly, medical practice in those days. All her teeth had been removed, something routinely done at that time to those in such institutions. Separated from her husband and ignored by her father, she needed money.

Lucian Freud found the classes focused him on what he wanted to do with his life. Being among other artists gave him 'a feeling of sureness'. He was happy and relaxed in this milieu. Ernst Freud was pleased that at last his son had found something to which he was dedicated and told Lett how grateful he was 'for the trouble you took with Lux [Lucian] and the kind interest you have shown for his wellbeing for his progress as a painter. We are quite aware that what you did was absolutely outside the scope of the East Anglian School. Lux has been to see us and he seems more sensible than usual.'[193] Ernst was always concerned about the fees and told Lett that Lucian was to 'economise and find a means of earning a living'.[194] The poet Stephen Spender had offered to pay Lucian's fees, but his help was politely declined by Ernst. Lett did not encourage Spender's generosity either, telling him that he was spoiling Lucian.

In 1941 Freud completed a portrait of Morris dressed in red neckerchief and set against a beige background. His expression is relaxed, as if in a daydream. The following year Cedric painted Lucian, who told Stephen Spender, 'Cedric has painted a portrait of me which is absolutely amazing, it is exactly like my face [it] is green it is a marvellous picture.'[195] Around the same time Cedric painted a portrait of two students, Barbara Gilligan and David Carr, who had recently married.

Freud was so strongly influenced by Morris that some of his early paintings could easily have been executed by his teacher. He seemed to absorb everything about him, even adopting his dress of Arran sweater and neckerchief. Cedric's refusal to dictate to Freud worked perfectly

for him. 'He didn't say much, but he let me watch him at work. Cedric taught me to paint and more importantly keep at it.'[196]

Lett was so impressed by Lucian's diligence that he even wrote to his father commending his efforts. Ernst replied, thanking him but saying that he could not help but loathe the last picture his son had brought to London, adding hopefully 'but his style and his subjects might change.'[197] Perhaps he would have been more pleased with Lucian's exquisitely detailed watercolours and the drawings of branches and brambles that he was painting at the same time.

Benton End was finally fit for purpose by the autumn of 1940 and Marion Davies stayed on to cook and teach. Although Cedric and Lett were now in residence, Cedric was reluctant to give up The Pound. He would make frequent trips back there until he found a suitable tenant in 1943. Benton End had a few rooms for student accommodation, unlike The Pound. This had its advantages but would make the East Anglian School of Painting and Drawing a completely immersive and sometimes intense experience for everyone.

Lett had given himself the title of the 'technical expert, manager, organising secretary'.[198] He was also caterer, housekeeper and cook, which meant dealing with the annoyances of wartime forms and rationing, leaving little time to pursue his own painting. Keeping the students in art materials was a struggle. Canvases were hard to come by, and the students were advised to paint over their previous works if they were not satisfied with them. Angus Wilson offered his many artworks for recycling.

Admonishments arrived in the post frequently from Hadleigh Food Control Committee, complaining of the late return of Benton End's registers of consumption. Lett also had to reply to letters from students' concerned parents. David Kentish's father was asking for progress reports, feeling despondent about his son's future. In September 1941 Ernst Freud asked Lett to persuade his son to register with the army properly and Lucian's mother was enquiring as to where he was registered for his rations of cheese, milk and eggs. Much to the consternation of his mother, Lucie, Lucian Freud never told her his whereabouts, whether he was at the school or roving round the country. She finally put pen to

paper, asking Lett 'if you would let us have some news from Lucian as he does not write at all himself', apologetically adding, 'I am so sorry to trouble you but I think you will understand that it is worrying to know next to nothing of one's child.'[199] Lett and Cedric had become Lucian's de facto guardians. In one letter to Cedric Lucian started with the heading 'foster parents' and put a question mark in front of it.[200]

The police sometimes called at Benton End to point out occasional failures to completely draw the blackout blinds. The Benton End gardener, First World War veteran Arthur Girling, would berate new students from Hadleigh about 'the weirdness of the arty-crafty gentry'. When a German bomb landed on Hadleigh, it was blamed on one of Cedric's guests who had recently painted a picture of the location. But those whose homes had been destroyed were very grateful to Cedric and Lett, who immediately offered them accommodation at Benton End.

To supplement food rations Cedric grew every kind of vegetable and herb. There were English staples, but also globe artichokes, asparagus and even red peppers in pots, from which Lett created a menu far more exotic than the typical British wartime diet. Cedric's picture *Wartime Garden* (1944) shows rows of vegetables in the walled garden, framed with a box hedge.

Food at the students' lodgings in Hadleigh was not so good. Millie Hayes blamed the poor quality of food there for the bad behaviour of the young men, especially Lucian Freud. 'I thought the main trouble with those boys of yours is that they all suffer from their landlady Mrs Mitchell's diet. She feeds them so badly that I am convinced she gives them indigestion. Certainly Lucian at least is constipated as he wouldn't have such unhealthy skin as he has,' she speculated. 'I am sure that is what makes him so tiresome, because he is capable of being the sweetest person if he wants to be.'[201]

Alcohol was difficult to buy; frequently pubs had no beer and when there was a delivery, it was rationed to half a pint per person in an evening. Lett's nephew Patrick Ogilvie, on leave from the army, recalled how his uncle made cocktails out of fruit juice and surgical spirit, which gave everyone head-splitting hangovers. Next day nobody could admit how they were feeling; there was no excuse for not painting. Lett even

A LESSON IN ART & LIFE

served these toxic drinks to his solicitor, Mr Witch. On returning some document by post the next day, Witch told Lett how much he had enjoyed himself and expressed the hope that his host had had no ill-effects.

In 1941 two young artists, the couple Dicky Chopping and Dennis Wirth-Miller, wished to join the art school. At the outbreak of war, they had moved from London to a cottage near Colchester. On a warm summer's day their friend Joan Warburton secured a party invitation for them at Benton End. Chopping was ill, but wobbly bicycle rider Wirth-Miller accompanied Warburton to the house through the tiny Suffolk lanes. Wirth-Miller reported back to Chopping, with whom he had a somewhat drunken and tempestuous relationship, that Lett and Cedric had shown him how a relationship could be.

Wirth-Miller and Chopping were desperate to enrol but lacked funds to pay for tuition and board. Cedric offered Wirth-Miller a place in return for kitchen and gardening help. Chopping's job was to manage the accounts, for which he had an aptitude. He also agreed to pose nude. During wartime, life models were difficult to find, and when students were not willing, females from London not involved in munitions work were invited to pose. The few male models from London were rumoured to be conscientious objectors.

Wirth-Miller and Chopping's presence did not make for a harmonious household. Wirth-Miller had taken great exception to Lucian Freud because one day he had added a few brushstrokes to one of Chopping's flower paintings. Fuelled by alcohol on Chopping's birthday at the King's Head in Hadleigh, the drunk Wirth-Miller became loud and obstreperous, ranting about Freud. Lett and Cedric were acutely embarrassed and irritated. According to Jon Lys Turner in his biography of Chopping and Wirth-Miller, *The Visitors' Book*, Wirth-Miller believed that Freud had become arrogant following the publication of one of his drawings in *Horizon* magazine. The feud was to last a lifetime and, as Freud became more famous, Chopping frequently wrote lists of petty grievances he had had against him during their time at Benton End. Freud was not averse to winding up his fellow pupils and the combination of two tricky, sensitive and explosive characters in Freud and Wirth-Miller became an unwelcome distraction at the school. There was an air

of hostility between the male pupils, with one faction fighting another. Freud and David Carr were decidedly unfriendly to Wirth-Miller and Chopping, who reciprocated in kind. The other students, Millie Hayes, Tom Wright and Lucy Harwood, felt the tension.

Lett recorded Lucian's annoyances and misdemeanours in his diaries. In January 1941 he wrote, 'Lucian in trouble for his bedroom fire'. Over the school term he was becoming increasingly fed up with Lucian, who came and went during 1941. Lett noted in January 1942, 'Lucian Freud (I hope his last appearance).' It was not, and on 19 February Lett's diary reads, 'Lucian turns up mainly to sell his picture to Lucy for £3. Was not well received by Cedric. Got him cash, he went off without saying goodbye and not giving me £1 he promised. He gave me a cigarette, but it was broken.'[202]

Over the next few years Lucian would return to Suffolk, but only when his wartime and military commitments allowed. Cedric was not always keen to see him, however. 'Cedric wrote a letter to my mother asking her to persuade me not to come down again as I was too destructive and unscrupulous. It does not surprise me really, as he was unusually friendly over the weekend. I think they must have found out that I don't come down to Hadleigh entirely to see them,' Freud told Lucy Hellaby.[203] Lucy was now his girlfriend. His depiction of her in *Girl on a Quay* (1941) is his first full-length portrait and shows strong traces of Cedric's work.

Dicky and Dennis lasted eighteen months at the school. When they announced their intention to leave, Lett noted in his diary with relief, 'Dicky and Dennis have buggered off.' There had been some bad feeling between Freud and Wirth-Miller over a missing painting; Lucian Freud's portrait of fellow pupil John Jameson suddenly disappeared while on show at a local fête at Tendring Hall. Although Wirth-Miller, with his intense dislike of Freud, was a supect, he never admitted to having removed the painting. He told anyone who brought the subject up that Lucian had given the picture to him and then later in life insisted he had found it in a junk shop. The picture remained in Wirth-Miller's possession all his life. A stint at Benton End certainly helped the careers of Chopping and Wirth-Miller. Kathleen Hale helped Chopping with his illustrations and he was taken up by the

Bloomsbury figure Frances Partridge. He was later chosen to design the front covers of Ian Fleming's James Bond books. Wirth-Miller became a fashionable painter in the 1960s and was recommended by interior designer David Hicks to all his well-heeled clients.

As the war progressed artists were finding it difficult to commit to full-time terms at the school due to military duties. In the new year of 1942 Millie Hayes wrote to Cedric, 'I hope the school will survive this relentless round-up of all able-bodied creatures, heterosexual ones that is, and support itself on under twenties and over forties.'[204]

Local people started to take painting classes at Benton End, not to become professional artists but to enjoy painting as a hobby in congenial surroundings. Evening drawing classes were introduced and were a great success, attended by local ladies, soldiers on leave and young people from Hadleigh and the surrounding villages. All found the classes a welcome respite from their daily lives. By midsummer the number at evening classes with both male and female life models was up to eighteen.

Lett decided to try and attract not just painters but craftsmen and even budding cooks. He proposed to offer evening classes in sign painting, stage design, block printing for fabrics and horticulture, but also start courses with a practical application. Writing paper was printed with the heading 'East Anglian School of Building Construction'. Courses were advertised in woodwork and cabinet-making, cooking, plumbing, upholstery, weaving, even child welfare – with the proviso that it would consist of lectures and advice only. A teacher was never appointed and there appeared to be no effort to recruit participants. The East Anglian School of Building Construction seemed to be an idea that Lett pretty much kept to himeself.

Benton End was perceived by the young people of Hadleigh and surroundings areas as a school of painting, drawing and design, not as somewhere to study vocational and practical courses. The parents of Ellis Carpenter, Bernard Brown and Derek Waters sent their young sons to Benton End to learn to paint in the school holidays. When Brown's father learned that his young son, barely ten years old, was painting naked men, he expressed his shock. Cedric batted away his concerns, assuring his father, a fellow member of the Labour party, that it was all strictly

professional. Ellis Carpenter's stepmother thought all painters were wicked. But they all agreed that spending time at Benton End was a good way to keep their children out of mischief. In return for some instruction the young people were given jobs around the place. Lett decided that twelve-year-old Derek Waters had a natural talent for painting and in exchange for lighting stoves and helping with food preparation he was given guidance and art materials. He was also given recipe tips by Elizabeth David, who was often in the kitchen cooking with Lett. Ellis Carpenter pulled up the weeds alongside Cedric and developed a lifelong love of irises. As a grown man he revisited Benton End frequently. Robert Davey was a young boy from Hadleigh who drifted down to the school with his friends to investigate the rumours of the unusual goings-on at the 'Artists' House'. Rather than being shooed away, the boys were ushered in by the Benton End residents, who coaxed shy admissions from them of a desire to paint. In these young people Benton End engendered a love of gardening and painting that would sustain them throughout their lives. Mollie Russell-Smith's family was evacuated to Hadleigh from London and she was given a scholarship by Lett in return for help in the kitchen. Mollie had such fun at Benton End that instead of going back to her aunt's in the evening, she lived in at the school for two years. Robert Davey helped Trevor White, a fellow student, with his headscarf prints. Students from Benton End sent their designs to three textile companies in Manchester, Capel, Cepea and Allan Walton Textiles. Davey later became Cedric and Lett's solicitor and trustee. Capel silks were very keen to obtain fresh ideas for dress silks from the students, although they had strict guidelines. They would not accept 'spikey flowers, stiff directional flowers such as daffodils and delphiniums. Abstracts repulse buyers,' warned the buyer from Capel. Free-flowing, soft-petalled flowers were what was required.[204] In 1941 Capel bought three paintings from Lucy Harwood, two from Joan Warburton, one from Lucian Freud, one from Dicky Chopping and four from Dennis Wirth-Miller, along with a painting by Cedric, to transpose into dresses and scarves.[205] Cepea Fabrics requested a number of designs from Cedric, Lett and Lucian Freud on the theme of 'a good earth'. Spiky flowers designs by Cedric and a number of students were also sent but rejected.

During the war, when travel was difficult, Cedric concentrated on painting flowers from the garden at Benton End and still lifes. His approach to still lifes remained similar from the 1940s to the 1960s. The colour balance and contrast is striking. Vegetable and fruit are sculptural rather than textural, often on plates tipped towards the viewer, a sort of oblique projection where the sizes of the objects are not actual. In 1940 he painted *Succulents in African Pot*. *Irises* followed in 1941 and a fresh-looking *Iris Seedlings* (1943) depicts stems in white, pink, blue, yellow and purple arranged in a gold jug. Peeping through the flower arrangement is a painting of one of Cedric's landscapes. In *The Orange Chair* the chair is set against a yellow wall and in front of a table on which are red onions, lemons and a succulent plant. *Succulents on an African Stool* (1945) is similarily colourful. *The Eggs* (1944) depicts brown and pink eggs in an earthenware dish tipped forward and set against a wall in yellow and grey.

In 1941 John Banting had taken up a position as arts editor of *Our Time* magazine and was keen for Cedric to do some drawing for the publication. The ethos of the magazine was very much in line with Cedric's views: it described itself as a practical publication for practical people, dealing with positive techniques of social living, theatre, music, painting: 'everything that will make your life happier in a time of war'. In the same year Morris was the lucky recipient of a grant from the Artists' Benevolent Fund. Cedric's other piece of good fortune was the gift of Benton End by Paul Odo Cross, who generously decided to make over the property to Cedric to do what he liked, even allowing him to choose whom to leave it to in his will. Cedric now felt more financially secure and, with Benton End in his name, he had a greater sense of permanence there. He decided to lease his beloved Pound to a specialist vet, Laurie Ogden.

Wartime travel restrictions focused Cedric not only on gardening and painting but also on writing. His article in the *Studio* in May 1942 set out his views on flower painting: 'Unless a flower painter can express the presence of entities other than human who concern themselves with the well-being of plants, he has not entirely achieved his object,' he wrote. 'He must get across something as well as the esoteric meaning of plants.

Flower painting has an extra set of values, which vary with individual artists but must always show great understanding and interest in plants.'[206] In 1943 he submitted an article to the Iris Society Yearbook entitled 'Concerning Plicatas'; and despite the travel restrictions of the war iris growers would make the journey to Benton End to marvel at his plants. He also wrote fiction and poems, more for his own satisfaction than with a view to publication, including 'The Love Story'. 'I will be myself and I will not pretend,' is the story's opening sentence. 'I am quite different to all those who love me.'[207] The poems he wrote were often about birds and plants; and of one of the many cats at Benton End, in 'Passage On', he writes 'Farewell, most charming of females, good hunting wherever you may be . . . you ruled this house with your soft insistence, both cat and man; were faithful to your shabby Tom, . . . Asking nothing but a little food and such attention as all women do.'[208]

One of the unexpected consequences of the war was the creation by the Labour and Conservative coalition government of the Council for the Encouragement of Music and the Arts (CEMA) to help promote and maintain the arts, although there was no money offered to artists or museums. The thinking was that art and music could boost morale and fighting spirits. Cedric felt vindicated by all of his efforts in Wales during the 1930s. He believed that this mood of optimism from the government would spread into Wales and raise greater awareness of the settlements set up by University College Cardiff in the early years of the twentieth century, originally in Splott, then other locations, with the expressed aim of helping the unemployed learn new skills. Cedric believed that with some organization and a commercial outlook the settlements could be self-supporting. He wanted to continue offering encouragement to Dowlais artists, and when invited judge competitions and offer criticism of their work. He showed special interest in the Quaker settlement at Trewern House in Dowlais and found an artist interested in taking up a teaching role there. During the war Mrs Horsfall from Gwernllwyn House in Dowlais was being sent an increasing number of Jewish refugees and one artist was keen to help give instruction in painting and crafts. After studying in London in 1944 a young German-Jewish refugee, Heinz Koppel, had settled in

Pontypridd and was very willing to help teach adults and children at Trewern House. Koppel's paintings of the surrounding countryside and decaying industrial buildings in strong colours showed influences of German Expressionism and were admired by Cedric.

The enthusiastic and capable painter Arthur Giardelli also taught at Trewern House and shared Cedric's vision of expanding the arts in Wales. Giardelli was of English and Italian descent and first began to take his art seriously in the 1940s, when the school at which he taught in Kent was evacuated to Merthyr Tydfil. From then on he made the Welsh mining community his home and was a keen promoter of the arts in Wales. He organized an exhibition of David Jones and Cedric Morris at the Pontypridd settlement and was to become one of the founders of the South Wales Group. His admiration for Cedric was unstinting. When Cedric was offered CEMA's first one-man show in Wales in 1943, Giardelli wrote in *Wales Magazine*: 'The choice of painter is appropriate, Cedric does not paint to satisfy the aesthetic creed of some small coterie or would-be artistic dictator. He paints to satisfy himself and, prejudice and fashion aside, emerges as everyman's painter.' Giardelli gives Cedric Morris's wartime flower and bird paintings a psychological twist: 'It takes more than the painting of the bomber or ruined houses to express the horror of Rotterdam. The war paintings of Cedric Morris have a wider reference. He finds the very spirit of evil lurking in dark, horrid, primeval growth or hovering in the bird of prey.'[209]

Giardelli travelled to London from Wales to visit Cedric's exhibitions and write encouraging letters. At Cedric's show at the Leicester Galleries in April 1944 he told him how much how his art shone in the company of recently deceased artists Morland Lewis and Walter Sickert. In his opinion Morris's *Lord Hereford's Knob*, a classical column in a landscape, should be in a public collection. However, the newspaper reviews were not so enthusiastic. The *Telegraph* critic wrote, 'from an artistic point of view they might be bettered. One does not feel that Mr Morris has arrived at quite the right convention for his paintings of growing flowers, they ought to be more formally decorative or casually naturalistic, but they are apparently lovely in colour. One odd and apparently spontaneous effect of Mr Morris' familiarity with birds is that he makes you feel

their reptilian ancestry.'[210] The *Morning Post* wrote that there were 'signs of improvement, but in one or two pictures rawness of palette knife clotting interferes with the natural passage of the eye from tone to tone and plane to plane – those stopping places at the wrong junction so to speak'.[211] Cedric would not have another London exhibition until 1952, again at the Leicester Galleries, having declined the offer of one in 1949.

During a couple of wartime summers Cedric invited both Koppel and Giardelli to paint at Benton End. They were delighted to visit such a completely different environment, a far cry from their mining and industrial communities. It was a stimulating experience for both men. Lett's reputation for delicious food was much talked about at Trewern House. Returning home to Wales after one visit to Suffolk, Giardelli was cross-questioned by his wife and mother on how and what to cook.

Artist Esther Grainger also made the journey from Wales to Benton End. She had met Cedric in Pontypridd and they quickly became great friends. Grainger became Cedric's eyes and ears in all things to do with Welsh art. Esther, who painted in a colourful, vibrant style, was an organized woman with an enthusiasm for promoting young Welsh painters. Morris showed at art exhibitions arranged by her at the National Eisteddfod. At an exhibition in the early 1940s put on by Grainger at the Pontypridd settlement, seventeen-year-old Glyn Morgan entered two pictures. Cedric Morris was judging. 'He thought that mine were promising and said: "Why not come to my painting school in Suffolk?"', Morgan later wrote.[212] In the summer of 1944, the year he finished at Cardiff, Morgan booked a week at Benton End. After the war he enrolled at the Camberwell School of Arts and Crafts, but found it unsympathetic, his strongest memory being 'the smell of cabbage drenched in bicarbonate of soda'.[213] The only place he wished to paint was Benton End and he spent every holiday there that he could for nearly forty years. Cedric gave Glyn Morgan, with his perfect, pale Celtic complexion and thick black hair, the nickname 'the Prince'. 'Benton End was a world apart where painting is the most important thing in life,' he later wrote. '[Cedric] had a freedom of spirit few achieve and this enabled him to give out unstintingly, expecting nothing in return but good manners and a commitment to work.' [214]

11.

PEACE
AT LAST

WHEN THE WAR ENDED THE COUNTRY ELECTED A LABOUR GOVERNMENT headed by the reforming socialist Clement Attlee. At the July 1945 general election word got around that Benton Enders had flung rotten eggs at the curmudgeonly local Tory MP Colonel Burton when he addressed a gathering at the local pub, the Marquis of Cornwallis. According to East Anglian School of Painting and Drawing student Bernard Brown, Cedic and Lett donated money to the local Labour party.

Cedric celebrated the end of the Second World War with an allegorical picture of vegetables entitled *Yalta* (*Plate 24*). He told his friend advertising luminary Bobby Bevan, when the picture came into public view, that the red pimento represented Stalin, the brassicas Roosevelt and the carrots Churchill. Fellow artist Henry Moore had recommended him for a CBE for services to painting, but nothing came of this.[215]

Peace brought a spirit of optimism everywhere. Cedric and Lett were feeling a sense of achievement that they had managed to keep the school going as an enclave of creativity and self-expression throughout the dark days of war. This had been tough, and Lett felt that he had shouldered a lot of the burden with limited help. He complained that

he had been forced to be in charge of the catering and business side, not through choice but because he couldn't get help during wartime. He called Cedric a stubborn dreamer 'who won't help about the place' and complained that he himself would love to paint but his time was spent in endless cooking and washing up.[216] But these comments were not made in anger but with affectionate resignation.

Seeing the happy amazement on people's faces when they visited Benton End cheered up both him and Cedric. 'Coming after five years of dreary existence, making do with worn-out clothes, absence of light and colour . . ., suddenly to be in this garden and a house full of irises of incredible colours, cats wandering around and modern and exciting paintings everywhere – it was beyond belief,' student Bernard Reynolds recalled later.[217]

Felicity Wakefield came for a holiday at Benton End in 1947. Her mother Rose Marrable was there learning to paint and also looking after the domestic side of things. She had also succeeded Kathleen Hale as Lett's lover. Felicity recalls that Cedric dug up some clay from the river below the garden and gave it to her to model. 'Cedric liked me because I was partly Welsh. He had strong opinions but was gentle in expressing them,' says Felicity.[218] In 1951 Felicity married Peter Wakefield, and her mother and Lett celebrated the occasion together in Cagne in the South of France. Felicity spent her honeymoon at Benton End with her new husband. Peter Wakefield came from a narrow background and had attended a conventional public school, 'I had not encountered anything like Benton End before. Cedric and Lett made an art out of living which was open and fun and life enhancing,' he wrote. He remarked on Lett's plain-speaking: 'Lett was interested in people and could notice things which one might have preferred to remain unseen and unsaid.'[219] He admired Lett's grasp of art and what he called Cedric's puckish charm and his absolute concentration on his vision. Peter Wakefield went on to have a distinguished diplomatic career and he and his wife bought many of Morris's pictures. 'I suppose I had been blessed with an "eye" but I had been brought up to suppress my love of pretty things as if it was something unmanly, to be ashamed of ... Benton End changed my life.'[220] Following his retirement from the diplomatic service he became

Director of the National Art Collections Fund and was instrumental in getting Cedric's work into public collections.

However, back in 1947 Cedric was worrying about money. By their own admission neither Morris nor Haines had any business sense. Cedric had a small private income and Lett an even smaller one. Cedric was concerned. 'It seems that the school's finances are somewhat precarious, whereas after all the trouble we have taken they should at least be sound. It is impossible for either of us to do more work.'[221] His plan to bring in extra income was to engage a gardener who knew about growing plants sufficiently well but who also had what he called 'an organisational capacity'. He calculated that if more bulbs and seeds were propagated and sold, the garden could yield £200–£300 a year. But he did not actively look for such a person.

Shortly after the end of the war Cedric was invited to be the art master at Ardingly College in Sussex.[222] He declined, believing it would take him away from the garden, but recommended a student, Ernest Constable, who had the same ideals as Cedric, a wish to instil a love of painting in those who might not realize they had talent. They would correspond frequently, discussing primer and paint finish recipes. At Benton End a thorough preparation of the canvas was insisted on before anyone could start work. Michael Wishart, who attended Benton End in the late 1940s, recalled how Cedric spent time teaching him to stretch and prime canvases.

Teaching was certainly a good way for artists to earn money and continue with their own work at the same time. Cedric was approached by schools looking for artists to join their staff to replace teachers who had not returned after the war. In 1946 the headmaster of Clifton College in Bristol wrote to ask Cedric if he knew of a man between thirty and forty to take up the position of director of art. Private schools such as Clifton could offer free board and lodging, but artists teaching in London were not so fortunate. Denise Broadley, who was giving art classes in London, struggled to pay rent, later giving it all up to join a convent, much to Cedric's disappointment. Just before she took holy orders Cedric and Lett were very amused when she appeared in the left-wing newspaper, the *Daily Worker*, for which they had a

subscription. Opening the paper they were surprised by a photograph of Denise, paintbrush in hand, standing in front of an easel on the London Embankment next to a road sweeper. The caption read 'Two Workers with a Brush'. At the school Denise had been shy around men and Lucian Freud had drawn a picture of her surrounded by all the male students, mischievously entitled *Denise and her Suitors*.

Concerned parents of recent pupils asked Lett for advice on their children's future. Margery Keay wrote about her son David, 'he doesn't know what to do when he finishes at Birmingham School of Art, just paint? I know he doesn't want to teach but I don't think it would hurt him for a couple of years, money would be useful. I am sure he would take your advice. I am afraid he wouldn't do good work at home; the atmosphere isn't right.' David, who had been encouraged by Lett to make pottery, did get taken on as a teacher at the art school thanks to his support. David Kentish's mother was more indulgent; she felt her son was too young for a serious job and told Lett that the young man needed to get all the sun and air he could. 'I was not at all keen for David to spend a winter in London with all its fog and lack of sun,' she wrote.[223]

In 1946 CEMA became the Arts Council and as such the recipient of government money. In addition, the new Labour administration funded forty-six local art organizations to spend money on the arts. Cedric continued to work tirelessly in his support of local and small art societies and groups now that government money was available. He encouraged the efforts of the regional organizations that were outside the fashionable London bubble, whose aim it was to foster something very individual and entirely representative of their surroundings.

The foundation of the Arts Council encouraged artists to form art societies and Cedric was involved in the efforts in both Suffolk and Wales. When the news of this new national body reached Colchester, Reg Hazell, head of the Colchester School of Art, met with Colchester-born Roderic Barrett and other local artists. Fuelled with zeal, they ran the idea past well-known and well-connected artists of Cedric's generation living in the region, including John Nash. The idea was to have around 150 members. A general committee would be made up of fourteen people, including Lucy Harwood, with a selection

committee of fifteen. Lucy Harwood, Cedric Morris, Arthur Lett-Haines, Blair Hughes-Stanton, Geoffrey Sainsbury, Rowland Suddaby and Henry Collins were on the selection committee. A discussion ensued as to whether photography should be included and it was decided against. Cedric, who was present at one of the first meetings, was described by Roderic Barrett as 'insistent in his usual kindly, malicious, goaty way that John Nash must be offered the presidency on account of being a Royal Academician'.

The first exhibition took place in Colchester Castle in 1946. The selection committee had chosen thirty-seven artists purely on merit. Their background, experience or popularity was not allowed to influence the decisions. The artist and designer Henry Collins devised the posters for the exhibition as well as the society's logo. Exhibitions were to be annual and included work by East Anglian School of Painting and Drawing students. In 1948 Cedric Morris exhibited his portrait of Lucian Freud (*Plate 20*) which he sold for £50.

In February 1947 Cedric was invited to join fellow Welsh artists Alan Tennant Moon, Josef Herman and Ivor Williams and writer John Steegman in a radio discussion on the Welsh Home Service entitled 'Welsh Art'. Despite the formation of the Arts Council in England, there was no such body in Wales to offer government support for original Welsh artists. Cedric spoke forcefully. 'The artist cannot live in Wales as things are today,' he declared. He felt that the Welsh middle classes did not care enough about Welsh art. 'They are too materially minded and overwhelmed by a mass of out-of-date taste which comes from England.'[224] Josef Herman, who had fled anti-semitism in Poland to settle in Wales, had a more positive view on contemporary Welsh art: 'I think the public view is changing; whereas before they were shocked, they now show a readiness to think and are prepared to be convinced.' Cedric was a keen advocate of what he called 'culture clubs'; Esther Grainger had already set up what she called Baby Arts Clubs and acted as an administrator and fundraiser for many of them in South Wales. Cedric believed that selected artists needed to be subsidized, although neither he nor the other Welsh artists in the discussion had any idea of how to choose worthy recipients. All were agreed that a Council of

Art in Wales, independent of London, should be formed but 'we don't want it to be a body of dictation,' was Cedric's caveat.[225] The panel agreed that original work by Welsh artists was what was needed and an exhibition of Welsh art should be staged soon.

The following year the South Wales Art Group was founded by Cedric Morris, Arthur Giardelli and Ceri Richards. The requirements for inclusion were that artists had to be living in South Wales or, if residing elsewhere, they must be Welsh or have a strong connection with the principality. Requests to show were sent to members of small art groups throughout Wales and to other known Welsh artists in Britain. In 1949 the South Wales Art Group was renamed the Welsh Group and held its first exhibition at the National Museum of Wales in Cardiff.

Lett's post-war prospectus for the East Anglian School of Painting and Drawing was written in a spirit of altruism, almost public service: 'The object of the institution is the encouragement of the practice of Fine Arts. It provides no pecuniary advantages whatever to my partner or myself. Cedric Morris is the titular head of the school and teaches in class, also grows garden produce for the establishment and receives no salary other than for his board and lodging. I am the technical expert, manager, organising secretary doing the office work. I am also the caterer, the housekeeper and the cook, supplying never less than 400 main meals per week at cost. Those paying full fees are usually higher salaried teachers and educational authorities on short refresher courses.'[226]

An influx of ex-servicemen much older than the students hitherto, some of whom had experienced the trauma of war, created a more grown-up and soul-searching environment at Benton End. The fees were three guineas per week, including lodging, tuition and three meals, tea and wine. Tuition only was two guineas ten shillings a week. Many of the young students were on reduced fees, with some gaining free tuition in exchange for helping around the place. Robert Davey was modestly remunerated as a Man Friday. Strangely, he was given the job title of stenographer, though his tasks did not involve shorthand. He was in charge of all dos-and-don'ts notices pasted round the house. One read: 'Residents are required to close windows in rough weather and

women to make their own beds and tidy rooms, men also if properly capable.'[227] There were still shortages of many things including artists' canvas and Davey cut up hessian sugar bags as a surface to paint on. There was no question of making economies and even the pupils were conscious that the cost of free-flowing wine and large quantities of delicious food could not have been covered by their fees. Glyn Morgan commented later, 'you didn't pay much considering you had two enormous meals with wine – they couldn't have made much profit.'[228]

Now discharged from military service, the artists who had studied at Benton End were looking for work. Making a living as an artist in a country where few people had much spare cash was not easy. In March 1948 the Cobbold brewing family asked Lett if any East Anglian School of Painting and Drawing students could paint new pub signs for the Shoulder of Mutton in Hadleigh, the Sun in Dedham and the Skinners' Arms in Manningtree. Many pub and village signs had been removed during the war to confuse the Germans in the event of an invasion. Just after the war Cedric had painted the horse that John Skeaping had drawn for the sign at the Black Horse in Stratford St Mary. Tom Wright was the artist recommended to carry out the work for the Cobbold commission.

Many former pupils came back to attend classes or simply to paint at Benton End whenever they could. Joan Warburton was one of them; she had married Peter O'Malley, a lecturer at the Royal College of Art in London, and now called herself Maudie. Many needed the escape to renew their confidence and take a break from the harsh reality of making money as an artist. Esther Grainger remarked how a core of students would return like migrant birds between Easter and autumn and stay as long as possible. Sometimes at dusk Cedric or Lett would have to tramp across the meadows searching for the artists. They looked to Cedric and Lett for encouragement, advice and friendship. There was always a pile of letters on their doormat relating news and asking for theirs in return. In 1946 among the people wishing to study painting at the school was the revered psychoanalyst Marion Milner, known as Moll, who had studied cognitive development from the writings of Swiss psychologist Jean Piaget and also the work of Jungian analytical

psychologists. She was particularly interested in bisexuality. She was a keen painter too and incorporated art into her therapy work. She felt that conventional methods of art instruction were not fulfilling enough and wished to examine the unconscious creative process of painting. She saw Benton End as a good environment to investigate free automatic drawing and how and why an idea travelled from the brain to a piece of paper. Her findings and analysis were to form a fascinating book about the nature of the creative process, *On Not Being Able to Paint*, published in 1950 to great critical acclaim. Anna Freud noted in her foreword to the book that 'The amateur painter who first puts pencil or brush to paper seemed to be much in the same mood as the patient during his initial period on the analytic couch.'[229] Milner became very fond of Cedric and Lett and was a frequent visitor to Benton End in the 1950s. She wrote affectionate, sometimes flirtatious, letters to Lett, addressing him as 'Lett Darling' and telling him how much she missed them both when she was in London. Lett often stayed with her in Hampstead.

After Moll's visit the school attracted a number of psychotherapists and psychologists over the years. Other students regarded them with a mixture of mirth and wariness and Cedric and Lett would tease them. When the shy and serious-minded Anne Coghill, who had been working as an organizer of cultural activities at a mental hospital, arrived in 1948 Cedric placed a rose on her breast, announcing 'this is where the rose wants to be.' It took time for Coghill to relax, but later she was to say that the atmosphere of freedom to be yourself was one of the most important aspects of Benton End.

Gerry Stewart, the son of Lett's sister Oenid, hoped he might find work at Benton End. Gerry was a poet manqué, but not a painter. Oenid had died in 1927 when he was just three years old and his father had married again. He and his brother Patrick were bought up by foster families. Gerry described his childhood as a bleak place. He was too young to see active service in the war but was sent to Palestine with the army in the aftermath. Gerry was gay and troubled and he looked to Lett for support as a benevolent uncle who sent him books and to whom he submitted his poetry.

Attitudes to homosexuality were becoming far more intolerant than they had been during the war, when John Jameson boasted of his encounters with sailors at Ipswich dock during the blackouts. Soldiers and sailors in uniform often gave Jameson and Dennis Wirth-Miller buttons from their uniforms after a sexual encounter (Wirth-Miller amassed a huge box of them). When returning to civilian life soldiers and sailors were expected to marry and produce children, and women were encouraged to give up work and look after them. The media reinforced the message that homosexuality was an illness, but an illness unlike any other as it was an illegal one. Films such as *The Homosexual* labelled gay people as 'sick' and tabloid newspapers ran features entitled 'How to spot a homosexual'. During the early 1950s the British police conducted a purge. Between 1945 and 1955 the number of annual prosecutions for homosexual behaviour rose from 800 to 2,500, one thousand of whom received prison sentences.[230] Ronald Blythe has said that during those intolerant times the wearing of coloured socks was viewed as sign of effeminacy and anyone who displayed any flamboyance was open to accusations of unnatural habits. Fortunately, Lett and Cedric seem to have been left alone, labelled by the locals as artistic and eccentric, although Glyn Morgan recalled that among the students Cedric could be very camp, walking with 'wincing and wilting step'.[231] Locally they were considered business partners and at Benton End suspicion of a relationship was assuaged because they slept in different bedrooms. Cedric's forays into Hadleigh, which he always referred to as 'the village', were very rare.

Gerry felt under suspicion and even contemplated marriage. He confessed to Lett, 'The factor which will finally deaden military life for me is the question of marriage. Believe it or not, my desire is for some sort of marriage, despite the obvious trials such a state would bring.'[232] Fortunately, he could never bring himself to ask some unsuspecting girl, but instead decided that he would try to live in Suffolk and be part of his uncle's life.

The relationship between nephew and uncle was tricky and complicated; Gerry felt easily slighted but desperately wanted to belong to the Benton End community and was fascinated by all the

gossip and goings-on there. He felt very jealous of the students and the attention Lett gave them, as he showed in a terse note to Lett, blaming 'irresponsible' students for the theft of a missing belt. Gerry wrote frequently from a British army base in Palestine wanting to know what was going on at Benton End, not understanding that Lett might be too busy to write detailed accounts of life there. 'What mystery surrounds Benton End or is the fog of silence intentional?'[233] 'Supposing I managed to get leave, would my coming to Benton End be looked on with gladness or as tiresome necessity?'[234] wrote Gerry. When Lett did not reply, he took umbrage: 'Do I detect a note of annoyance and pique in your letter or is it merely the result of overwork and too little time? Do tell me if my coming down would inconvenience you. For God's sake don't alter your plans.'[235] He wanted to leave the army and, with no other plan, decided he would offer his services to Benton End, enquiring if Lett's previous offer of a place there still stood. However, it was not to be and Gerry came to realize why: in an honest exchange he admitted that to share Lett with so many others would be difficult. 'There are problems of spheres and temperaments. A clash would inevitably arise.'[236] Instead Gerry took off with his male lover, former Benton End student Tony Daniells, and they spent the next twenty-five years together in the Middle East. But his relationships with Tony and Lett were not smooth and happy. He became increasingly dependent on alcohol and would fly into rages and rant about Lett.

Lett's adoring mother, who during the war had kept him warm by sending him jerseys, was now in her seventies and was still worrying about him as much as ever. Her letters from Tas Cottage near Eastbourne, where she had moved in 1939, always started 'Darling Son' and with a worry about him. Now she replaced her concerns that bombs would fall on her boy with worries that he had not been to the dentist. She often paid for Lett and Cedric's household insurance as well as sending him money to augment Cedric's expenses for his painting trips abroad. In 1947 she moved into sheltered accommodation. She wrote frequently to her son: 'Now do eat properly yourself, you give others too much,' she advised Lett when he was fifty-six.[237] She continued to keep in close touch with Lett's estranged wife, Aimee, who now lived in Santa Barbara, California.

In the summer of 1947 at the age of eighty-eight Cedric's father inherited the baronetcy from a distant cousin, but by November he had become seriously ill. A very sad letter arrived from his nurse in October: 'I am bound to write on behalf of Mrs Morris to let you know your father is very ill with cardiac [sic]. At present, she finds herself unable to write to anybody, your father is terribly weak and as usual is worrying about your mother. Mrs Morris' nerves are very shaken.'[238] George Morris died on 23 November 1947 in Henley-on-Thames. Lady Willie, Cedric's mother, followed him within a year.

A few weeks earlier Cedric had visited his sister Nancy in Newlyn. She had fled to Cornwall after a nervous breakdown brought on by a break-up with a married woman. She was slowly recovering and Cedric wanted to help her find out what she wanted to do with her life. 'She would like The Pound if we get rid of Laurie [Ogden] and would like to take students if she could make enough to pay a woman to cook properly.... I should prefer to have her where I can get at her to save myself from worrying about her at a distance,' he explained to Lett. 'Also, she would take her share of Ma when that unpleasantness arrives,' he reasoned.[239] The plan did not materialize and Nancy moved to Henley-on-Thames near her mother.

Cedric loved both his parents but he was not as close to them as Nancy. No letters between Cedric and his parents have survived, nor are there any entries in Lett's diaries noting that Cedric was visiting them or that they were coming to Suffolk. He knew his mother thought Lett not the ideal partner because she made her feelings known through Nancy. Cedric bore no ill will towards Nancy as the go-between, and in recognition of her greater sense of loss after their parents' death, he painted a picture of Nancy's deceased bull terrier Swirl to cheer her up. He called the picture *Belle of Bloomsbury* in memory of Nancy's dog, who had lived with her in London during the 1930s. It is believed to be the only picture Morris copied from a photograph.

The inheritance of a baronetcy did not come with any substantial amount of money, only a few bits of furniture. However, Lett was pleased to put 'Sir Cedric Morris' on the Benton End writing paper.

12.

THE GARDEN

C EDRIC HAD GIVEN OVER MUCH OF THE LOWER GARDEN AT BENTON END TO around a thousand new bearded irises that he was breeding. By late May the garden was riot of tall bearded irises on the verge of flowering. From the early days of the war, he raised a thousand seedlings a year by hand-pollination, sifting and assessing them for vigour and form and using his artist's eye to produce painterly colours, including pioneering soft pinks and muted yellows. 'Irises with their economy of growth and delicacy have always interested painters,' he wrote.[240] He also posited that there is a distinction to be made between flower painting and a good painter of flowers. Cedric's most important consideration when painting them was conveying a direct bond with his subject matter.

Cedric told a friend that his involvement with plants deepened his perception as an artist. He had a vivid imagination when it came to describing a plant. Many years later when Tony Venison described a species of salvia as smelling like aniseed, Cedric asked what else it brought to mind, replying before the nervous writer could answer, 'a whore sucking a bullseye'. Morris admired 'plants' ruthless lack of fear'. His friends were becoming those people with whom he could talk about plants. 'It's always such a relief to talk about plants,' he told Venison. Painter John Nash had made a beautiful wild garden at Wormingford near Colchester and the two would discuss their latest discoveries and acquisitions. Nash was often out by himself painting in the Suffolk landscape and welcomed the conviviality of Benton End. Longing for some social interaction after a day at his easel, he would

announce to his wife Christine and lodger, the young writer Ronald Blythe, 'We are off to see the boys!'

In 1946 the garden at Benton End had come to the attention of *Country Life* magazine's sister title, *Gardening Illustrated*, through the submission of a freelance journalist's article on the irises. A photographer was sent to Suffolk and the article appeared soon after. Morris's reputation as an extraordinary plantsman, although he hated being described as such, was spreading and he was receiving regular requests to visit Benton End from keen gardeners, who would have to weave their way past students' easels to view an exuberant bloom. Gwendolyn Anley recommended all her gardening friends to go to Benton End. Sacheverell Sitwell visited in 1949 and was mindful that he had to carefully look after the precious irises Cedric had given him. His thank-you letter assured Cedric that the plants he was given would be planted in a perfect spot at his home, Weston Hall near Towcester. 'The iris has become something different in your hands, and they are very safe hands, it must be a wonderful thing,' Sitwell told him.[241] Cedric's irises feature in Sitwell's book on art, music and flowers, *Cupid and the Jacaranda*, in which he muses on what sixteenth-century Japanese painters would have made of the Benton End irises 'in shades of vellum, chamois and fuchsia!'[242]

Cedric expressed his disdain for gaudy American colours and 'knicker or salmon pink' and was unstinting in his efforts to produce a pure, delicate pink. The iris he named 'Benton Edward Windsor', so called in recognition of the prince's concern for the Welsh unemployed, was the first 'true' pink, unique in its subtle tone. When he discovered that 'Benton Edward Windsor' took on a grey hue in some weathers, he refined his pollination to produce the shell pink 'Benton Crathie', named after the church at Balmoral. In *The Tall Bearded Iris* by Nicholas Moore, considered the iris bible of the time, the author describes the Benton irises as notable not only for their substance but also for the characteristic delicacy and artistry of their markings.

His naming of the bearded irises prefixed with Benton reflected people he admired and who amused him. Many irises were named after friends, cats and birds, Shakespearean characters and, on a few occasions, beautiful towns such as Evora in Portugal. He named an

apricot iris 'Benton Strathmore', the name of Queen Elizabeth's father, the Earl of Strathmore, and much to his delight it won a British Iris Society award, as did 'Benton Petunia' in pink and purple. The colours reminded him of Elizabeth's dresses.

He submitted a variety of beautiful, soft-coloured plants for sale to Wallace's Nursery and Orpington's Nursery. His line drawings were chosen to illustrate Wallace's 1947 catalogue. A black and white photo of the profusion of Benton irises within a box hedge was also included. Twenty-one Benton irises were offered for sale, including the 'Edward Windsor'. The 'Benton Baggage' showed a pale rose colour with a blue blaze; 'Benton Mocha' was a coffee-coloured iris with a bright orange beard. 'Benton Persephone' was pure white with very large flowers.[243]

In 1948 Cedric was again invited to submit five bearded irises, prefixed 'Benton', to Wallace Nurseries, for whom he provided more black and white line drawings. The catalogue rapturously describes 'Benton Cerdana', now believed to be extinct but keenly sought after by iris fanciers, as very large and beautiful, with falls (lower petals) of bright blue, and 'Benton Benedict' as 'an outstanding introduction, quite distinct from all others. The large flowers are of exceptional standard and perfect form with pink flushed with fawn and widely flaring, pure white edges.' The same year he won the British Iris Society silver medal for an unnamed seedling, B716. 'Benton Orlando' was another beautiful cultivar described in Wallace's 1955 catalogue as 'late flowering with exceptionally broad falls of a lovely peach pink and a vivid tangerine beard'.[244] An RHS Order of Merit was also given to Cedric in 1948 for an *Allium albidum*, a bulb with a head of silvery mauve flowers. Ornamental members of the allium family which Cedric grew were later much praised by the young Beth Chatto.

In June 1949, the British Iris Society held its first large show since the war at the Horticultural Halls, Westminster. Cedric was given the Edward Williamson Challenge Plate for an unnamed seedling of great size, which grew into a mid-blue flower lightly flecked with white. He was also awarded the Foster Memorial Plaque by the British Iris Society with the accolade 'a special personal award for those contributing to the art of the genus'.

The early 1950s saw England gripped by a mini outbreak of iris mania akin to the Dutch tulip mania of the seventeenth century; some single rhizomes such as 'Edward Windsor', rated 'as one of the most remarkable colour breaks evolved in England', changed hands for nearly twice the amount of a gardener's weekly wage.

In 1954 Morris bred the iris 'Benton Cordelia', which garden writer Tony Venison described as 'one of his most exciting introductions of the 1950s'. This iris, with its dark mauve buds opening to milky orchid pink with deep rosy tangerine beard and silky feel, received the most prestigious of all horticultural awards, the Dykes Medal, in 1955.

Gardening in the 1950s had become more expressive and although traditionalists such as the very distinguished Graham Stuart Thomas, chief gardens advisor to the National Trust, drily remarked that Benton End was not a good garden but 'full of good plants', others felt differently. The garden's freedom, wildness and riot of colour were very much admired by Beth Chatto and a new generation of young gardeners and visitors from around the world. Many of the great gardens in Britain still surrounded large country houses, whose owners employed a hierarchy of garden staff to follow their directions. Cedric became known and respected as the 'dirty-handed gardener' because he worked outside in all weathers. Unlike Vita Sackville-West and Harold Nicolson at Sissinghurst, he was less interested in careful, schematic planting with formal features and architectural structure. When student Bernard Reynolds wanted to fit some tulips into a preconceived design for a picture and suggested to Cedric that he would like to cut the flowers and put them into a pot, Cedric exclaimed, 'Good God, man, you can't rearrange the landscape on the earth's surface, you have to rearrange on your canvas!'[245] Cedric's planting plan followed a scheme of right plant, right place, an idea that Beth Chatto would develop to revolutionize gardening ideas. He would be willing to accept any plant, but it had to earn its space in the garden, however rare or whoever gave it to him. If it did not thrive, it would be removed. The individual structure of flowers appealed to him and he was a keen observer of places and conditions where plants thrived.

One visitor merrily told Blythe how he felt Cedric was teasing the

gardening establishment, remarking that 'his irises were raunchy blooms sticking their tongues out.'[246] Throughout the 1950s Cedric spent the winters plant-collecting and painting around southern Europe and North Africa. Benton End, he claimed, was one of the driest part of England and its gravelly, neutral lime soil was good for many Mediterranean plants. In 1950 and 1951 he brought back a great number of fritillaries from Portugal, Spain and Morocco. Unlike today, there was little restriction on the digging up of wild flowers and importing plants from abroad. Back in England he added roses and peonies to the garden, along with fritillaries, clematis and a persimmon tree. From Lady Byng he acquired pink and white peonies and among the roses, 'Madam Tabard', 'Rosa Mundi', 'Tour de Malakoff', 'Canary Bird', and 'Gypsy Boy'. From Notcutts Nursery he bought clematis, cotoneaster and some alpine roses.[247]

Gardening had become his main preoccupation, although he had to prepare paintings for a one-man show at the Leicester Galleries in October 1952. For this he delivered a mix of Welsh and Suffolk landscapes and scenes from his foreign travels. His next exhibition, however, would not be until fourteen years later at the Minories in Colchester. Gardening, teaching and painting were to be his priorities over the next decade. He was not looking to take part in large London gallery shows. Cedric's *faux-naïf* figurative style, with its simplicity of composition and focus on attractive subject matter, was out of fashion. He had little interest in the prevailing painting styles of the time, which were developing in two distinct directions. One group, comprising John Bratby, Jack Smith, Derrick Greaves and Edward Middleditch, were known as the Beaux Arts Quartet; later they were called the Kitchen Sink painters. Their subjects were the flotsam and jetsam of everyday life, chosen not for their aesthetic qualities but to show how people really lived. Elsewhere abstraction from the USA was influencing British tastes and this was expounded by a group of young painters living in St Ives, such as Peter Lanyon, John Wells and Patrick Heron.

In 1953 Eddie Marsh bought Cedric's painting *Irises and Tulips* and presented it to the Walsall Art Gallery. The picture is less surreal and otherworldly than some of his earlier depictions of flowers with

their dark backgrounds. The blooms are infused with a light delicacy, but their vitality is still there. Included in the display are a dazzling white arum lily and two stems of yellow *Gentiana lutea*. The time is early summer, when tulips droop and the irises are coming in. A large picture of flowers in a blue and white vase, *Floreat* (1955), was hailed by Tate Gallery curator Richard Morphet as 'surely one of the most amazing flower pictures of its time. His flower pictures can only be by somebody who loves the natural world. His affinity with nature was extraordinary, plants to him had characters and his study of them inspired painters and gardeners alike.'[248] Cedric, when questioned about flower painting, later stated, 'Good flower painting must show a great understanding between painter and painted, otherwise there can be no connection and truth.' 'Reality not Realism' is a phrase Richard Morphet used to describe Morris's work.

Invitations to the iris parties at Benton End in the summer were highly sought after. These parties were an opportunity to show off Cedric's wonderful new creations to fellow enthusiasts. Ronald Blythe and John Nash would join the garden tour, listening attentively to Cedric describing plants and their peculiar needs and behaviour, sometimes adding double entendres. Indeed, curators have perceived some of Cedric's still lifes of vegetables and fruit as sexually suggestive.[249] The last stop was at four o'clock, when tea and rock cakes were served by former student and local resident Lucy Harwood.

Lett did not entirely welcome these visitors with open arms. He always referred to them rather disdainfully as 'Cedric's gardening friends'. His underlying complaint was that Cedric's preoccupation with gardening left less time for painting. John Nash echoed this opinion when he visited. 'What about the artwork, old boy?'[250] Ronald Blythe defended Cedric as not just a plant collector but someone who made friends with flowers, not unlike the poet John Clare. Understandably, Lett felt it was his job to promote Cedric's art and not to have to entertain plant enthusiasts with whom he had little in common.

Thankfully, Gwendolyn Anley could deal with what Cedric could not: promotion and selling to enthusiastic American growers. There was one important customer who had admired Cedric's garden at

The Pound. Constance Spry had a shop in London and was eschewing pre-war formal flowers displays and instead mixing wild and garden flowers in an innovative fashion. She would drive down to Benton End for inspiration and return to her London shop, her car overloaded with tall, translucent seed heads of honesty, huge artichoke thistle heads, alliums in flower and seed, and ornamental rhubarb, the curious lipped flowers of bear's breeches (*Acanthus mollis*) and *Alchemilla mollis*. These she sold as 'country bunches'. Flower boxes filled from the garden at Benton End were frequently sent from Hadleigh railway station to Spry's shop. These would often be combined with horticulturists' blooms from Covent Garden market. In London Spry would dry the flowers for winter displays.

Now it was becoming possible to travel in Europe freely again, Cedric was keen to spend the winters in Spain, Portugal and the Canary Islands. He was quick to dispel the idea put about by students that these were holidays. 'I have only had one holiday in my life,' he insisted. He was on plant-hunting and painting work. Sometimes Lett accompanied him, sometimes not.

In January 1950 Cedric and Lett decided to travel to Portugal with Primrose Codrington, a keen gardener and painter who later married fashionable garden designer and writer Lanning Roper. The journey was nothing if not eventful. Their departure from Liverpool was fraught, as Cedric was nowhere to be found when the SS *Lucian* was about to set sail. He had gone missing at the Adelphi Hotel. Lett found the voyage boring; 'plenty of dull food and no drink', he noted in his diary. He was on the trip to learn Portuguese, while Cedric and Primrose mostly painted and looked for plants. The weather was terrible and Cedric caught a cold. Primrose and he did manage to collect some sweet-smelling xiphium (Spanish iris) in two colours, interesting alliums, tulips and narcissi. Cedric produced a picture, *Monchique Foothills of the Algarve* (1950), now in the New Art Gallery Walsall. As on most of the trips, they seem to have had an active social life. Their hosts were English gardeners and artists and people of independent means who had chosen to live in Europe. In Portugal, they met a relation of Cedric's, Major Andy Haig, nephew of First World War Field Marshal Earl Haig.[251]

Cedric often travelled to Cyprus. One year in the early 1950s his hostess, a Mrs Pemberton, who gave him the beautiful *Colchicum troodii*, requested a portrait of herself to give to her daughter. Cedric did not allow her to see the picture until it was finished. When she finally saw the completed work, her face dropped and she exclaimed that it was not the kind of picture she could give to her daughter. Cedric took the scissors from her needlework box, cut up the picture and threw it into the fire. He did not want to upset her daughter. 'It was a good portrait, one of the best I have ever done,' he reflected later.[252] Curiously, at the time Lucian Freud's sympathies were with Mrs Pemberton. He remarked that Cedric's portraits 'were revealing in a way that was almost improper'.[253] Maggi Hambling added later that the directness of his portraiture speaks of love and gives the spirit of the subject.

On his return to England in 1951 Cedric was faced with a financial reality. The school was not bringing in sufficient money to pay for his trips. Despite receiving horticultural awards, the garden and the school at Benton were costing more to run than they earned. Fortunately an opportunity presented itself on very generous terms. An invitation arrived from the dynamic and reforming principal of the Royal College of Art, Robin Darwin, to teach on the textile design course. Darwin was introducing exciting new courses and new teachers at the institution. In 1947 Cedric's friend, the former editor of *Vogue* Madge Garland, had been invited to become the first professor of fashion and Frank Dobson was now in charge of sculpture. Cedric's brief was to teach a textiles course from the viewpoint of an artist. Darwin told Cedric he could do what he liked, when he liked: 'I long for you to instil a little poison into us here, it is just what we all need.'[254] 'What is needed is a really fine painter with a natural sense of free design, an essential love and appreciation of flowers, who cannot help spotting and smelling out the conventional pastiche,' Darwin wrote at the end of 1951.[255]

The offer and the flattery were irresistible. 'It is impossible to do any work in this country in the winter, so I might as well teach,' he reasoned.[256] He was paid £5 a day plus travel from Benton End, or a hotel room in London if he needed it. Darwin also offered to send down Royal College students with sketch pads to work in the garden

for a day. Cedric described the first day in his new post as 'like *Alice Through the Looking Glass*'. Self-deprecating as ever, he reported to Lett, 'I am treated deferentially – why, God knows, they seem to think I know how to teach.'[257] He taught textiles for only two years. He left in 1953 and was not replaced for the autumn term. No reason was given by the Royal College or Cedric for his departure but, although he had school holidays, Cedric missed his garden. In autumn 1951 he had met Nigel Scott, a young man full of energy, who had worked in plant nurseries. Cedric was immensely impressed by Nigel's knowledge and enthusiasm for gardening and the feeling was mutual. Nigel had fallen in love with Mediterranean plants when exploring the hills and mountains when on leave from his minesweeper duties during the war. 'He is a real plantsman and they are rare,' Cedric told Lett.[258] He telephoned John Nash, who knew Nigel and sang his praises. A few weeks later Nigel asked Cedric for a job. Not because he needed one, he pointed out; he had offers of work from a number of local nurseries. These were not of interest to him, he explained; he only wanted to work at Benton End with Cedric.[259] Cedric tried everything to put him off, feeling a bit pressurized that he might not live up to Nigel's expectations. However, Nigel was determined and moved in to Benton End in the spring of 1952. Immediately he immersed himself in propagating, planting and nurturing. John Nash later described him as 'a propagator of plants with almost a wizard's tooth'.[260] He and Cedric created a stunning iris with flowers of two shades of rich violet and paler edges, which Cedric named 'Benton Nigel'. Throughout the garden he introduced new plants, including alpines. An area in the upper garden at Benton End became known as 'Nigel's garden'. 'Nigel was naturally acquisitive where plants were concerned and possessed an almost childlike and endearing quality of being unable to refuse some new plants for the collection at Benton End,' John Nash recalled.[261]

Beth Chatto, who did not at that time know Cedric but had heard about his garden, was taken to Benton End by Nigel Scott. Nigel and Cedric were so well suited in every way, she recalled: 'They shared a passion and even resembled each other physically. With a wave of thick dark hair, he was handsome.' She described Cedric as a Viking,

with his narrow face, nose and sharply jutting eyebrows.[262] Her husband, Andrew Chatto, an Essex farmer, was also a learned plant environmentalist who combed through journals of scientific literature in French, German and Russian to discover the origin of plants and what conditions suited them. He carefully archived his findings.

'I was very young, rather innocent and naive about the set-up there,' recalled Beth. 'I knew Cedric wanted to really talk to my husband, so I just observed the surroundings, pale pink walls rising high above us hung with dramatic paintings of birds, landscapes, flowers and vegetables whose colours, textures and shapes hit me. Shelves were crammed with coloured glass vases, jugs and plates with mottoes, a curious hotpotch of remnants from travels past. I remember my first impression so clearly. Cedric dressed in crumpled corduroys with a small silk scarf above his shirt was smoking a pipe, which he held with his beautiful slender hands. After tea, he showed us all round the garden. It was not conventionally designed with carefully selected groups of trees and shrubs creating a background or leading the eye to some premeditated feature or walk. There were surprisingly few trees and shrubs, mostly ancient fruit trees, dotted around. A tall cherry wreathed in ropes of wisteria made the principal feature. There was an area divided into rectangles by narrow paths, edged by low box hedges. Pillars of old shrub roses and several huge clumps of the sword-leaved yucca glories were within. The rest was a bewildering, mind-stretching, eye-widening canvas of colour, textures and shapes, created primarily with bulbous and herbaceous plants. Later I came to realise it was possibly the finest collection of such plants in the country, but that first afternoon there were far too many unknown plants for me to see them, let alone recognise them.'[263]

Cedric and Nigel were to form an intense relationship on many different levels. In his first summer at Benton End Nigel suggested they open the garden for the National Gardens Scheme for two days in May and one in June. On the first day a party was given for friends, including Lady Ailwyn, Mrs Anley, Sacheverell Sitwell, Madge Garland and accomplished wood engraver Blair Hughes-Stanton. The following year on the open day in May the garden attracted over three hundred visitors.

Every winter for the next six years Cedric and The Bird or Cock, as he called Nigel, would go on annual plant trips to Tenerife, one of the Canary Islands, and Portugal. Nigel would become a scribe and send Lett their news in response to his letters. Cedric by now did not put pen to paper very often. 'What a lovely long letter you have written. We are very sad to hear about your illness, it is a shame that you must miss so many invitations to lunches dinners and parties,' Nigel wrote teasingly from the then wild Torremolinos in the winter of 1954.[264] Sometimes he would jokingly write 'Dear Arthur' – the name Lett never used – 'you would love this place.' Neither man wrote to Lett about plant-hunting. When Cedric did write, he included wry observations. From Alicante, Spain, he wrote, 'this place is charming in every way except that there is never any hot water, one reason among many why Americans will ever invade this country.'[265]

It came as a huge shock and portent of things to come when, on 9 October 1954, The Bird suffered a serious brain haemorrhage. As the ambulance door closed, he shouted to Cedric and Lett, 'Goodbye, you two,' as if he would never see them again. When Cedric went to the hospital, Nigel did not recognize him; Cedric was so upset that he did not visit again, giving the excuse that it would tire Nigel. His grief was only slightly alleviated when his friend Griselda Lewis returned with a letter for him explaining Nigel's improving situation. Nigel made a sufficiently good recovery to go to Gran Canaria on a plant trip after Christmas. The illness was a shock to Cedric, and his friends realized this and wrote him sympathetic letters.

Unbeknownst to Cedric, his movements and activites in Europe were being followed by the Foreign Office, as he was to discover later in 1955 when a letter arrived marked 'Private and Strictly Confidential'. 'This office is interested in a journey which it is believed you intend to make in the autumn of this year and I should value the opportunity of a confidential discussion,' it read.[266] The letter was received with bemusement by him and the students, who interpreted it as an invitation to some spy work. A man from the Foreign Office in black coat and striped trousers then appeared at Benton End, asking Cedric to listen to what people were saying on his next European painting trip,

offering to put him ashore in a naval destroyer boat. Cedric's cousin Michael Lloyd recalled the conversation. Cedric told the civil servant, 'I am just a painter and gardener, nothing to do with politics.' The reply came back, 'just the person who would be least expected'. In a last ditch attempt to persuade him, the man asked Cedric to consider doing this for his country. 'I am an unpatriotic man,' said Cedric defiantly.[267]

Portugal was Cedric's next journey with Nigel Scott, in the winter of 1956. They were to meet gardener and plantsman Basil Leng there. Leng lived in the South of France and had advised Lawrence Johnston on both his gardens, Hidcote in Gloucestershire and at La Serre de la Madone in the Val de Gorbio near Menton, which is open to the public today. Basil saw a tiny yellow narcissus which was unfamiliar to him growing in the short turf on the Costa Verde in northern Spain. He gave it to Cedric, saying it would do better in England than in the South of France.[268] It was fortunate they recorded the spot where this rare bulb grew, for on returning there a few years later Cedric found it had been covered by a new road. The bulb has never been found elsewhere in the wild and it is thanks to Cedric and Beth Chatto that *Narcissus minor* 'Cedric Morris' has become a highly desirable winter flowering treasure.[269] But tragedy was to strike on the trip. On 27 January 1957 Nigel Scott was admitted to a clinic in Tenerife. Next morning, he decided to end his life by jumping out of the clinic window. He died from a brain haemorrhage brought about by a fractured skull. Cedric, in a hotel nearby, was physically sick when he heard the news. Primrose wrote to Lett explaining what had happened. Cedric was in shock, telegramming Andrew Chatto without giving details. His distress was so great he couldn't bear to write to Lett, who was fearfully worried for his state of mind. 'Wot [sic] will Cedric do, just come home without a word? – stay with Primrose?' he wrote in his diary. Fortunately, he received a letter from her: 'I know how worried you must be about Cedric but he is wonderfully calm and fatalistic about the whole thing.'[270] Cedric took the boat home on 2 February. Over the following days Lett struggled to find out what had happened, allowing his imagination to run wild. He was trying to work out why Nigel had taken his life. 'Perhaps in his delirium and drugs he thought

that Cedric had deserted him – that tick he had around insecurity, his intense role as good comrade Samaritan could lead him into irritating insecurities,' he wrote in his diary on 8 February. Nigel was buried on Tenerife and fortunately Primrose and Lanning Roper were able to attend the ceremony. At Benton End one of the ginger tom cats disappeared. 'Has he gone to join The Bird?' Lett wondered. An obituary by John Nash appeared in the *East Anglian Daily Times* and explained to the wider circle of friends Nigel's influence and help. 'As a result of working with Cedric Morris in mutual enthusiasm, that remarkable garden was further extended and enriched,' Nash wrote.[271]

On 14 February Cedric arrived at London docks. 'Will Nigel's ashes be with him?' Lett thought to himself. Back at Benton End letters of condolence poured in, some also addressed to Lett. Elizabeth David showed concern for both men: 'that dear man you pulled back from death before with your devotion. Poor Cedric, so helpless too, I don't mean that he hasn't plenty of resources in himself but he is not good at coping. Can I do anything? But he probably won't want to see anyone but you.'[272]

'Feeling awful,' was Cedric's response to the many condolence letters he received. Joan Warburton came to stay and found him ill in bed, looking grey and sad in his checked lumber shirt. Lett kept quietly in the background, but from his bedroom he could overhear their conversations. Cedric did not refuse requests by gardeners to come and see him; garden talk was a diversion from his grief. Ipswich bus drivers Mr Smee and Mr Pratt unknowingly amused him by recounting the minute details of their personal habits and gardening methods.[273]Cedric was invited to go to the Stubbs exhibition in London with his local gardening friend Jenny Robinson. They also went together to the Botanic Gardens in Cambridge, where he visited an iris show. He entertained the East Anglian Iris Society at Benton End and also showed sixty people from the Gardeners' Benevolent Society round, but the intense creative partnership he had shared with Nigel Scott had resulted in a garden of such originality and emotion that Cedric found it difficult to sustain on his own thereafter. He continued to garden keenly but less energetically, and in solitude.

13.

EXCEPTIONAL FOOD

LETT RARELY ENTERED THE GARDEN AND WHEN HE DID IT WAS ONLY TO LIE DOWN in the sun or look for some herbs and vegetables for his cooking. While Cedric rose early to paint in his studio or the garden, Lett never appeared until midday, to start preparing lunch. Lett was master of the house and with the increasing number of students and former students, friends wishing to visit and people wanting to see Cedric's pictures, he was kept busy. In early 1950 he corresponded frequently with Jack Barker, a New York agent who ran a personal representation service. Barker was trying to persuade Cedric to take a group of English artists to New York.[274] There was also a plan to get American artists to study at Benton End. Neither of these schemes materialized.

Lett began to assume a patrician air. Some addressed him as 'father' half-jokingly, but there was a way in which he acted *in loco parentis* to some pupils whose fathers did not understand or support their children's artistic endeavours. Young students wanted Lett and Cedric's approval. You were in the inner circle when Lett assigned your nickname. Maggi Hambling, who joined in 1960, was 'Maggi Soop' because she worked in the kitchen; school helper Robert Davey answered to 'Stoner Monk' on account of his perceived appearance and John Jameson, 'Monkey Man', in tribute to his physical prowess.

Elizabeth Wright was nicknamed 'Body'. The nicknames were spelled out in letters cut out of magazines and displayed in the downstairs lavatory. 'When I saw the name "Body" on the wall I felt then I truly belonged and was accepted for who I was. It is as if this was what I had been waiting for all my life!' she wrote later.[275] She thought Lett a bit of snob and too concerned with what people, especially in the county, might think of him. She remembered his making a fuss over introducing her mother as the Countess van Horn. He gave a long explanation of the importance of introducing the younger woman to the older, unless the younger was titled, in which case the rule was reversed. He would show certain students a rolled-up document listing all the baronets in the United Kingdom, which he had in his room at Benton End. Cedric, on the other hand, she saw as a 'free spirit in our class ridden society'.[276] Student Bernard Brown remembered big, heavy-framed paintings on most walls and many more stacked along the main hallway and in the studio. There was a huge nude of a lady from Raydon, a local village. 'I had often seen her biking to Hadleigh and it was years before I could pluck up the courage to enter the shop where she served.'[277]

Very few people were turned away when they knocked on the blue door at Benton End. It was a bohemian set-up, where soft furnishings and a modern kitchen were not considered necessities. Kathleen Hale described it as a ramshackle, underfurnished house in which little housework was done. 'This', she said, 'somehow resulted in a great freedom of mind.'[278] Lett was starting to amass volumes of poetry, biographies and novels, which jostled with old copies of the *Studio* magazine and the *Daily Worker* and old art gallery exhibition catalogues. Cedric was not a reader, though he would occasionally pick up a detective story. A treasured volume was *The Morris Book of British Birds* by nineteenth-century parson-naturalist Francis Morris. Cedric's humour was mildly bawdy. Students recalled how Cedric would burst into giggles at the least provocation. There would probably be picture postcards lying around illustrated by Donald McGill, whose drawings of buxom ladies with suggestive captions were very popular at the time. In the downstairs lavatory, words had been cut out of Hadleigh

cinema programmes and reassembled to make sexual puns.[279] Cedric kept an ancient stuffed elephant's penis in his studio and when asked by respectable ladies what it was, he would gleefully tell them. The house was full of objects collected and created. A Gaudier-Brzeska drawing took pride of place above the fireplace. Pictures of seabirds and lustre porcelain against a pale ochre wall caught the attention of Ronald Blythe on his first visit.

The house could be very cold, even in summer. The main source of warmth was an electric bar fire next to Cedric's capacious wing chair. There was only one bathroom in a house of seven bedrooms with a sit-up hip bath next to Lett's bedroom, which made some females uncomfortable, fearing that he might hear every splash through the thin dividing wall. Kathleen Hale said that in the spring swallows built their nests inside the bathroom and the window was always left open for them. 'It was delightful to be fanned by the wings of these almost tame birds as they flew in and out with food for their young. But they made such a mess on the floor that when a whole family had been safely reared and had departed the window had to be kept shut.'[280]

Students always suspected that Lett listened to their telephone conversations on the extension in his bedroom. Lett's lair was something of a tip: beautiful cloaks and clothes were scrunched up on a peg, empty champagne bottles and packets of biscuits littered the floor. Precarious pillars of books made it difficult to move in any direction. Cedric's room at the back of the house by contrast was minimally furnished and kept clean and tidy, with paints carefully stashed under his bed, which was covered with a white bedspread.

This colourful chaos was the antithesis of the ordered bourgeois way of life at the time, with its ticking clock in the hall and dark polished mahogany giving an air of solemnity. Just stepping through the blue door at Benton End showed visitors how different life could be. Ronald Blythe credits the place for giving him confidence to pursue his own path: 'The atmosphere was well out this world so far as I had previously witnessed and tasted it. It was robust and coarse, exquisite and tentative all at once, rough and ready and fine-mannered and also faintly dangerous'.[281] Inside, Ronald Blythe remembered delicious

cooking smells coming from behind a door covered in drying herbs and dangling ropes of garlic.

As Cedric's interest in gardens increased, Lett's interest in cooking grew. The departure of their male servant/helper from The Pound and the difficulty with finding a replacement just before the start of war made it necessary for Lett to cook and serve. At Benton End meals in what they called the Eats Room were a moveable feast; anyone who happened to be there could come to the table when summoned by a Portuguese cow bell Cedric had found on a painting expedition. Food was served on an oak refectory table from his friend Ambrose Heal and eaten off wooden plates. Bread was provided to mop up gravy and sauces, a French and North African habit then unknown in Britain. In Elizabeth David's words, 'there was no polishing the silver and ironing the doilies at Benton End.'

The pets of the house were apt to make their presence known at meal times. Cedric's tame jackdaw was drawn to the knives and forks, which it scattered over the floor, often when an important art dealer was coming to lunch. The jackdaw would leave little beak marks in Lett's delicious apple pies. The house was full of cats pouncing from all surfaces. 'Were you by chance passed by a lamb cutlet travelling fast in the other direction?' Cedric asked Tony Venison just as lunch had been placed in the Eats Room. Cedric had a sentimental attachment to cats and, although he never painted a cat, he did write a poem on the death of one (see page 128).[282]

Lett would produce lunches and dinners from menus carefully planned a week in advance. A young Ronald Blythe could not believe that Lett, 'who had known all the famous artists and writers of the twentieth century', was cooking his meals while Cedric sat at the far end of the table holding court. 'Conversation on all topics would flow as freely as the wine.' Sometimes there would be a conversational tussle between the two men. Lett would enter from the kitchen in a striped butcher's apron, a martini in one hand and a plate of food in the other, now a bit drunk, hot and bothered, and interrupt Cedric in the middle of a gossipy story, much to his annoyance. A vulgar quip in faux-camp astonishment would be delivered as he served the food. 'Do you know

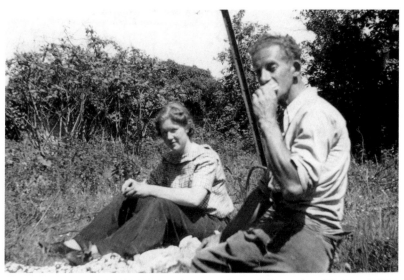

15. Cedric Morris with Joan Warburton in the garden of The Pound, 1939.

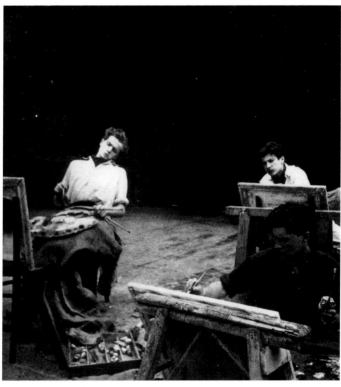

16. David Carr (*left*) and Lucian Freud (*right*) in the studio at Benton End, 1940.

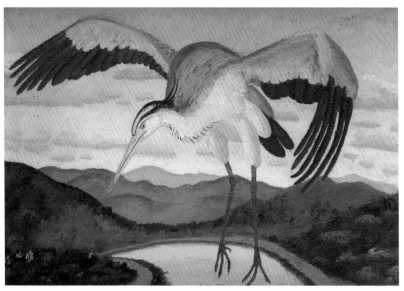

17. *Heron*, 1941, by Cedric Morris, oil on canvas, 50 x 75 cm (19½ x 29½ in).

18. Cedric Morris resting in a hammock, Benton End, 1941.

19. Cedric Morris and Arthur Lett-Haines together in the garden at Benton End, late 1950s.

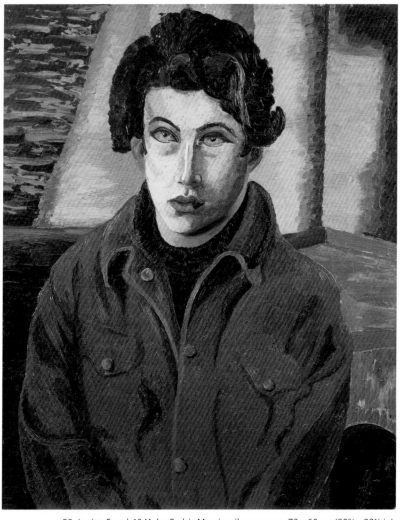

20. *Lucian Freud,* 1941, by Cedric Morris, oil on canvas, 72 x 60 cm (28¾ x 23½ in).

21. Pupil Ellis Carpenter painting in the garden, Benton End, 1948.

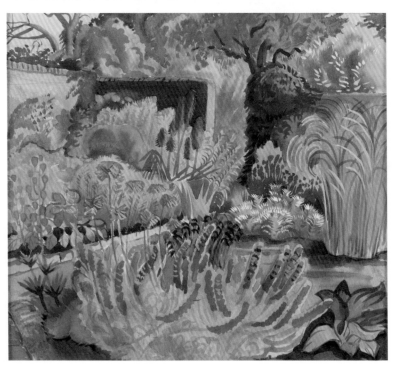

22. *The Garden at Benton End*, 1950s, by Kathleen Hale, pencil and watercolour, 28 x 24 cm (11 x 9½ in).

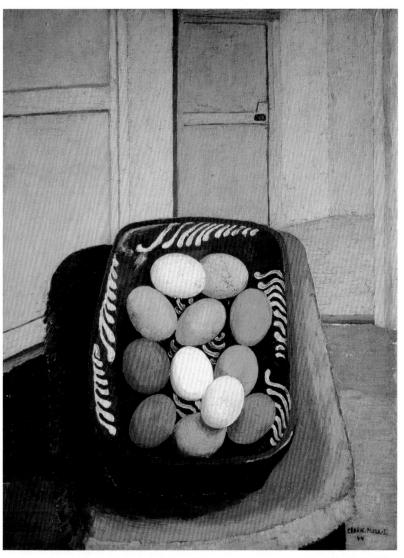

23. *The Eggs*, 1944, by Cedric Morris, oil on canvas, 61 x 43 cm (24 x 17 in).

24. *Yalta*, 1945, by Cedric Morris, oil on canvas, 81 x 109 cm (31 x 42 in).

25. The Walled Garden at Benton End, 1950s.

26. Lett-Haines in his studio, late 1960s, painting *Vereda Tropicale*, pigment and adhesives on paper, 77 x 57 cm (30¼ x 22½ in).

27. Cedric Morris in the garden at Benton End, mid-1960s.

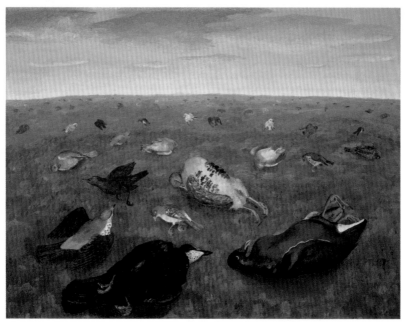

28. *Landscape of Shame,* 1960, by Cedric Morris, oil on canvas, 75 x 100 cm (29½ x 39¼ in).

29. Iris time at Benton End, 1960s.

that camels copulate backwards?' he once announced. Arguments and spats between the men would break out over the tiniest thing and students knew not to interrupt. Beth Chatto recalled how they just had to sit and wait until the squall passed. 'We waited and suffered with our idols, seeing them as human beings, our bonds of shyness shattered by the storm.'[283] At last Cedric would announce with a sigh, 'Well, we will just have to agree to disagree.'

Although Lett would moan that the students would be just as happy with a ham sandwich, the most delicious dinners continued to appear. His catering was not about producing bland, hearty dishes within budget. He managed to combine the best of fresh English ingredients with some French piquancy. The menus included herbs and spices and Continental ingredients, not only difficult to acquire in Suffolk, but not liked by the average local, who lived on unseasoned roast meats or liver and chops with boiled vegetables and stodgy suet puddings. He was liberal with his olive oil, which in England in those days was a medicine for ear infections, only available in chemists. He laced dishes with garlic and chilli, viewed by many English people as the devil's food. Lett cooked roast fowl with *salsa verde*. Cold leeks were drizzled with juniper, olive oil and cider vinegar. His silverside of beef was marinated in garlic, lemon juice and lovage. Elizabeth David, who through her books introduced European food to Britain, was often on hand to support, advise and share cooking ideas. Naturally there was rarely any food left over, causing Cedric on a number of occasions to complain about how greedy people had become.

Food rationing in Britain did not end until 1954. Lett may have found some of Cedric's gardening friends tedious, but he was grateful for the variety of fruit and vegetables introduced to the garden. Cedric was a keen follower of Kathleen Hunter, who had started importing unusual vegetable seeds from the United States after the war. The garden at Benton End began to be filled with purple-podded runner beans, a round cucumber called 'Crystal Apple' and a little round green squash known as avocadella marrow. Cedric had found asparagus peas (*Tetragonolobus purpureus*) from southern Spain, which produced crimson flowers and were delicious to eat. Lett made delectable tomato

bisques, raspberry ice cream and tartes aux cassis. There was always peach and cherry jam for breakfast and afternoon tea from their own orchard fruit. Chicory and sea kale would be blanched then stored in the dark cellar for roasting and adding to winter salads. Garden produce became a subject for Cedric to paint. *Ratatouille*, which could have been a perfect colourful illustration for a recipe book, was painted in 1954. In *Still Life of Garden Produce against an Old Chimney* (1958) he placed a bowl of vegetables from warmer climes next to English fruit.

Lett was able to pursue his ever-increasing interest in food thanks to Spearlings, the Continental grocers in Dedham, who were able to procure things rare then such as yoghurt, avocados, Greek olives and vine leaves for dolmas. Lett could be considered an early food forager, not combing woodland but seeking out shops that sold unusual food. (He tracked down Malga Vita, a new imitation cream, to a dairy in Southall, Middlesex.)

It was the duty of students to wash the dishes after dinner and Gwynneth Reynolds was shocked when she first went into the kitchen. Dirty pots and pans fought for space with papers, bills and supplies. Black dust from the ageing, coke-fuelled Aga coated everything. A stone sink was nearly always filled with dirty dishes, with only an old, slimy cloth to wash them with. Ancient spongy chopping boards had to be scrubbed clean with disintegrating scouring pads. To get to the sink, helpers had to navigate their way around bowls of cat food for the large feline population and sometimes men's woollen underwear soaking in buckets. At midnight Lett boomed indecipherable words across the landscape, banging a tin to attract the wild cats for scraps.

In summer black clouds of flies from the next-door pig farm would invade. Fortunately, one of the students, Bryan Brooks, a proctologist and amateur painter, nicknamed 'Arsehole Brooks', would be on hand to dispense medicines if anyone got a stomach upset, although students recall that after a while they managed to build up immunity to the unhygienic conditions. Some were more squeamish. When Vita Sackville-West came to talk with Cedric about gardens and plants, she would stay and eat at a local hotel. Others brought their own cutlery and plates.

Lett always recorded in his diary the meals he ate. For example, on 11 December 1951: 'Dinner at 24 Halsey Street with Elizabeth David her husband Anthony and Stella her mother – wonderful meal – cocktails, sherry and olives, crayfish soup, filet stake in mushroom crust (suet), Greek onions, Carlsbad plums, crystallised pineapple and cheese of many kinds.'

Elizabeth David and Lett discussed recipes and their origins and dinners they had eaten in the finest detail. 'Darling Lett, I did not mean to contradict you, I was only querying, you were talking about a sauce Dugléré, which you say stems from English chop house cookery. I have searched Larousse Gastronomique, Escoffier, Ali Bab, Phileas Gilbert and several other books of classic French cookery and find no mention. Escoffier has sole dugléré, however the main ingredients are tomatoes and white wine' was typical of the type of correspondence between them.[284]They would also critique restaurants. 'As for L'Escargot,' David wrote to him, 'the *Guide Michelin* can give it as many stars as the milky way and Princess Margaret can marry the proprietor's brother, but it will not alter the fact that what I ate there was potted rat.'[285] They sent each other mint 'Eau de Cologne' and preserves such as crab apple jelly and orange and banana jam through the post.

Elizabeth David showed Lett the manuscripts of her cookery books for comment: 'You are one of the few people who really know what they are talking about where food is concerned,' she wrote.[286] He was a stern critic. When he received *A Book of Mediterranean Food* in 1950, he told her that she went on too much about 'the great Marcel Boulestin'. 'As far as I remember, I only mentioned him once and then as plain Marcel Boulestin; anyway, he was a good writer,' she replied.[287]

Elizabeth David wanted Cedric to illustrate her book *French Country Cooking*, scheduled to be published in 1951, and she told him that her publisher John Lehmann was delighted by the idea. 'There will also be a chapter on pots and pans and one on arranging a meal (how one bosses people),' she explained. 'It won't all be peasant food but how to use good country ingredients in a simple way as opposed to International Palace food and *Good Housekeeping* Technicolor.'[288] She wanted him to be given free rein for the cover. Lehmann, however,

decided to go with the artist John Minton, who had illustrated her *Book of Mediterranean Food*. Elizabeth eventually got Cedric's work on one of her book covers: *Eggs* (*Plate 23*) was chosen as the cover for the first edition of her collection of food articles, *An Omelette and a Glass of Wine*, in 1984. In 1965, when she opened her shop in Pimlico, David wished to sell earthenware pots and asked for Lett's help in selecting handsome ones.[289] David credited Lett for adding a more exotic touch to the Chelsea bun, as ubiquitous in cafés in England as brownies are today, in her book *English Bread and Yeast Cookery* (1977). Lett's recipe was included: 'I like Chelsea buns but find them rather large and bucolic. So, make them very small, exaggerate the quantity of fruit, chopping small and serve them no larger than big petit-fours coated with royal icing,' he advised readers.

West Suffolk continued to attract young artists and creative types in the early 1950s as it had done before the Second World War. The area was only just over an hour from London by train and it was still much cheaper to rent or buy there than somewhere in the Home Counties. Cedric and Lett were by now established as eminent figures whose establishment had to be visited. One evening Benjamin Britten and Peter Pears dropped by on their way home from dinner and found Cedric and Lett with some students seated in the light of a bonfire. To the assembled wide-eyed group, Pears sang 'The Foggy, Foggy Dew' accompanied by Britten on a borrowed guitar.[290]

Rodrigo Moynihan, professor of painting at the Royal College of Art and a colleague of Cedric's, had recently moved to Boxford near Sudbury with his first wife, Elinor Bellingham-Smith, also a painter. Bobby Bevan, son of the Camden Town Group artist Robert Polhill Bevan and at the time chairman of Britain's largest advertising company, S. H. Benson, had taken up residence at Boxted. His wife Natalie, ceramicist and muse to Augustus John and Mark Gertler, who painted her twice, was a lavish hostess. An invitation from the beautiful Natalie to eat delicious food and drink wine from Bobby's excellent cellar was much sought after. Their house was beautifully decorated with Persian carpets, colourful patterned fabrics and artfully arranged marble eggs, shells and stones collected by the couple. Staffordshire

and Chelsea ceramics sat on Bobby's collection of eighteenth-century furniture. The walls displayed Camden Town Group paintings Bobby had inherited and work by Walter Sickert and Harold Gilman, together with paintings and drawings by the Bevans' own artist friends, John Armstrong and Spencer Gore's son Freddie. Natalie bought Cedric Morris paintings and on one visit to their house he was surprised to see that she had pinned a dead goldfinch to one of his bird paintings.

Cedric and Lett were entertained regularly by them and saw a cross-section of interesting people there. Francis Bacon and gardeners Beth Chatto and Robert Gathorne-Hardy would be fellow guests, as would humorist and politician A. P. Herbert. Randolph Churchill, the troubled, divorced son of Winston Churchill, who had bought a house nearby in East Bergholt, was a frequent visitor (and a lover of Natalie's, who would gaze adoringly at her). Natalie entertained with swagger, often wearing flamboyant hats beneath her lustrous blond hair and knickerbockers with matching silk stockings and colourful high-necked shirts. Champagne, or 'shim-pain-pong' as she called it, would be proffered on arrival. Guests did have to sing for their supper, though; 'Oh, do try a bit,' she would chide a reticent guest. Participation in games was also expected and on summer evenings she would attach night lights in red glass holders to croquet hoops for a midnight game.[291] The art dealer James Birch recalls that, once when visiting as a boy, much to his embarrassment after Sunday lunch Natalie suggested a game of naked croquet. Maggi Hambling remembers in the early 1960s being taken by Natalie to sit with her down by the lake and says that she has always regretted that she was too naive to respond to a sensual advance.[292]

By 1954 Lett's mother had become increasingly frail and he visited her frequently in Sussex. She still wrote to her 'Son Darling' almost daily, worrying about him being cold, not having enough money, being tired and thanking him for all the things he had done. He replied with equal frequency, telling her news and sending her clothes and walking sticks and sorting out her business affairs. He found it hard to see her condition deteriorating. 'I don't like my mother so ancient and discontented,' he wrote in his diary.

With Benton almost always full of people – gardeners, artists, new students and an increasing number of private buyers – Lett was exhausted by the end of term in October. 'Benton End is never noisy, it roars; Benton End never sleeps, it snores,' he said wearily. He felt he needed a rest from it all and, when Cedric left for Europe's warmer climes in December to look for plants and paint out of doors for two winters in the mid-1950s, he repaired to the luxurious Brown's Hotel in London's Mayfair, announcing to everyone he wanted to save money.

In 1957 his mother moved to the Redoubt Rest Home in Eastbourne and her furniture came to Benton End for Stella Gwynne to sell at her shop in Dedham. He would visit her frequently and as she dozed, he wrote ideas for dark short stories with disturbing titles such as 'I am going to marry Mummy, when I grow up' and 'Dispatching Mum'. In the winter of 1958 he went to Beirut to see Gerry and his lover Tony Daniells. Beirut was a glamorous place in the two decades after the Second World War. Dubbed the Paris of the East, the city became a playground for European and American film stars and writers. Archaeologists and spies would base themselves in Beirut and political and religious tensions added an air of danger. Lett enjoyed the atmosphere and was fascinated to meet Gerald Harding, who brought the Dead Sea Scrolls to public attention and who later was the model for Father Merrin in William Peter Blatty's 1971 book, *The Exorcist*.[293]

On 12 January 1959 Lett's mother died. She was cremated at Ipswich with what her son described as an 'impersonally conducted service'. He missed his mother's letters and her fussing over him, but at around the same time he received a letter from Mike Hampden Turner, now a seventeen-year-old boy, which made him very happy. Every year he had sent Mike birthday and Christmas presents and received a child's formal thank-you. This letter was different. He had wanted to invite Lett to his confirmation but 'the idea was discountenanced by family. My father is extremely bitter about you for reasons which have long ceased to interest me. I have declared an official ban about all spiteful tales concerned with divorce. I do however remember how generous you have always been,' he wrote.[294] In another letter, Mike explained, 'I must confess I am worried you are going to hurt yourself on account of

me. Please understand that never before has any relation demonstrated any affection for me at all.' 'It's not that I do not appreciate or value affection, it's just I am unused to it and it makes me uncomfortable . . . You have always been represented to me as an ageing pederast whose great hands reached out to grab small boys.'[295] It was a breakthrough Lett had been longing for. Once disabused of the unfounded paedophilic allegations, Mike's trust and affection for Lett grew. From then on they were to have an extraordinarily close relationship. Mike went on to the Harvard Business School and became a management philosopher and author of very influential books. Lett cut out every article about him he found and Mike and his wife Shelley would visit him when they came to England.

As his relationship with his son deepened, Lett's confidence and wish to create his own work grew. He started painting surreal watercolours and fashioning sculptures out of found objects with a renewed enthusiasm. It was a boost for him when the Ixion Society he had set up some thirty years earlier to sell paintings from East Anglian School of Painting and Drawing artists was offered a permanent exhibition space at the De Vere Hotel in Kensington.

14.

SIXTIES FLOWER POWER

I N J UNE 1960 V ITA S ACKVILLE -W EST WROTE AN EFFUSIVE AND FLATTERING card decorated with butterflies to Cedric after her visit to Benton End. 'My Dear Cedric, You are so kind, thank you for offering to send me fritillaries when you have so much to do. I must say the iris you sent me, 'Benton Nigel', flowered superbly this year, a magnificent Imperial purple . . . I thought you would appreciate this writing paper given me by a Chinese friend, I keep it for very special people like yourself.' After her next visit she wrote an equally charming card. 'Thank you, thank you for a most stimulating afternoon in your garden and your stimulating company. I did enjoy it so much – I can't make phrases about it but can only say I loved every minute of it. If you would care to come for the night, please tell me. I should be proud to have you as my guest.'[296] Cedric spoke about Vita as a great lady who never lost her integrity. She grew many of his tall, bearded irises although she later abandoned them because, she said, they needed too much staking. In return Cedric added her old-fashioned roses to his collection of fragrant Gallicas, damasks and musks.

By the early 1960s the garden at Benton End had reached a glorious state. Cedric's experiments with delicate and variegated tones and their juxtaposition with neighbouring plants created a dense panoply

of ever-changing colour. By now, some of the exciting finds from his overseas travels in the previous few years had become well established. When the gardening authority Fred Chittenden saw a tassel hyacinth (*Muscari comosum* 'Album') that Cedric had found in Portugal, he told him it had no right to exist because it was not in the Royal Horticultural Society's *Dictionary of Gardening*.

There was something interesting to see in the Benton End garden throughout the year. In mild winters the purple *Crocus sieberi* 'Cedric Morris' with its bright yellow throat could peek through the ground at Christmas. Drifts of snowdrops, including *Galanthus* 'Benton Magnet' with delicate, distinctive bells, discovered by artist and plantsman John Morley, rippled in the breeze beside *G. elwesii* 'Cedric's Prolific', so named and registered by Beth Chatto because of its bulbs' ability to multiply so quickly.

Fritillaries in all their variety delighted Cedric, from the tall orange crown imperials he put into his flower paintings to the tiny specimen he discovered in Spain, which bears his name, the purple and bronze *Fritillaria pyrenaica* 'Cedric Morris'. A number of plants would be given his name, although never by him; he left that to others.

The south-west-facing walled garden had light soil and was full of rare plants, including yuccas, viburnums, silverberries and European bladdernut. The walls were covered with wintersweet, different kinds of ivies and rare roses. To give a vertical dimension Cedric had planted juniper, pear and cherry trees. Hellebores grew under an old medlar tree. Tony Venison recalled the strong scent of *Cyclamen hederifolium*, which grew 'in ground shaded from the late summer's noonday sun. During the late days of August and through September their flowers opened in icing sugar pinks, pale rosy and dusky pinks ... when in full bloom you did not even have to stoop for their fragrance to reach you.'[297]

Lilies appeared in many of his paintings of the 1960s. The beautiful yellow lily (*Lilium szovitsianum*) features in *Benton Blue Tit*. In 1963 he painted *Flower Piece with Red Lilies* and in 1966 *Lilies and Cosmos*. Tony Venison was impressed by Cedric's patience and determination when it came to breeding lilies. 'This is the belle of the garden,' Cedric said, pointing to a buff coloured *Lilium chalcedonicum*: 'it took ten years to

breed it.' After the war the Dutch lily expert Michael Hoog would come over every summer to look at the lily seedlings at Benton End and make purchases.

Cedric also drew great enjoyment from the colours and petal textures of the poppies he had propagated. He had included them in his paintings as early as 1922 and embarked on a breeding programme with big perennial oriental poppies soon after his arrival at The Pound. He was determined to refine them to achieve a subtle suffusion of smoky grey and soft pink. The variety that bears his name was given the Royal Horticultural Society Award of Garden Merit. He received an AGM a second time for a spiky blue clematis, *Clematis alpina* Francis Rivis.

Cedric was a gardener who did not have much time for flowers which needed sowing every year, but his annual 'Mother of Pearl' poppies in shimmery pinks, subdued blue-reds, lavender blues and purple-greys, which twinkled in the late summer sunshine at Benton End, were an unparalleled triumph. Three 'Mother of Pearl' poppies appear in his painting *Flowers in a Brown Jug* (1950), and in *Minton Pot* his pink and grey poppies are combined with the green-hot pokers he had bred from red-hot pokers. These green pokers ranged in colour from creamy yellow to moss jade and cooking apple green. Beth Chatto named them Kniphofia 'Green Jade' and sold them at her nursery. He shared his love of poppies with illustrator Wilfrid Blunt, whom he met in 1966.

One of Benton End's wall borders was filled with a fennel (*Ferula tingitana*) he had found in Morocco; the plant, with layer upon layer of shiny, deep bottle green lacy leaves some 2 feet long, could grow to 9 feet high. According to the esteemed former Kew Gardens horticulturist Christopher Grey-Wilson, it was the first of the species grown in cultivation. In late summer *Colchicum troodi*, with its pale lilac pink flowers, which had been virtually unknown in Britain, flourished at Benton End. *Colchicum specosum* 'Rosy Dawn' was another success. Its mass of dots on the petals had the look of a Pointillist painting.

The artists, with their easels propped up by a flower bed, would receive extraordinarily precise instructions for mixing colours to achieve an accurate image of the plants they painted. Cedric's idea of colour was not just a matter of mixing primary colours from a tube;

the inherent nature of pigments fascinated him and he knew where to find the exact raw materials he was looking for. He was always experimenting to try and discover a new hue, warning students against muddy, drab tones. He once joked with Glyn Morgan, 'You have a disgraceful sense of colour, you may indeed become an artist.'[298]

Beyond the garden walls Cedric was appalled at what farmers were doing to the countryside. He never had an easy relationship with the farmer next door to The Pound, because of his aggressive killing of wild animals termed vermin, but he was even more dismayed by the increasingly indiscriminate use of poisons that caused deaths that were all too visible as they ascended the food chain through insects and flowers to birds and mammals. Cedric was an early environmentalist, a conviction reinforced by Mary Butts' two pamphlets, *Warning to Hikers* and *Traps for Unbelievers*, written in the early 1930s, which asserted that man was abusing nature. His *Shags* (1938), which depicted three birds looking with revulsion at an oil tanker flushing out its tanks into the sea, pointedly demonstrated his support for her view. His very powerful 1960 picture *Landscape of Shame* (*Plate 28*) was the same subject matter as *Landscape of Birds* (1928), in which herons and woodpeckers flit happily across a pond, but it is a very different picture. His message in *Landscape of Shame* is totally unambiguous and direct. In a scene of desolation, dead or dying birds lie on an open expanse of brown earth, possibly a ploughed field, under a blue sky with high grey clouds. In the foreground are two large birds, a rook, painted in blue-black, to the left, and a moorhen. Dominating the centre of the composition is a male partridge with dark red markings on its smoky grey underside, included perhaps to show farmers and landowners that game shooting was also threatened. The rest of the picture is filled with the carcasses of other British birds set in rows as far as the eye can see. He had wanted to title the picture with the name of a chemical company but was dissuaded by Lett for fear of litigation. Although Rachel Carson's book *Silent Spring* (1962), which warned against the use of poisons in agriculture, had recently been published, it would take forty years for a worldwide ban on some of the deadliest chemicals to come into effect. In the farming county of Suffolk in the

late 1950s and early 1960s there was a great deal of excitement about the benefits of chemical sprays. In 1958, when wildlife deaths were beginning to be noticed, the *Suffolk Free Press* ran a story entitled 'Harvests – A Story of Big Increase: Dreams Come True'.[299] The article was written by a technical advisor for Fisons, the company responsible for the manufacture of fertilizers, fungicides and chemical poisons Dieldrin and Aldrin, later banned. *Landscape of Shame* remained unsold until the 1980s.

The rest of his paintings during the following decade were less controversial. Among his flowers, he painted some very fine interior still lifes, including *Still Life Garden Produce in Old Kitchen* (1961), *Still Life Garden Produce in Spanish Basket* (1961), *Pumpkin and Pots* (1968) and *Still Life Fruit before a Sussex Fireback* (1969). This painting has a slightly surreal feel – a bowl of lemons and limes of solid appearance is placed in front of a backdrop of seemingly insubstantial cavorting Classical figures.

Lett's 1960s diaries show a constant stream of visitors dropping by the 'Artists' House' for lunch, tea and supper. Frequent visitors included Beth and Andrew Chatto and Canadian author and gardener Elizabeth Smart, who also lived nearby. David Gascoyne, a friend of Smart's, could often be found soaking in the atmosphere. David and Barbara Carr now lived in Startston Hall near Diss in Norfolk; although very much influenced by Cedric's subject matter and painting style in his early work with the similar use of strong colours, sharp contours and smooth thickly painted surfaces, Carr's work had now taken a different direction. His series of paintings 'Man and Machine' has strong Cubist overtones. The young writer Ronald Blythe was amazed and impressed that, despite the stream of people coming to the house, Cedric was able to get things done both in the garden and on the canvas.

In the early 1960s Lucy Harwood, who was living in the nearby village of Layham, had become a part of daily life at Benton End. She would arrive with buns and chunks of bread and jam to serve elevenses and afternoon tea for the pupils. In the summer months, when Lett and Cedric entertained iris fans and other friends in the garden, she served strawberries in egg cups. Her bad driving was legendary in the

neighbourhood and all passengers whom she chauffeured, including Cedric and Lett, sometimes feared for their lives. She was a prolific artist, painting local landscapes, vegetables and portraits of students and local people. Due to a botched operation, which caused her to be partially paralysed on her right side, her technique was to swing a loaded brush at the canvas. The effect was strong, colourful, naive and physical. She brought every one of her works for approval by Cedric and Lett. Typically Cedric might tell her he did not like the flowers and Lett would say that the flowers were fine but that he did not like the rest of the picture. She often brought back the picture unchanged the next day and they heaped praise on it. Cedric was always a strong influence. She was furious when she was refused an exhibition at the Leicester Galleries because her work was deemed to be too like Cedric Morris's. She never hid her admiration for Cedric's work, but her sympathies were for Lett, who flirted with her outrageously. In her opinion Cedric took Lett's hard work for granted. She could hardly contain her excitement when she was included in an Ixion Society show in London in 1961: 'I do so admire Lett, being so utterly true to art and helping so many artists,' she wrote in her diary.

'It became apparent soon after arrival that your loyalties had to be either to Cedric or Lett,' said Ashe Eriksson, who joined the school in the early 1960s. Afternoons followed a strict ritual: 'Even though we had seen Cedric painting at the gate, we had to pretend to be visiting Lett as he was jealous of any attention being given to Cedric.'[300] Kathleen Hale said that 'Cedric's tastes were simple, almost puritan leftwinger, impatient of different points of view, so that to be accepted by him it was necessary to become a sort of disciple.'[301]

In 1960, aged fifteen, Maggi Hambling, whose father was a bank manager in Hadleigh, took her first two oil paintings of Suffolk landscapes to show Cedric Morris in the hope that his approval might reassure her parents regarding her decision to become an artist. Maggi had first seen Cedric when, in an attempt to be adopted as the Labour councillor for the local area, he had given a mumbled speech in Hadleigh.

'The "Artists' House" was considered by Hadleigh to be the home of every vice under the sun. Lett answered my nervous knock and I asked

if I might see Sir Cedric Morris? From his great height he announced imperiously: "Cedric Morris is having his dinner." I asked, "May I wait, please?" Reluctantly Lett opened what in retrospect proved to be the most significant door of my life,' Maggi Hambling remembers. 'Cedric was sitting in solitary splendour at the head of the long kitchen table. He welcomed, giggled and charmed, as Lett appeared, red wine in hand and served him a succession of mysterious dishes. The paintings were eventually propped up on the night storage heater and Cedric offered criticisms with encouraging suggestions. Lett reappeared and offered contradictory criticism, equally coupled with encouraging suggestions. He asked if I would like to come and paint in the school holidays.'

As the next school term finished Maggi went up to Benton End. 'Nothing would have stopped me,' but she was too shy to go up to the house. 'I sat in the ditch outside the gate and painted its dark muddy depths. Suddenly, Lucy Harwood appeared ringing a cow bell to announce elevenses and that was the beginning.'[302]

Maggi Hambling was asked to help in the kitchen in exchange for art instruction. 'I had to scrape maggots from the meat, offspring of the constant cloud of flies. The fridge stood next to the Aga and its door never agreed to close. One morning when Elizabeth David was being given a grand tour of the larder and butler's pantry, Lett ceremoniously lifted the big silver lid of a tray of cold collations and out flew a moth!'

'In that kitchen Lett became my mentor. He was a harsh critic, at first reducing me to tears, excusing himself with the pronouncement, "you don't pick holes in a rotten apple", meaning, apparently, that I was a good one.'

Hambling was agog at the stream of visitors. She was once overcome by shyness in the company of Francis Bacon and became completely tongue-tied. 'Is she dumb?' he asked. Bacon, who now had a house in Wivenhoe near his great friends Dennis Wirth-Miller and Dicky Chopping, would drop by with them to Benton End from time to time. It was always difficult to predict their behaviour. Lett always felt uneasy that the 'tea-time drunks', as he called them, might disrupt the smooth running of the day.

But, thanks in large part to Lett, Maggi's confidence grew. 'He told me to make my work my best friend ... that I could approach whatever my mood, tired, elated, bored, miserable, randy, et al, and have a conversation. He also said that no one without imagination could be an artist and that work must be the priority of life. Both Cedric and Lett insisted on the constant practice of drawing and complete disregard of fashion.' Although she held Cedric in high esteem, she was a Lett person: 'Cedric was hermetic as a teacher and Cedric people doggedly adhered to his fixed ideas, clearly trying to emulate his work. Lett on the other hand was open to everything. He never trotted out a formula and if he couldn't answer a question, he admitted it – a rare quality in a teacher. He had the ability to address himself to a new student and bring out who or what he or she was.'

Cedric grew to trust Maggi as someone who could pick out a good picture. 'He trusted my eye and from time to time asked me to go through piles of paintings to help him decide which ones to destroy. At the end of a couple of hours half a dozen were selected, but inevitably replaced as he always found something he liked in each of them.'

She explains her take on Lett and Cedric's relationship: 'Lett had set up Cedric as the Master and himself as the Impresario. Occasionally Lett The Cook sat down to eat with the rest of us because by then, having produced the food, Lett was usually drunk, which removed our attention from Cedric. Lett's conversation was sophisticated, witty and laced with sex, which punctuated almost every subject in a surprising way.'

Maggi Hambling studied at Camberwell Art School and the Slade in London, 'but nowhere ever matched the cut and thrust of Benton End ... It prepared me for the world and I found out who I was. My mother once said, "I wish to goodness you had never set foot in that place" – but it was too late.'

Cedric continued to travel throughout Europe from December to March, staying en route in London with old friends Felicity and Peter Wakefield in Knightsbridge. He would visit the Wakefields at their diplomatic residences throughout the Middle East, where he found they had hung his paintings. On other occasions he would be given a bed by Joan Warburton and her husband Peter O'Malley in Chelsea.

He moaned to Joan about the lack of heating and facilities in Europe, saying he never wanted to go abroad again, but as the next winter approached, he left for the Continent once more. In 1963 he travelled further afield, to Zimbabwe, then called Rhodesia. His letters home talk about the injustices of the country and he condemned the treatment of the indigenous black population by the white settlers. He painted two beautiful pictures there, *Rhodesian Summer* and *Summer Veld*. In the garden of his hostess, Lady Murphy, he spied a large arum lily with leaf-green tips at the end of the porcelain white spathes. He grew these very successfully at Benton End in watertight glazed chimney-pots. Beth Chatto named them 'Green Goddess' and successfully grew these plants that would win Cedric his third RHS Award of Garden Merit. In the winter of 1965 he travelled to St Helena in preparation for an exhibition at the Upper Grosvenor Galleries in London and in 1966 he went to the Azores.

Cedric was unfailingly generous with his time and knowledge, giving away plants freely to keen gardeners. Indeed, on one garden open day seeds and cuttings surreptitiously taken by a visitor fell from his pocket in front of Cedric. He carefully picked them up and handed them back, sharing tips and inviting the man to come back again for more. Local ladies were curious to meet the handsome Sir Cedric and a good number of them enlisted for flower painting instruction from him. Kathleen Hale would tease him, calling him 'a sitting duck for amorous pursuit by middle-aged lady virgins'. His response, giggling mischievously, was, 'I would love to shake a wet lettuce up their petticoats.'[303] Nevertheless, he would never belittle their ambitions. Some years earlier he had addressed the opening of a Frances Hodgkins exhibition, declaring that 'an old maid on a camp stool is as potentially capable of achievement in the Arts as a lad of seventeen who crashes into the firmament of fame, alas, in many cases disastrously too soon.'[304] The old maids were blissfully unaware of the delicate balance required of young students to negotiate the bickering and petty jealousies between Cedric and Lett. They certainly played up, making petty squabbles into a performance for their audiences. 'Oh, that Arthur Lett-Haines, he has got some skeletons in his cupboard,' Cedric would say, hand on hip. Lett

may have not held court at the dining table, but at other times of day in front of a gathering of rapt students he would recount his scandalous exploits. Often the events would be wildly exaggerated and, when Cedric overheard, he felt obliged to add a correction.

But now in his seventies, browned by the sun, with a pipe in his mouth, a coloured neckerchief as usual round his neck and dressed in baggy corduroys, he was finding the garden increasingly hard work. Since Nigel had died he had not found a serious and knowledgeable person to help him in the garden, 'and because I have not sufficient time, it is deteriorating. It is not there is too much work but too much fiddling things to do.'[305]He needed an expert on a more full-time basis and approached highly regarded South African botanist, plant collector and painter Wessel Marais, who had just left his job at Kew. He arrived in the spring of 1967 and, much to Lett's dismay, did not leave until the autumn. Lett found him demanding, especially over his meal requirements, and had had enough of him after three months. 'July 26th, am round my breaking point, I don't know what to do,' Lett wrote in his diary. Wessel's help in the garden was much needed and appreciated by Cedric. He worked hard and oversaw the transfer of the valuable collection of plants from Mrs Anley's garden to Benton End due to her declining health. But Wessel overstepped the mark. Maggi Hambling recalls, 'When Wessel dared to suggest to Cedric that life would be much improved without Lett around, Cedric sent him packing and he left the next day.'[306]

In an attempt to avoid the gardening friends, Lett holed up in his room, sipping gin and smoking cigars, surrounded by the accumulated possessions of many years. On the ironing board were the materials for his tiny sculptures that he called 'weirdies' or 'humbles'. Crab shells and chicken bones left over from supper, pencil shavings, matchsticks and many other pieces of detritus would be fashioned into unsettling creations. Kathleen Hale remembered one of them called *The Garden*, which featured delicate, white thigh bones rooted in plaster, knobbly joints pointing upwards like buds on stalks, evocative of an alien plant grown in a dark cellar. Another she found the stuff of nightmares, describing the appearance of the luridly coloured plaster as suggesting

blood and mud topped by a glass eye.[307] One watercolour shows dragons and angels below a wash of watery colour where he had let the paint run across the painting.

While Cedric had Wessel to help him in the garden, Lett was greatly assisted by Millie Hayes, who had come back to them. In the early 1960s, while working as a still-room maid and odd-job woman at the Copper Inn in Pangbourne, Berkshire, she wrote to Lett enquiring after his well-being. She visited him in the winter of 1964, shortly after he received news that his wife, Aimee, had died in Santa Barbara, California, in October. Aimee had had no children and no new husband. She and Lett had never got round to getting a divorce. Millie found Lett attempting to juggle everything – painting, administration and cooking. She offered to cook for him and soon after moved in to Benton End. In her honour the kitchen and bathroom were retiled with three crates of Portuguese tiles. She was to become the third person in Cedric and Lett's partnership and all invitations extended to the men included her. Maggi Hambling recalls that she did not take kindly to Lett introducing her as a housekeeper: 'When we were visiting Lett in hospital another visitor arrived and Lett introduced Millie as his housekeeper. After the visitor had gone Milllie exploded. "How would you like to be introduced?" he asked her and she retorted: "Millie Hayes, a person?"'[308] It was typically kind of Cedric and Lett to come to her aid when her life was pretty miserable, but she did happen to be an excellent cook, who took the ancient, temperamental Aga in her stride. Her culinary magic created in very adverse conditions received high praise from Elizabeth David and regular visitor Archie Gordon, the Marquess of Aberdeen, who was becoming one of Cedric's closest friends.

With the arrival of Michael Chase as director of the Minories Gallery in Colchester in 1966 Lett and Cedric found their work in greater demand than it had been for years. Chase had been a director at Zwemmer, one of the first galleries to introduce Picasso, de Chirico and Miró to London. Cedric knew Michael Chase through his wife, Valerie Thornton, who had been at the East Anglian School of Painting and Drawing. Immediately on his arrival in Colchester, Chase offered a reluctant Lett a show at the Minories. Lett, however, told the local paper

that 'he never had a show satisfactory to himself, on every occasion being enjoined by circumstances into the presentation with insufficient time to assure the adequacy of the collection.'[309] But on 17 December he was able to provide fifty-two works in watercolour, watercolour and wax, pencil, pen-and-ink, chalk and mixed media. The date range was from 1916 to 1966, omitting 1934–50, when his output was negligible. He included landscapes, people he had seen on his travels and a self-portrait, *Aspects of Cedric Morris*, as well as more mysterious works with titles such as *Nocturnal Composition*, *Improvisation No. 22* and *Conjecture*. Prices ranged from £10 to £60. The reviewer from the *East Anglian Daily Times* said 'the show was a marked success.'

The following year, 1967, Chase included Cedric in a non-selling exhibition at the Minories called 'The Flower in Art'. Morris's *Several Inventions* (1964) and *Paysage du Jardin* (1932) hung alongside the great Dutch flower artists of the seventeenth century and Cedric's contemporaries Wilfrid Blunt, Ivon Hitchens and Winifred Nicholson. That year the Colchester Art Society had two exhibitions under its auspices in spring and winter, a spin-off show for the New Ipswich Art Group, both at the Minories. Cedric submitted work for both.

It was probably the Colchester exhibitions that prompted the National Museum of Wales in Cardiff to offer him a retrospective in the summer of 1968. The Keeper of Fine Art at the museum wrote to Cedric while he was in Libya to inform him that the exhibition would be very large and need lots of loans from private collectors. There were plans to tour it round Wales, then finish at Colchester. Lett wished to carry out all the necessary administration and correspondence despite bouts of ill health. The Keeper, Peter Kelly, told him that the museum particularly wanted Morris's pictures that had influenced Christopher Wood. 'We should try and bring out his historical importance as a master as well as his achievements as a painter,' he explained.[310] In the winter Cedric went to Libya to stay with the Wakefields. Lett went to London to stay in a flat he had rented in Chelsea.

15.

LAST DAYS AT
BENTON END

THE CEDRIC MORRIS RETROSPECTIVE AT THE NATIONAL MUSEUM OF WALES opened on 16 June 1968 with 118 oil paintings, and 18 drawings dating from 1920 to 1967. Around forty were offered for sale for between 150 and 200 guineas each. A small party of friends, lenders and former East Anglian School of Painting pupils travelled to Cardiff for the opening party, where they read Lett's exuberant introductory biography of the artist. 'Cedric Morris was born of phenomenal vitality,' was the opening line of his text. He did insert a little barb of his own by adding that the exhibition represented only a tenth of Cedric's output, 'which would be mightier still but for the creative experiment in horticulture for which he is celebrated.'[311] The trip to Wales and surrounding buzz were exhausting, however, for both Cedric and Lett.

In the winter Cedric went to Funchal in Madeira and found he could not walk back from the town. 'I guess it's my eightieth year announcing itself,' he wrote to Lett.[312] Cedric had never learned a word of Portuguese, nor was there another English speaker in the town to explain his symptoms to the doctor. He travelled on to Spain, to an area beyond Almeria where a drought can last two years. There he found a small grey-purple crocus which Tony Venison believes to be

Crocus nevadensis. He called the area 'moon country' and remarked laconically that 'it is a good place to die – dry and no noise.'[313]

He returned to England shaken by his inability to walk any distance and decided to make a will in favour of Lett. But Lett was far from well himself. In the summer of 1968 he was admitted to hospital again for a cardiograph and was put on a diet for suspected diabetes. Back at Benton End all was not running smoothly. Millie, perhaps under the influence of Lett's nephew Gerry Stewart, was getting drunk rather too often. Lett had been receiving distressing phone calls from an inebriated Gerry at the restaurant he had opened in St Austell, Cornwall, and invited him to come and stay for a few days in Suffolk. Cedric was becoming less good on his legs and was starting to fall over.

Both men were determined to continue to paint and exhibit. In August 1969 they had a joint show at a gallery in the Suffolk town of Long Melford and this time the *East Anglian Daily Times* reviewer commented on Arthur Lett-Haines's submissions: 'His work underwrites the predominant Surrealism with his own peculiar brand, his invention and mastery of watercolour medium being added to this time by a rather horrific oil, *Incantation*.' Shortly after the show the Auckland City Art Gallery in New Zealand borrowed a watercolour by Lett.

In May 1970 Cedric had an exhibition at the Upper Grosvenor Galleries in London, where his still lifes such as *Garden Produce in an Old Kitchen* (1958) and *Fruit Before a Sussex Fireback* (1960) were priced at £400 and £360 respectively, while the flower portraits were for sale at half that. This pricing was somewhat of a surprise to Cedric, who had always maintained that his flower paintings were the most sought after and of highest value.

For the first time in twenty-five years Cedric did not winter abroad in 1970. He was nearly eighty-two years old and told Joan Warburton he felt like a train sandwich curled up at the edges. In February 1971 he decided he had to go to Cyprus and enjoyed himself on his return regaling people with stories about the old retirees living in Cyprus, including a colonel he had met, naming him 'Shoot the Lot'.

Former pupil Joan (Maudie) Warburton had recently moved to Little Horkesley, five miles from Benton End. She visited Benton End

every week, spending time with Lett in his upstairs den then moving to talk to Cedric in his downstairs studio. She had found both men were calmer and less bitchy. 'Don't do too much except of [sic] painting,' Millie often exhorted Lett, 'and don't get tired out!'[314] Lett had become much less worried about the recent gales that had blown off one of the chimney-pots. He wanted to make the pot into a plinth for sculpture or pot plants. When he visited, Ronald Blythe found Cedric enjoying life and taking pleasure in his surroundings, 'sensuously basking in little treats'.[315] He was keen to build bridges with his sister Nancy, with whom he had had infrequent contact over the last thirty years. She invited him to stay with her and her bulldogs for Christmas in both 1974 and 1975 at her home near Henley-on-Thames, but he declined, preferring to stay at Benton End with Lett.

Nobody had replaced Wessel Marais to run the garden and it was becoming increasingly overgrown. Warburton noticed the weeds were overwhelming the plants, especially the fritillaries, although plants such as tiny mauve crocuses, ferns and colchicums had managed to fight through. It was becoming difficult to distinguish the paths from the flower beds. Cedric realized he needed help and started to ask friends if they knew anyone who might be prepared to come and do some weeding in exchange for drawing lessons. Elizabeth David recommended the young Frances Mount, who had been the manager of her London cookery shop. Frances Mount recalls Lett's bemused and disappointed expression when she arrived with her cat in a basket. He had misheard what she said on the phone, believing she was bringing a car.

Mount found that she was not doing much drawing but was working hard in the garden and keeping the peace between bickering Millie, Lett and Cedric. One of her first tasks was the weeding of the geranium bed. 'He thought of me as a town girl and a bit of novice, but practical,' she recalled.[316] Inside the house her tasks were clerical. She was also asked to look after the oil paintings, wiping them with Lux soap flakes then drying them with a silk cloth.

Frances worked at Benton End for eight years, preparing the garden for the Red Cross opening every summer. 'Cedric loved plants

with definite shapes, the ruder the better. If you look at his pictures, the importance of the shape of each flower, its length of stem is very evident, each flower has to stand on its own. He liked to grow small, strong plants like pinks that concentrated the eye.' She loved the childlike enthusiasm he still expressed when anyone brought him a new plant. However, she recalls among the few exceptions to his delight the large cultivated gladiolus and any form of dahlia.[317] As his eyesight started to deteriorate, he would identify plants by feeling and smelling their leaves and he was just able to identify birds in flight by observing their outline.

Lett and Cedric continued to go to parties. They would receive many invitations. They still enjoyed dressing in nice clothes; Cedric loved his sorrel-coloured sweaters and Lett would go out in one of his black cloaks. They attended a number of fancy-dress parties and Lett always dressed as an Edwardian dandy, complete with cane. Some of his beautiful old clothes had become worn and instead of mending a pair of trousers he would paint in the hole on his knee to match the colour and pattern. He continued his flirtatious behaviour. He told Frances Mount that if he had been forty years younger he would have married her. A young man recalled with embarrassment walking into Lett's bedroom to find him gleefully naked. His mind was still as acute as ever. He kept up interest in the goings-on of society grand ladies, cutting out and pasting into his diary an article headlined 'Duchess Tells All' about a memoir published by the Duchess of St Albans. He saved another article about William Shakespeare's supposed brother Nicholas's homosexual life in the taverns of London.[318] He still aimed acerbic comments at artists and friends. 'I wish you would take as much time with your painting as you do with your clothes,' he told Warburton. He had taken up the cause of a psychiatric patient, Dennis Seegers, whom he had met in London. Seegers wrote pleading letters to Lett asking for money. He had mental issues and was periodically detained in Broadmoor. On one of Seegers's visits to Benton End a frightened Frances Mount asked Cedric not to have to sleep in the room next to him. 'I didn't really think it was a good idea to have him there without supervision. Lett thought I was overreacting. I think I was too strait-laced for Lett,' she reflected later.

Even in old age Cedric was unwilling to turn any visitors away; collectors, gardeners and former pupils were always welcome. 'Cedric hated bores but was charming to them so they kept coming back for more,' Glyn Morgan recalled.[319] Felicity Wakefield says that he became increasingly deaf in one ear and used to seat people he found tiresome on the deaf side.

Referring to those who showed interest in his paintings, Cedric opined, 'I divide people who come here into two lots – those who want to be artists, those who want to make art.'[320] Since the Cardiff exhibition, art dealers who had not taken notice of him for years were circling. Millie tried hard to protect him from their intrusions. He took a sanguine view. 'Wanting to see one's name in lights is something that doesn't matter at all, it's people's ideas that live on, Jesus Christ, Michelangelo, their ideas are more alive than their bodies ever were. With myself it's my ideas that I want to live and the school, that's what I care about'.[321]

Bernard Reynolds, a pupil at Ipswich Art School in the 1940s, and later a teacher there, cast bronze busts of Cedric and Lett as distinguished old gentlemen. Young gardeners raved about Cedric's supremely sophisticated colours, and artists and gardeners were keen to talk to him about his younger days. He received a letter from Prince Bhanu Yugala of Thailand asking for arum lilies and offering him orchids from his country. A younger generation was becoming interested in Lett and Cedric's life and friendships between the wars. Prunella Clough asked to tape an interview with him. Sadly, no evidence of these recordings exists. Artist Anne Coghill, after reading Gerald Brenan's books about Spain, wanted to record some of the people Cedric had met and some of the things he had experienced. When his good friend and collector the artist Mary Cookson asked Cedric if he felt a responsibility for keeping the young Lucian Freud under control, he replied that he himself wasn't 'a grown-up' and therefore did not feel any responsibility towards him. 'He was just here to paint,' he said emphatically.[322] Freud told friends that Cedric never blamed him for the fire and they were still on good terms. Freud would often drive down to Suffolk in his Bentley to take Cedric out to

lunch. On one occasion in the late 1960s Freud asked where he would like to go. 'How about Dedham?' suggested Morris. 'It might revive old memories!'[323]

Although the school had been wound down to all intents and purposes, local ladies were allowed to come into the garden to paint and Cedric still offered advice, although his vision was becoming what he described as 'milky'. He squinted at the easel of Mina Smith, who wore a tweed skirt and thick stockings in the height of summer. 'Don't paint a half a tree, a quarter is OK, so is three-quarters, but never half.' To other nervous pupils he would pronounce 'nature abhors a straight line.' As his eyesight worsened, his relationship with his garden became more tactile.

In March 1972 Lett was very pleased to receive positive notices for his watercolours, collages and sculpture at his show at the Mercury Theatre in Colchester. 'Haines' Talent Still Advancing' was the headline in the *Eastern Daily Press*. 'This incredible man is not only still going but in fact is advancing in inventiveness.' The critic gave the highest praise to a large abstract collage made of all kinds of bits and pieces in a circular composition.

It was decided to have a clear-out of all the old pictures from former Benton End students. Lett put together an exhibition at Westgate House in Long Melford in aid of the local church. Lucian Freud's portrait of Dicky Chopping was offered for sale at £500 and Lucy Harwood's *Merlins aux Citrons* at £100. Cedric put up three oil landscapes and one of a yucca plant, while Lett contributed mixed media pictures and a pair of watercolours. Joan Warburton found it all a bit of a shambles; pictures were badly hung and many were not priced.

Through much of July and some of August 1973 Lett was in Ipswich hospital with an undiagnosed illness. Doctors told him it could be amoebic dysentery or a malfunctioning pancreas. Cedric took in a bunch of flowers from Benton End. 'The flowers are very much admired by everyone but had to be discarded after ten days. I have been hoping for some more,' he wrote in his diary.[324] As soon he was out of hospital in September he accompanied Cedric to the Anthony d'Offay Gallery in Chelsea to see a Lucian Freud exhibition. It was a big

A LESSON IN ART & LIFE

effort; Cedric was very unsteady on his feet and cataracts had started to form in his eyes.

In November 1974 the two elderly artists were given a joint show at the Minories. Cedric submitted a mix of portraits, landscapes and still lifes from over the years; forty pictures in total, ranging from £90 to £300. Lett's petite sculptures with titles such as *Objets Trouvés and Reforme, Le Henry Moore, Aspirant 1971 Wood and Bone* were priced from £27 to £65, with his paintings and drawings and sculpture ranging from £50 to £200.

In 1975 the New Grafton Gallery in London assembled a range of pictures by Cedric Morris from the 1920s to the present day. Friends and collectors were determined that Cedric should be given the respect he deserved. *The Times* reviewer William Gaunt reported that his work showed 'a consistently high level of accomplishment during a long space of time and calls for a remark of the continued activity of the artist, who has reached his 85th year'. However, sales were poor.

The following year one of the longest heatwaves on record brought a hosepipe ban and consequently the loss of many plants at Benton End. Both old men were now too frail to go outside and Cedric was finding it difficult to read. A visit to an eye specialist in London offered no cure. 'My eyes are deteriorating and my nerves are going,' he confessed to Tony Venison.

In the late autumn Cedric was determined to make one last painting trip to Portugal 'before my eyesight goes completely'. While out walking one day in Portugal he was bumped by a car and, although he came to no harm, he was very shocked and shaken. He returned home on 24 March the following spring and would never leave England again. Lett was becoming less and less active; if not in hospital, he was in bed at home. He had given over all the cooking to Millie. In early 1978 on return from a spell in hospital, he took to his bed never to get up again. He died on 25 February. As he fell asleep he remarked what an odd time of year it was for a thunderstorm. For the last two weeks of his life Gerry Stewart and Millie Hayes had nursed him round the clock.

In the immediate days after Lett's death Joan Warburton sat with Cedric, whose mind was starting to become disconnected from the

present and wander back to the past. He told her how he had been thinking about the times he had had with Lett in their youth. 'Lett's good looks were extremely disturbing,' he confessed.[325] He talked about their quarrels, but with affection and nostalgia. Lett's funeral in Hadleigh Church was well attended. Cedric had tears streaming down his face. He tottered out of the church and was driven back to Benton End, where he managed to recover his composure under his old floppy hat. Noticing Natalie Bevan in very expensive new headgear, he joked, 'I see we are wearing the same hats.'[326] As he talked to the fellow mourners, Warburton left the service thinking that Cedric was relieved it was all over. But the loss of Lett had advanced his years and diminished his ability to cope with life. He was becoming increasingly frail and forgetful and would sit in his chair for hours, listening to songs and story tapes. In his conversation he was mixing dreams with reality. The doctors thought he had suffered a mini stroke brought about by coughing, which had confused his thoughts. The frequent visits and gossip of his new friend Archie, the Marquess of Aberdeen, editor of the BBC's *Week in Westminster* and cross-bench peer, kept up his spirits. Peter and Felicity Wakefield wrote from Beirut, where Peter was the ambassador, telling him how his pictures which they had hung in the embassy had given them much solace and happiness.

A few months after Lett's death Peter Wakefield wrote to Cedric informing him that Michael Chase had called a meeting to discuss the future of Benton End. 'The idea of preserving the form and spirit of Benton End is appealing,' he explained, but he had no suggestions. 'It would be nice to think of someone sympathetic taking over, maintaining the garden and possibly running the school, but everything depends on the personality.'[327] Maggi Hambling's name was bandied about, but she decided she wanted to concentrate on painting, so nothing came of that.

With the help of Millie, Glyn Morgan and Joan Warburton, Cedric was guided to focus on the two exhibitions of his work in 1979. In January Cedric was very flattered by a visit by Robert Gibson from the National Portrait Gallery, who took away four portraits, of Rosamond Lehmann, Dylan Thomas, Antonia White and a self-portrait.

As spring gave way to summer Cedric began to regain some mental acuity. He would get up at six and sit peacefully in the garden in a dreamlike state in front of parade of irises in Indian sari colours of deep purple, brown, yellow, white, blue and pink. At eleven o'clock he was ready to receive visitors. Joan Warburton remembers discussing politics and, of course, Lett, who was never far from his thoughts. Cedric would ask her questions about Lett he had never asked him when he was alive.

In June 1979 Cedric was included in a show called 'English Artists, 1900–1979' at Blond Fine Art. He submitted *The Sisters*, which he had painted in Wales all those years ago and renamed it *The Upper Classes*. Renamed for a third time to *Two Sisters*, it was bought by the National Museum of Wales in Cardiff. He was determined to attend the show and got Millie to hire a taxi to take him from Suffolk. He dressed in a new pair of black trousers, his father's smoking jacket over a much-darned black sweater and a silk scarf, even though it was a warm day. He sported a yellow iris in his buttonhole. As he entered the exhibition he was fearful of being tired out by questions. Joan Warburton felt the pictures shown were not his best. Jonathan Blond complained that there were too many hangers-on. Cedric, however, felt the trip had done him good.

On 11 December, for Cedric's ninetieth birthday, his gardening friend of many years Jenny Robinson gave a lunch party at her big, old, rambling house in the nearby village of Boxford. She was a gardener he highly respected. A small group included the young and enthusiastic plantsman John Morley, Tony Venison, Archie Aberdeen and Maggi Hambling. Beth Chatto brought a large pot full of the beautiful Christmas-flowering dwarf yellow narcissus which Basil Leng had given him all those years ago in Portugal. She had treasured and nurtured the bulb, registering it as *Narcissus minor* 'Cedric Morris'. For the special occasion she had coaxed the narcissi to flower two weeks earlier than usual. He was also very touched to receive a photograph of himself standing by a spectacular white rambler rose named 'Sir Cedric Morris' by its grower, Peter Beales, who had discovered the seedling rose in Cedric's garden. Cedric had helped Beales set up his

Norfolk rose nursery by offering him cuttings and shoots from Benton End.

But despite the exhibitions and therefore renewed interest in Morris's work during the 1970s, London's Tate Gallery, which as one of its functions was supposed to represent the achievments of British art, had not purchased a single picture of his. Richard Morphet, a curator at the gallery, who famously caused press outrage with his exhibition of Carl Andre's bricks, *Equivalent VIII*, in the early 1970s, had become interested in Cedric's work but knew that under the directorship of Norman Reid an exhibition of Morris would never be approved. Felicity Wakefield had suggested to Reid in the late 1970s that the Tate might take some of Cedric Morris's pictures, 'and he said nothing and just laughed,' she recalled. Hockney and Freud were not of interest to him either. During Reid's tenure at the Tate from 1962 to 1979 the gallery purchased just two Freuds, one of which represented a human being, and only one Hockney. In the late 1970s Hockney had roused public controversy by attacking the relative narrowness of the Tate's acquisistion policy and in particular its neglect of figurative art.[328]

Morphet curated two Tate displays, in 1977 and 1978, which included a significant number of rarely exhibited, straightforwardly representational art. 'While favouring abstract art as well these displays were correctly seen at the time of being subversive of the then prevailing Tate policy because they were non-innovative,' he says.

Cedric Morris's paintings failed the criteria for inclusion in the Tate collection for two reasons, he explains: 'Quiet flower paintings and landscapes that were seen as not being innovative stylistically were considered (wrongly) to be too conventional to be of interest, while many of Cedric's portraits, not to mention works like *Landscape of Shame*, (*Plate 28*) were seen as being too primitive and too direct. Thus Cedric's work was sidelined both for its (mistakenly alleged) quiet conventionality and for its unacceptably forceful directness.'[329]

In 1980 the Tate appointed a new director, Alan Bowness, who according to Richard Morphet 'was concerned with a whole range of content, form and expression in art.'[330] In the same year Maggi Hambling was appointed the National Gallery's first artist in residence

and became a key figure in raising awareness of Cedric's paintings in the museum world. During her tenure at the National Gallery she mounted small displays, including her drawings of Lett. However, Morphet says that when Alan Bowness took over as director of theTate in January 1980 'everything suddenly became more possible.' Morphet went to see Peter and Felicity Wakefield's comprehensive and remarkable collection of Cedric's work at the embassy in Brussels where they were residing 'to explore the possibility of making work available for consideration of purchase by the Tate'.[331] The Wakefields generously offered Cedric's *Portrait of Lucian Freud*, 1941 (*Plate 20*). In December 1980 Morphet visited Cedric at Benton End to see his paintings and to be pointed in the direction of collectors of his work. Morphet reported back to the Tate and was given the go-ahead to acquire the Freud portrait as well as the double portrait of David and Barbara Carr (1940) and *Iris Seedlings* (1943). At Benton End Morphet also saw *Landscape of Shame* (1960) and recommended the Tate buy it.

The rest of the eleven Morris paintings now in the Tate collection were acquired after his death. Friends of the Tate presented *Landscape of Shame* in 1987; Elizabeth David donated *Eggs* (*Plate 23*) in 1992 and *Experiment in Textures* was purchased in 1995. The National Museums and Galleries of Wales acquired some beautiful Morris pictures. In 1992 the Tate purchased Lett-Haines's *Dark Horse* and in 1995 Michael Chase donated his *Power of Atrophe*. These two works from the 1920s depict metaphysical landscapes with a debt to de Chirico's and Wyndham Lewis's work of the same period.

By 1981 Cedric was nearly blind, had grown a soft white beard and enjoyed basking in the sun like a cat. He was slipping away gracefully, sitting in a peaceful state surrounded by friends, memories of the old days blowing into his head like a gentle breeze. On 4 February 1982 Cedric's hand slipped from the back of a chair and he stumbled to the floor. Friends gathered by his bedside in Ipswich Hospital as he started to withdraw from life. Maggi Hambling was at his bedside on 6 February. She returned to London and the next day made a drawing from memory, *Cedric, 8 February 1982*. It shows Cedric's head and shoulders against a pillow, his hand outstretched, and as Maggi Hambling recalls,

was completed just before she received a telephone call from Ipswich informing her of Cedric's death. He died of complications following a hip operation on 8 February. He was ninety-two. His funeral was held on 12 February in Hadleigh Church. His encomium was given by his friend Canon Rutherford and compared the light in his pictures and the light he brought into people's lives.

There was a reading of Cedric's will at Benton End attended by many friends and former pupils. Fiona Bonney, who was helping in the garden, was asked by one of his exectuors to jolly up the front entrance to the house where tomatoes were growing. In a quick fix between the tomatoes she planted lobelias and geraniums; 'no doubt this odd mix of plants would have greatly amused Cedric,' she smiled later.[332] Cedric left a sum of money to his executors for the purpose of providing a dwelling for Millie Hayes. Jenny Robinson was left the contents of the Benton End garden and it was Cedric's wish that his plants should be distributed all over the country after his death. There were still rows of iris seedlings in the garden. Many were taken by the British Iris Society. Jenny Robinson, his plant executor, dispersed the rest among friends and plant collectors. *The Times* obituary for Sir Cedric Morris made no reference to Arthur Lett-Haines.

Glyn Morgan returned to Benton End one last time the summer after Cedric died. Memories came flooding back to him: 'The creaking house and the glorious garden were the only real life and the outside world was a sort of shadow land. I never left without tears in my eyes.' He could not believe Cedric had really gone: 'it seemed as if he might call at the studio any moment, a personality like this does not easily leave a house that it has brightened so long.' The next year he called again and this time he knew that Cedric had left. 'The house was just a house; the rooms seemed half the size.' A wooden, hand-carved plaque was fixed to the building over a downstairs window which simply read The East Anglian School of Drawing and Painting.

Maggi Hambling has summed up the love and life of Cedric very movingly: 'One winter afternoon not long before Lett's death, Cedric shuffled into the classroom, carrying a delicate white flower. He presented it to Lett. No word was spoken, no words were necessary.'[333]

NOTES

For concision, the names of Cedric Morris and Arthur Lett-Haines have been abbreviated to CM and ALH in these notes.

CHAPTER ONE: Sons of Wales & London
1 Television documentary, *An Impertinent Spirit*, BBC Wales, 1984.
2 CM notebook, undated, Tate Gallery Archive, TGA 8317.3.1.
3 Cyril Piciotto, St Paul's School records, Blackie, 1939.
4 Ibid.
5 CM, notes in blue exercise book, undated, TGA 8317.3.1.5.
6 Ibid.
7 ALH, unpublished notes, TGA 8317.6.3.2.
8 TGA 200117.5.3.
9 Letter, CM to ALH, 2 July 1925, TGA 8317.1.4.19.

CHAPTER TWO: A *Coup de Foudre*
10 Tate Gallery Archive, TGA 8317.9.4.
11 Cardiff Retrospective, Introduction, 1968.
12 TGA 83171.4.27.
13 Ibid.
14 Ben Tufnell, *Teaching Art and Life*, Norwich Museums, 2003.
15 Typescript of opening speech by CM for Frances Hodgkins exhibition, Bournemouth, 1948, TGA 8317.6.4/2.
16 CM, blue notebook undated, TGA 8317.3.1.5.
17 T. W. Earp, *Design and Drawing*, 1928, TGA.8317.13.2.
18 T. W. Earp, Cedric Morris Exhibition, Arthur Tooth Gallery, London, 1928, TGA8317.9.1
19 ALH, unsent letter to Aimee Lett-Haines, 1920, TGA 200117/4/3-4.
20 Ibid.
21 Ibid.
22 Anita Berry, *Studio* magazine, 1928, TGA 8317.9.6.
23 *Daily Express*, 1928, TGA 8317.13.2.
24 *Western Mail*, 1926, TGA. 8317.13.3.
25 Anita Berry, *Design and Art*, Arts League of Service, 1928.
26 Denys Sutton, *Letters of Roger Fry*, vol. II, Chatto and Windus, 1972.

CHAPTER THREE: Paris: Finding the Lost Generation
27 ALH, private notebook, undated, Tate Gallery Archive, TGA 8317.7.
28 *South Wales Daily News*, 1920, TGA 8317.13.2.

29 'Cedric Morris and Arthur Lett-Haines' (author unknown, extracts translated from Italian by the author), Casa d'Arte Bragalia, TGA 8317.9.1.8-9.
30 *La Tribuna*, 1922, TGA 8317.13.
31 Kathleen Hale, *A Slender Reputation*, Frederick Warne, 1994.
32 Nathalie Blondel (ed.), *The Journals of Mary Butts*, Yale University Press, 2002.
33 *Paris Times*, 1924, TGA 8317.1.3.
34 *American Review*, 9 September 1924, TGA 8317.13.3.
35 Kathleen Hale, *A Slender Reputation*.
36 *American Review*, January 1925.
37 Ernest Hemingway, *The Sun Also Rises*, Scribners, 1926.
38 R. Meyer, 'Big Middle Class Modernism', *October*, no. 131, Winter 2010.
39 *New York Herald*, 1923, TGA 8317.13.
40 *Christian Science Monitor*, 1923, TGA 8317.13.
41 *American Review*, 1924.
42 CM, Description Tate Gallery, Experiments in Textures.
43 R. H. Wilensksi, Arts League of Service, 1924, TGA 8317.9.1.10.
44 *Good Housekeeping*, 1924.
45 R. H. Wilensksi, Arts League of Service, 1924, TGA 8317.9.1.10.
46 ALH, unpublished manuscript, c.1924, TGA 8317.2.8.1.
47 *Leeds Mercury*, 1924, TGA 8317.13.2.
48 Richard Morphet, *Cedric Morris*, Tate Gallery, 1984.

CHAPTER FOUR: Travels in Europe & Beyond
49 Collingwood Ingram, *A Garden of Memories*, H. F. and G. Witherby, 1970.
50 Letter from John Banting to CM, 1924, Tate Gallery Archive, TGA 8317.1.126.
51 *Nation*, March 1923, TGA 8317.13.3.
52 ALH, unpublished writing, undated, TGA 8317.7.1.24.
53 Nathalie Blondel (ed.), *The Journals of Mary Butts*, Yale University Press, 2002.
54 Letter, CM to ALH, March 1925, TGA 8317.4.1.
55 Ibid.
56 Letter, CM to ALH, June 1925, TGA 8317.1.4.15.
57 Letter, CM to ALH, June 1925, TGA 8317.1 4.14.
58 Letter, ALH to CM, August 1925, TGA 8317.4.35.
59 Ibid.
60 Letter, CM to ALH, March 1925, TGA 8317.1.4.1.
61 TGA 8317.1.4.5.
62 Letter, ALH to CM, April 1925, TGA 8317.1.4.231.
63 Letter, CM to ALH, April 1925, TGA 8317.1.4.5.
64 Letter, CM to ALH, April 1925 TGA 8317.4.
65 Letter, CM to ALH, April 1924, TGA 8317.1.4.232.
66 Letter, CM to ALH, July 1925, TGA 8317 1. 4.19.

67 Letter, CM to ALH, July 1925 TGA 8317.1.4.21.

68 Letter, CM to ALH, July 1925, TGA 8317.1.4.27.

69 Ibid.

70 Ibid.

71 Letter, CM to ALH, August 1925, TGA 8317.1.4.36.

72 Ibid.

73 *Morning Post*, February 1926, TGA 8317.13.3.

74 *Western Mail*, February 1926, TGA.8317.13.3.

75 *Leeds Mercury*, February 1926, TGA 8317.13.3.

76 Richard Ingelby, *Christopher Wood: An English Painter*, Allison and Busby, 1995.

77 Richard Morphet, *Cedric Morris*, Tate Gallery, 1984.

78 *New Yorker*, October 1926, TGA 8317.13.2.

79 Seven and Five catalogue (author unknown), January 1927.

80 Frank Rutter, *Sunday Times*, January 1927, TGA 8317.13.3.

81 Unpublished interview with Ben Tufnell, 30 May 1997.

82 E. H. McCormick, *Portrait of Frances Hodgkins*, Auckland University Press, 1981.

83 Christopher Wood, *Dear Winifred: Letters to Winifred and Ben Nicholson, 1926–1930*, ed. Anne Goodchild, Sansom and Co., 2013.

84 Letter, ALH to Nancy Morris, October 1926, TGA 8317.1.3.9.

85 Letter, CM to ALH, September 1926, TGA 8317.1.4.43.

86 Kathleen Hale, *A Slender Reputation*, Frederick Warne, 1994.

87 R. H. Wilenski, Arts League of Service, TGA 8317.9.1.

88 *Christian Science Monitor*, 1924, TGA 8317.13.3.

CHAPTER FIVE: Bohemian Life in Fitzrovia

89 Letter, CM to ALH, February 1928, Tate Gallery Archive, TGA 8317.1.4.46.

90 Ibid.

91 *Apollo*, February 1928, TGA 8317.13.3.

92 *Daily Graphic*, November 1928, TGA 8317.13.3.

93 *Evening Standard*, 9 May 1928, TGA 8317. 13.3.

94 T. W. Earp, 'Cedric Morris', 1928, TGA 8317.9.1.

95 Linda Gill (ed.), *Letters of Frances Hodgkins*, Auckland University Press, 1993.

96 Letter, CM to ALH, June 1928, TGA 8317.1.4.48.

97 *Daily Express*, September 1928, TGA 8317.13.2.

98 *Studio*, vol. XCVI, no. 427, October 1928.

99 John Skeaping, *Drawn from Life: An Autobiography*, Collins, 1977.

100 'The Chic Cactus', *Daily Chronicle*, 28 February 1927, TGA 8317.13.3.

101 *Dundee Courier*, 24 April 1928, TGA 8317.13.3.

102 Draft letter, ALH to Nancy Morris, TGA 8317.1 3.26.

103 Michael De-la-Noy, *Eddy: The Life of Edward Sackville-West*, Arcadia, 1999.

104 Esther Grainger, BBC radio interview, undated.

105 John Skeaping, *Drawn from Life*.
106 Ibid.
107 *Daily Mail*, 20 July 1927, TGA 8317.13.2.
108 'Artists' Pets', *Southwark Echo*, 28 February 1928, TGA 8317.13.3.

CHAPTER SIX: A Garden in the Country
109 CM, Gardening Papers, Tate Gallery Archive, TGA 8317.4.1.
110 Ibid.
111 'Birds, Flowers and Landscapes', *Manchester Guardian*, 9 May 1928.
112 CM, notebook, TGA 8317.2.1.
113 Frank Rutter, *Times*, 16 February 1930, TGA 8317.13.
114 *Scotsman*, 31 March 1930, TGA 8317.13.3.
115 *The Times*, 30 March 1930, TGA 8317.13.3.
116 CM notebook, TGA 8317.2.2.
117 Letter, CM to Arthur Tooth Gallery, TGA 8317.1.2.
118 Linda Gill (ed.), *Letters of Frances Hodgkins*, Auckland University Press, 1993
119 Ibid.
120 Penny Johnson, 'Adventures in Art', Towner Gallery,1992.
121 Karen Taylor, Collections Curator, Towner Gallery, conversation with the
 author, October 2018.
122 John Skeaping, *Drawn from Life*, Collins, 1977.
123 Ibid.
124 Christopher Wood, *Dear Winifred: Letters to Winifred and Ben Nicholson,
 1926–1930*, ed. Anne Goodchild, Sansom and Co., 2013.
125 Ibid.
126 British *Vogue*, 17 April 1929.
127 Letter, CM to ALH, 9 December 1931, TGA 8317.4.58.
128 Frank Rutter, *Sunday Times*, 1931, TGA 8317.13.3.
129 Pablo Picasso quoted by Ben Nicholson in Jeffrey Myers, *The Enemy: A
 Biography of Wyndham Lewis*, Routledge and Kegan Paul, 1980.
130 R. H. Wilenski, 'The Modern Movement in Art', *Spectator*, 12 April 1935.
131 John Potvin, *Bachelors of a Different Sort: Queer Aesthetics, Material Culture
 and the Modern Interior in Britain*, Manchester University Press, 2014.
132 Letter, CM to ALH, June 1935, TGA 8317.1.4.87.
133 *Evening Standard*, 17 May 1935.

CHAPTER SEVEN: The Draw of Wales
134 Letter, CM to ALH, 28 February 1935, Tate Gallery Archive, TGA 8317.4.85.
135 Letter, CM to ALH, September 1933, TGA 8317.1.4.72.
136 Letter, CM to ALH, July 1928, TGA 8317.4.52.
137 *Western Mail*, TGA 8317.13.3.

138 Letter, CM to ALH, August 1935, TGA 8317.1.4.94.

139 Letter, CM to ALH, August 1934, TGA 8317.1.4.76.

140 Letter, CM to ALH, June 1935, TGA 8317.1.4.86.

141 Letter, CM to ALH, August 1935, TGA 8317.4.93.

143 Critical and Creative Writing of ALH, TGA 8317.7.1.

144 Letter, CM to ALH, December 1935, TGA 8317.4.106.

145 Letter, CM to ALH, August 1935, TGA 8317.4.97.

146 Letter, CM to ALH, summer 1937, TGA.1.4.107.

CHAPTER EIGHT: Lett Helps with International Relations

147 Letter, Huntly Carter to ALH, January 1933, Tate Gallery Archive, TGA 8317.1.1.467.

148 Letter, Frances Hodgkins to ALH, December 1933, TGA 8317.1.2062.

149 Letter, ALH to Jacob Epstein, TGA 8317.6.1.37-38.

150 Letter, ALH to Duncan Grant, TGA 8317.6.1.36.

151 R. H. Wilenksi, Anglo-German exhibition catalogue, December 1933, TGA 8317. 6.1.11.

152 *Yorkshire Post*, 23 December 1933.

153 ALH, diary, 3 February 1934, TGA 8317.7.2.

154 ALH, diary, September 1934, TGA 8317.7.2.

155 ALH, diary, December 1934, TFA 8317.7.2.

156 Letter, CM to ALH, February 1935, TGA 8317.1.4.85.

157 Prospectus for the East Anglian School of Painting and Drawing, undated, TGA 8317.5.3.

CHAPTER NINE: A Lesson in Art & Fun

158 Joan Warburton, 'A Painter's Progress: Part of a Life 1920-1984', unpublished manuscript.

159 Letter, Eleanor Clark to ALH, May 1937, TGA 8317.1.528.

160 Letter, Eleanor Clark to ALH, 28 August 1937, TGA 8317.1.536.

161 Warburton, 'A Painter's Progress: Part of a Life 1920-1984'.

162 Reynolds and Grace, *Benton End Remembered*, Unicorn Press, 2002.

163 ALH, notebook, TGA 8317.7.1.6.

164 Gwynneth Reynolds and Diana Grace, *Benton End Remembered*.

165 *East Anglian Daily Times*, December 1937.

166 Guggenheim, *Out of this Century: Confessions of an Art Addict*, Anchor Books, 1980.

167 Letter, CM to ALH, 15 February 1939, TGA 8317.1.4.111.

168 Peggy Gugenheim, *Out of this Century*.

169 Ibid.

170 Newspaper reviews, TGA 8317.13.

171 Hale, *A Slender Reputation*, Frederick Warne, 1994.

172 Letter, Aimee Lett-Haines to ALH, undated, TGA 8317.1.1. 2498.
173 Letter, Lillian Mellish Clark to ALH, 26 April 1940, TGA 8317.1.562.
174 Letter, Kathleen Hale to ALH, undated, TGA 8317.1.1.1476.
175 Letter, Kathleen Hale to ALH, 13 October 1939, TGA 83171.1.1477.
176 Hale, *A Slender Reputation*.
177 Letter, Kathleen Hale to ALH, TGA 8317.1.1.1477.
178 Letter, Kathleen Hale to ALH, 17 November, 8317.1.1.1481.
179 Hale, *A Slender Reputation*.
180 Letter, Kathleen Hale to ALH, 2 March 1946, TGA 8317.1530.
181 Hale, *A Slender Reputation*.
182 Ibid.
183 Geordie Greig, *Breakfast with Lucian: A Portrait of the Artist*, Vintage, 2013.
184 Ibid.
185 Warburton, 'A Painter's Progress: Part of a Life 1920–1984'.
186 Letter, Lucian Freud to CM, undated 1939, TGA 8317.1.1142.
187 Letter, CM to ALH, 19 December 1939, TGA 8317.1.4 118.
188 Letter, CM to ALH, 1 December 1939, TGA 8317.1.4.115.
189 Letter, CM to ALH, 1939, TGA 8317.1.2.119.
190 Letter, CM to ALH, 17 November 1939, TGA 8317.1.4.116.
191 Letter, CM to ALH, November 1939, 8317.1.4.117.
192 Letter, CM to ALH, 1 December 1939, TGA 8317.1.4.115.

CHAPTER TEN: Wartime at Benton End
193 Letter, Ernst Freud to ALH, 17 October 1939, TGA 8317.1.1135.
194 Letter, Ernst Freud to ALH, 3 June 1940, TGA 8317.1.1137.
195 Letters from the collection of the late Felicity Helllaby sold at Sotheby's, 2005.
196 Lucian Freud, exhibition catalogue, Cedric Morris, Museum of Wales, 1968.
197 Letter, Ernst Freud to ALH, 18 January 1941, TGA 83171.1.1140.
198 ALH, headed writing paper, TGA 83175.3.5.
199 Letter, Lucie Freud to ALH, undated, TGA 8317.1.1.11521.
200 Letter, Lucian Freud to CM, undated, TGA.8317.1.1145.
201 Letter, Millie Hayes to CM, 3 June 1940, TGA 8317.1.2020.
202 ALH diary, TGA 8317.7.2.
203 Letter, Lucian Freud to Hellaby, sold at Sotheby's, 2005.
204 Letter, Millie Hayes to CM, 2 January 1942, TGA 8317.1.2021.
205 Letter, Capel Silks to CM, 11 December 1940, TGA 8317.1.363a.
206 Cedric Morris, *Studio*, vol. CXXX, no. 590, May 1942.
207 CM, undated notebook, TGA 8317.3.1.8.
208 Ibid.
209 *Wales*, vol. 4, no. 2, October 1943.
210 *Daily Telegraph*, April 1944, TGA 8317.13.2.

211 *Morning Post*, April 1944, TGA 8317.12.2.

212 Art UK biography, Glyn Morgan.

213 David Buckman, Glyn Morgan not dated, www.artuk.org.

214 Gwynneth Reynolds and Diana Grace, *Benton End Remembered*, Unicorn Press, 2002.

CHAPTER ELEVEN: Peace at Last

215 ALH diary, 1945, TGA. 8317.7.2

216 Ibid.

217 Gywyneth Reynolds and Diana Grace, *Benton End Remembered*, Unicorn Press, 2002.

218 Felicity Wakefield, conversation with the author, October 2018.

219 Grace and Reynolds, *Benton End Remembered*.

220 Ibid.

221 Letter, CM to ALH, 16 March 1945, TGA 8317.1.4.120.

222 Letter, Kenneth Tatershall to CM, 29 July 1945, TGA 83171.1.47.

223 Letter, M. Kentish to ALH, TGA 8317.1.12373.

224 Typescript for Welsh Forum Broadcast, BBC Welsh Home Service, 21 February 1947, TGA 8317.3.1.2

225 Ibid.

226 ALH, typed notes, undated, TGA 8317.5.3.

227 Ibid.

228 David Buckman, *Glyn Morgan at Eighty*, Sansom Press, 2006.

229 Marion Milner, *On Not Being Able to Paint*, Heineman Education, 1950.

230 LGBT Foundation, https://lgbt.foundation

231 Reynolds and Grace, *Benton End Remembered*.

232 Letter, Gerry Stewart to ALH, 13 September 1945, TGA 8317.1.1.3580.

233 Letter, Gerry Stewart to ALH, 7 April 1949, TGA 8317.1.1.3609.

234 Letter, Gerry Stewart to ALH, 23 August, 1948. TGA 8317.1.1.3608.

235 Letter, Gerry Stewart to ALH, 8 October 1945, TGA 8317.1.1.3581.

236 Letter, Gerry Stewart to ALH, 13 September 1949, TGA 8317.1.1.3616.

237 Letter, Esme Lett-Haines to ALH, 16 October 1950, TGA 8317.1.1.1377.

238 Letter, Celia Harris to CM, undated, TGA 8317.1.1.1951.

239 Letter, CM to ALH, undated, TGA, 8317.1.4.127.

CHAPTER TWELVE: The Garden

240 *Studio*, vol. CXIII, no. 590, May 1942.

241 Letter, Sacheverell Sitwell to CM, 9 January 1950, TGA 8317.1.1.3465.

242 Sacheverell Sitwell, *Cupid and the Jacaranda*, Macmillan, 1952.

243 Wallace Catalogue, 1947, TGA 8317.4.2.

244 Wallace Catalogue, 1955, TGA 8317.4.2.

245 Gwynneth Reynolds and Diana Grace, *Benton End Remembered*, Unicorn Press, 2002.

246 Ronald Blythe, *The Time by the Sea: Aldeburgh 1955–1958, Faber and Faber, 2013.*

247 CM, Gardening Papers, TGA 8317.4.1.3.

248 Richard Morphet, *Cedric Morris*, Tate Gallery, 1984.

249 Nicholas Alfrey et al., *Art of the Garden*, Tate Gallery, 2004.

250 Ronald Blythe, *Outsiders: A Book of Gardening Friends*, Black Dog Books, 2008.

251 ALH, diary, 1950, TGA 8317.7.2.

252 Tony Venison, 'Bulbs at Benton End', *Hortus*, no. 91, Autumn 2009.

253 Morphet, *Cedric Morris*.

254 Letter, Robin Darwin to CM, January 1951, TGA 8519.2.

255 Letter, Robin Darwin to CM, 20 December 1951 TGA 8519.1.

256 Letter, CM to ALH, 10 January 1951, TGA 83171.4.132.

257 Letter, CM to ALH, 25 January 1951, TGA 83171.4.134.

258 Letter, CM to ALH, November 1951, TGA 8317.1.139.

259 Letter, Nigel Scott to CM, undated, TGA 8317.1.13322.

260 Obituary of Nigel Scott, *East Anglian Daily Times*, 13 February 1957.

261 Ibid.

262 Beth Chatto in Erica Hunningher (ed.), *A Painters Palette: Gardens of Inspiration*, BBC Books, 2001.

263 Beth Chatto, 'A Sage in Suffolk', *Guardian*, 15 September 2001.

264 Letter, Nigel Scott to ALH, undated, TGA 8317.1.3327.

265 Postcard, CM to ALH, 1954, TGA 8317.1.4.146.

266 TGA 8317.1.3327.

267 Reynolds and Grace, *Benton End Remembered*.

268 Chatto, 'A Sage in Suffolk'.

269 Venison, 'Bulbs at Benton End'.

270 Letter, Primrose Codrington to ALH, February 1957, TGA 8317.1.590.

271 *East Anglian Daily Times*, 13 February 1957.

272 Letter, Elizabeth David to ALH, February 1957, TGA 8317.1.942.

273 Joan Warburton, 'A Painter's Progress: Part of a Life 1920–1984', unpublished manuscript.

CHAPTER THIRTEEN: Exceptional Food

274 Letter, Jack Barker to ALH, January 1950, TGA 8317.1.1.36.

275 Gwynneth Reynolds and Diana Grace, *Benton End Remembered*, Unicorn Press, 2002.

276 Ibid.

277 Ibid.

278 Ibid.

279 Ibid.

280 Kathleen Hale, *A Slender Repuation*, Frederick Warne, 1994.

281 Ronald Blythe, *Outsiders: A Book of Gardening Friends*, Black Dog Books, 2008.

282 CM, notebook, undated, TGA 8317.1.43-62.

283 John Potvin, *Bachelors of a Different Sort: Queer Aesthetics, Material Culture and the Modern Interior in Britain*, Manchester University Press, 2014.

284 Letter, Elizabeth David to ALH, 31 January 1954, TGA 8317.1.1.941.

285 Ibid.

286 Letter, Elizabeth David to ALH, undated, TGA 8317.1.1.964.

287 Letter, Elizabeth David to ALH, 10 December (year unidentified), TGA 8317.1.1.936.

288 Letter, Elizabeth David to ALH, 12 December (year unidentified), TGA 8317.1.1.937.

289 Letter, Elizabeth David to ALH, undated, TGA 8317.1.966.

290 Reynolds and Grace, *Benton End Remembered*.

291 Alice Strang, Obituary of Natalie Bevan, *Independent*, 28 August 2007.

292 Maggi Hambling, conversation with the author, December 2018.

293 ALH, diary, 1958.

294 Letter, Michael Hampden Turner to ALH, March 17 (year unidentified), TGA 8317.1.1865.

295 Ibid.

CHAPTER FOURTEEN: Sixties Flower Power

296 Card Vita Sackville-West to CM, TGA 8317.1.1.3298.

297 Tony Venison, 'Bulbs at Benton End', *Hortus*, Autumn 2009.

298 David Buckman, *Glyn Morgan at Eighty*, Sansom Press 2006.

299 *Suffolk Free Press*, 9 July 1958.

300 Gwynneth Reynolds and Diana Grace, *Benton End Remembered*, Unicorn Press, 2002.

301 Ibid.

302 Maggi Hambling, these and the following quotations come from a conversation with the author, December 2018.

303 Kathleen Hale, *A Slender Reputation*, Frederick Warne, 1994.

304 Richard Morphet, *Cedric Morris*, Tate Gallery, 1984.

305 Ibid.

306 Maggi Hambling, conversation with the author, December 2018.

307 Kathleen Hale, *A Slender Reputation*.

308 Maggi Hambling, conversation with the author, December 2018.

309 *East Anglian Daily Times*, November 1966.

310 TGA 8317.2.5.7.

CHAPTER FIFTEEN: Last Days at Benton End

311 ALH, catalogue biography of Cedric Morris, Cedric Morris retrospective, National Museum of Wales, 1968.

312 Letter, CM to ALH, undated, 8317.1.4.171.

313 Tony Venison, 'Bulbs at Benton End', *Hortus*, Autumn 2009.

314 Letter, Mille Hayes to ALH, 11 June 1966, TGA 8317.1.2030.

315 Ronald Blythe, *Outsiders: A Book of Gardening Friends*, Black Dog Books, 2008.

316 Frances Mount, conversation with the author, 2017.

317 Ibid.

318 ALH, diary, 1974.

319 Gwynneth Reynold and Diana Grace, *Benton End Remembered*, Unicorn Press, 2002.

320 Maudie O'Malley, also known as Joan Warburton, *Art and Artists*, May 1984.

321 Joan Warburton, 'A Painter's Progress: Part of a Life 1920–1984', unpublished manuscript.

322 Mary Cookson, conversation with the author, 2016.

323 Lucian Freud, exhibition catalogue introduction, *Cedric Morris*, Blond Fine Art, 1981.

324 ALH, diary, TGA 8317 7.2.45.

325 Warburton, 'A Painter's Progress: Part of a Life 1920–1984'.

326 Ibid.

327 Letter, Peter Wakefield to CM, 26 May 1978, TGA 8317.1.3900.

328 Letter, Richard Morphet to the author, October 2018.

329 Ibid.

330 Ibid.

331 Ibid.

332 Reynolds and Grace, *Benton End Remembered*.

333 Maggi Hambling, conversation with the author, December 2018.

SELECT BIBLIOGRAPHY

Alfrey, Nicholas, Martin Postle, and Stephen Daniels, eds, *Art of the Garden: The Garden in British Art, 1800 to the Present Day*, Tate Publishing, 2004

Berry, Anita, Drawing and Design, Volume IV: 1928

Blondel, Nathalie, *Journals of Mary Butts*, Yale University Press, 2002

Blythe, Ronald, 'Cedric Morris', in *People: Essays and Poems*, ed. Susan Hill, Chatto and Windus, 1983

--, *Outsiders: A Book of Garden Friends*, Black Dog Books, 2008

--, *The Time by the Sea: Aldeburgh 1955-1958*, Faber and Faber, 2013

Bryant, Chris, *The Glamour Boys: The Secret Story of the Rebels who Fought for Britain to Defeat Hitler*, Bloomsbury Publishing, 2020

Buckman, David, *Glyn Morgan at Eighty*, Sansom and Co., 2006

Carr, David, *The Discovery of an Artist*, Quartet, 1987

Chaney, Lisa, *Elizabeth David*, Macmillan, 1998

Chatto, Beth, 'A Painter's Palette', in *Gardens of Inspiration*, ed. Erica Hunningher, BBC Worldwide, 2001

Cooper, Emmanuel, *The Sexual Perspective: Homosexuality in Art in the Last 100 Years in the West*, Routledge and Kegan Paul, 1986

De la Noy, Michael, *Eddy: The Life of Edward Sackville-West*, Arcadia, 1999

Earp, T. W, intro., *Flower and Still-Life Painting*, ed. Geoffrey Holme, The Studio Ltd, 1928

Gathorne-Hardy, Jonathan, *The Public School Phenomenon, 597-1977*, Hodder and Stoughton, 1977

Gill, Linda, *Letters of Frances Hodgkins*, Auckland University Press, 1993

Goldring, Douglas, *The Nineteen Twenties: A General Survey and Some Personal Memories*, Nicholson and Watson, 1945

Goodman, Jean, *Life of Alfred Munnings, 1878-1959*, Erskine Press, 2000

Gordon, Lois, *Nancy Cunard: Heiress, Muse, Political Idealist*, Columbia University Press, 2007

Greig, Geordie, *Breakfast with Lucian: A Portrait of the Artist*, Vintage, 2013

Guggenheim Peggy, *Out of this Century: Confessions of an Art Addict*, Anchor Books, 1980

Hale, Kathleen, *A Slender Reputation*, Frederick Warne, 1994

Hemingway, Ernest, *The Sun Also Rises*, Scribner, 1926

Hepburn, Nathaniel, *A Forgotten Friendship: Cedric Morris and Christopher Wood*, Unicorn Press, 2012

Hyman, James, *Battle for Realism: Figurative Art and its Promotion in Britain during the Cold War, 1945-59*, University of London, 1995

Ingleby, Richard, *Christopher Wood: An English Painter*, Allison and Busby, 1995

Ingram, Collingwood, *A Garden of Memories*, H. F. and G. Witherby, 1970

Jones, Jonah, *An Impertinent Spirit*, television documentary, BBC Wales, 1984

Lewison, Jeremy, *True and Pure Sculpture: Frank Dobson, 1886–1963*, Kettle's Yard, 1981

Lottman, Herbert, *Man Ray's Montparnasse*, Harry N. Abrams, 2001

Lys Turner, Jon, *Visitors' Book: In Francis Bacon's Shadow; The Lives of Richard Chopping and Denis Wirth-Miller*, Constable, 2016

McCormick, E. H., *Portrait of Frances Hodgkins*, Auckland University Press/Oxford University Press, 1981

Mead, A. H., *Miraculous Draft of Fishes: History of St Paul's School, 1509–1990*, James & James, 1990

Milner, Marion, *On Not Being Able to Paint*, Heineman Educational Books, 1950

Moore, Nicholas, *The Tall Bearded Iris*, W.H. & L. Collingridge Ltd., 1956

Morphet, Richard, *Cedric Morris*, Tate Publishing, 1984

Morris, Cedric, 'Concerning Flower Painting', *Studio*, vol. CXXIII, no. 590, May 1942

--, 'Concerning Plicatas', *Yearbook*, British Iris Society, 1943

Myers Jeffrey, *The Enemy: A Biography of Wyndham Lewis*, Routledge and Kegan Paul, 1980

Neve, Christopher, and Tony Venison, 'A Painter and his Garden', *Country Life*, 28 April 1979

Nicholson, Virginia, *Among the Bohemians: Experiments in Living, 1900–1939*, Penguin, 2003

O'Keefe, Paul, *Some Sort of Genius: A Life of Wyndham Lewis*, Jonathan Cape, 2000

Partridge, Frances, *Life Regained: Diaries, January 1970–December 1971*, Weidenfeld and Nicolson, 1998

Potvin, John, *Bachelors of a Different Sort: Queer Aesthetics, Material Culture and the Modern Interior in Britain*, Manchester University Press, 2014

Reynolds, Gwynneth, and Diana Grace, *Benton End Remembered*, Unicorn Press, 2002

Richardson, John, *A Life of Picasso, Volume III: The Triumphant Years, 1917–1932*, Jonathan Cape, 2007

Rowan, Eric, *Art in Wales: An Illustrated History, 1580–1980*, Arts Council of Wales, 1985

Shephard, Sue, *The Surprising Life of Constance Spry*, Macmillan, 2010

Sitwell, Sacheverell, *Cupid and the Jacaranda*, Macmillan, 1952

Skeaping, John, *Drawn from Life: An Autobiography*, Collins, 1977

Spalding, Frances, *British Art since 1900*, Thames and Hudson, 1986

--, *Duncan Grant*, Chatto and Windus, 1997

Sutton, Denys, *Letters of Roger Fry, Volume II*, Chatto and Windus, 1972

Todd, Dorothy, and Raymond Mortimer, *The New Interior Decoration: An Introduction to its Principles, and International Survey of its Methods*, B. T. Batsford, 1929

Tufnell, Ben, with contributions by Nicholas Thornton and Helen Waters, *Cedric Morris and Lett-Haines: Teaching Art and Life*, Norfolk Museums and Archaelogy Service, 2003

Venison, Tony, 'Art and Irises', *Hortus*, no. 78, Summer 2006

--, 'Hidden and Forgotten: Cedric Morris's First Garden', *Hortus*, no. 113, Spring 2015

Warburton, Joan (as Maudie O'Malley), 'A Painter's Progress: Part of a Life, 1920-1984', unpublished manuscript, Tate Gallery archive (968/2/20)

Wertheim, Lucy, *Adventures in Art*, Nicholson and Watson, 1947

Wishart, Michael, *High Diver*, Blond and Briggs, 1977

Wood, Christopher, *Dear Winifred: Letters to Winifred and Ben Nicholson, 1926-1930*, ed. Anne Goodchild, Sansom and Co., 2013

www.suffolkartists.co.uk

INDEX

References in **bold** are to plate numbers

Abbott, Berenice 41
Aberdeen, Archie Gordon, 5th
 Marquess of 46, 119, 179, 188
Aberystwyth 89
abstract art 7 ,39, 43-4, 81, 98, 100, 126,
 147, 186, 190
Acton, Harold 64
Adenauer, Konrad 98
Agar, Eileen 60
Ailwyn, Lady 152
Aldin, Cecil 23
Aldridge, John 73
Algeria 46
Alicante, Spain 153
Allan Walton Textiles 79, 126
Allied Artists Association 30, 31
Amateur Wrestling Association 18
American Review 41, 43
Amroth, Wales 90
Andre, Carl, *Equivalent VIII* 190
Anglo-German Society 97, 99, 100
Anley, Gwendolyn 71, 144, 148, 152
 Irises and their Selection 71
Anrep, Helen 35
anti-semitism 135
Apollinaire, Guillaume 36
Apollo (magazine) 60, 78
Ardingly College, Sussex 133
Armistice Day (1918) 24, 35
Armstrong, John 165
Army Remounts Service, Reading 23
Arnold, Thomas 19
Arp, Jean 54
Art for Children (book) 32
The Artist (magazine) 117
Artists' Benevolent Fund 127

Artists' Rifles 23
Arts Council (earlier CEMA) 134-5
Arts League of Service 31, 22, 43, 74
Artwork magazine 42
Ashton, Frederick 7, 64
Astaire, Fred 67
Attlee, Clement 131
Auckland City Art Gallery, New
 Zealand 180
Audubon, John James 33
Azores 177

Babiński, Henryk ('Ali-Bab') 163
Bacon, Francis 78, 165, 175
Baldwin, Stanley 87
Ballets Russes 35
Balmoral Castle, Aberdeenshire 144
Baltimore, Lord 14
Banting, John 47, 60, 65. 73, 76, 107, 110,
 127
Barcelona 47
Barker, Jack 157
Barnes, Djuna, *Nightwood* 94
Barney, Natalie 39
Barrett, Roderic 134-5
Barry Dock scheme 16
Bawden, Edward 73
BBC
 Education Service 32
 Week in Westminster 188
Beales, Peter 189
Beardsley, Aubrey 24
Beaux Arts Quartet (later Kitchen Sink
 painters) 147
Beddington, Jack 65, 78
Beirut 166, 188

Bell, Clive 55
Bell, Quentin 40
Bell, Vanessa 65, 79
Bellingham-Smith, Elinor 164
Benson, S. H. (advertising firm) 164
Benton End, Hadleigh, Suffolk 8-10, 113,
 116, 119-33, 136-41, 143-155, 157-66.
 169-78, 181-92
 Eats Room 158
 House and Garden Trust 9
 purchase of 118
Berlin, Zoo 46
Berry, Anita 31-2, 44
Betws-y-coed, Conwy 115
Bevan, Bobby 131, 164
Bevan, Natalie 164-5, 188
Bevan, Robert Polhill 53, 164
Bhanu Yugala, Prince of Thailand 185
Birch, James 165
Birch, Lionel 27
Birch, Samuel 'Lamorna' 27
Birmingham School of Art 134
Blatty, William Peter, *The Exorcist* 166
Blaue Reiter movement 97
Blond, Jonathan 189
Bloomsbury Group 65, 79, 81, 124
Blunt, Wilfrid 171, 180
Blythe, Ronald 8, 139, 144, 146, 148, 159,
 160, 173, 183
Bob (manservant) 107
Bonney, Fiona 192
Bordeaux 49
Boulestin, Marcel 72-3, 163
 Herbs and Salads 72
Bournemouth 114
Bousefield, Daphne 106-7
Bowness, Alan 190-1
Boxford, Suffolk 164, 189
Boxted, Essex 164
Bragaglia, Anton 38
Brangwyn, Frank 89

Braque, Georges 42
Bratby, John 147
Brenan, Gerald 185
Breton, André, Surrealist Manifesto 54
Brinkworth, Ian 103-4, 106-7
Bristol Channel 13
British Iris Society 128, 145, 192
 Dykes Medal 146
 Edward Williamson Challenge Plate
 145
 Exhibition, Horticultural Halls,
 Westminster (1949) 145
 Foster Memorial Plaque 145
 Yearbook 128
Brittany 22, 55, 56,116
Britten, Benjamin 9, 164
Broadley, Denise 105, 109, 133
Brooks, Bryan 162
Brooks, Romaine 39
Brown, Bernard 125, 131, 158
Brussels, British Embassy 191
Bryanston School, Dorset 114
Buhler, Madame 66
Burra, Edward 36, 81, 100
Burton, Col. 131
Butts, Mary 40, 41, 49, 56, 77, 110, 172
 The Crystal Cabinet 77
 Traps for Unbelievers 172
 Warning to Hikers 172
Butts, Tony 107
Byng, Lady 147
Byng Lucas, Caroline 89-90, 102
Byng Stamper, Frances 89-90, 102

Cambridge 102
 Botanic Gardens 155
 Kettle's Yard 28
 University of 18
Camden Town Group 76, 164-5
Canada 21, 23
Canary Islands 149, 152-3

Capel (textile company) 126
Cardiff 89, 128
 National Museum of Wales 136, 180,
 181, 189
 Splott district 128
 University College Cardiff 128
Carpenter, Ellis 125-6, **21**
Carr, Barbara 173, 191
Carr, David 106, 108, 116, 119, 120, 124,
 191, **16**
 'Man and Machine' series 173
Carson, Rachel, *Silent Spring* 172
Carter, Huntley 98
Catlin, George 107
Cepea Fabrics 126
Céret (Pyrenees) 46-7
Cézanne, Paul 22, 30-1, 39, 55, 58
Chappell, Billy 64
Charterhouse School, Surrey 19-20
Chase, Michael 179-80, 188, 191
Chatto, Andrew 151, 154, 173
Chatto, Beth 7, 9, 145-6, 151, 154, 161, 165,
 170-1, 177, 189
Chirk Castle, Wales 90
Chittenden, Fred 170
Cholerton, Alfred 46
Chopping, Dicky 123-4, 126, 175, 186
Christian Science Monitor 43, 58
Christianity 88
Churchill, Randolph 165
Churchill, Winston 60-1, 66, 165
Clare, John 148
Clasemont, Morriston 14-5
Clifton College, Bristol 133
Clough, Prunella 185
Cobbold family 137
Cocteau, Jean 40, 42, 56, 59, 77
Codrington, Primrose (later Roper) 149,
 154-5
Coghill, Anne 138, 185
Colchester, Essex 105-6, 123, 143, 174

Castle 135
Colchester Art Society 180
Mercury Theatre 186
Minories Gallery 147, 179-80, 187
 'The Flower in Art' (exhibition) 179
School of Art 134
Coldstream, William 66
Collins, Henry 135
Collins, Matt 9
Communism 47, 88, 99
Conran, Loraine 85, 91-2, 100, 110
Constable, Ernest 133
Constable, John 8, 63
Contemporary Art Society of Wales 90
Cooke, Sarah 10
Cookson, Mary 185
Cornwall 23, 27, 29-31, 33, 51, 54-6, 62,
 141, 182
Cory, John and Richard 16
Cory, Reginald 16
Cory, Thomas 15
Costa Verde, Spain 154
Council for the Encouragement of
 Music and the Arts (CEMA), later
 Arts Council 128-9, 134
Country Life 62, 98, 144
Courtauld, Samuel 52, 79
Cresta Silks 79
Crickhowell, Wales 90
Crossley, Lionel 105
Crowley, Aleister 66
Cubism 7, 29, 37, 44, 46, 58, 173
Cunard, Nancy 35, 103
Cunard Line 79
Cyprus 149, 182

D'Abernon, Edgar Vincent, 1st Viscount
 97
Daily Chronicle 64
Daily Express 62
Daily Herald 117

Daily Mail 67
Daily Sketch 110
Daily Telegraph 129
Daily Worker 133, 158
Daniells, Tony 140, 166
Dartington Hall School, Devon 114
Darwin, Robin 150
Davey, Robert 126, 136, 157
David, Anthony 163
David, Elizabeth (née Gwynne), 9, 68,
 73, 126, 155, 160, 161, 163, 175, 179,
 183, 191
 A Book of Mediterranean Food 163, 164
 English Bread and Yeast Cookery 164
 French Country Cooking 163
 An Omelette and a Glass of Wine 164
Davies, Marion 119, 121
Davies, Tom 119
De Chirico, Giorgio 39, 179, 191
Dead Sea Scrolls 166
Dedham, Essex 8, 76, 101, 104–5, 116, 137,
 162, 166, 196
 Marlborough Head pub 105, 109 116
 Old Grammar School 109
 Spearlings (grocer), 162
 Sun Inn 119
Degas, Edgar 27
Deia, Majorca 47
Delécluse, M. 37
Dennis, Cecilia 114
Derain, André 80
Desenfans, Margaret (née Morris) 14
Desenfans, Noel 14
Diaghilev, Serge 35
Dismorr, Jessica 81
Djerba 48
Dobson, Cordelia (née Tregurtha) 24, 1
Dobson, Frank 24, 27, 29, 35, 79, 100,
 150, 1
 Cedric (sculpture) 29
Doone, Rupert 35, 110

Dordogne 46
Dowlais, Wales 115-6, 128
 Gwernllwyn House 115, 119, 128
 Trewern House 126–7, 128-130
Doyle Jones, Douglas 63
Doyle Jones, Vivien 80
Drawing and Design magazine 30
Dreier, Katherine 42
Duchamp, Marcel 42
Dulwich Picture Gallery 14
Dundee Courier 64
Dyffryn Estate, Vale of Glamorgan
 16-17

Ede, Helen 28
Ede, Jim 28, 77
Earp, T. W. 30, 32, 61,110
East Anglian Daily Times 155, 180, 182
East Anglian Iris Society 155
East Anglian School of Painting and
 Drawing 8, 10, 104, 105-109, 114, 119-
 125, 130 135-37, 167, 179, 181, 192
 after Morris's death 192
 fire at Dedham 8, 116, 117, 124, 185
 first students 105
 founded 104
 and Ixion Society 167
 Lett's post-war prospectus 136
 Lucian Freud at 8, 114, 120-24
 proposal to offer classes to craftsmen
 and cooks 124
East Bergholt, Suffolk 165
Eastbourne, Sussex 71, 85, 102, 117, 165
 Redoubt Rest Home 166
 St Cyprian's School, Eastbourne 19
 Tas Cottage, Eastbourne 140
Eastern Daily Press 186
Ebbw Vale 87
Edward VIII, King 7, 87
Elizabeth, Queen (later Queen Mother)
 144-5

Epstein, Jacob 25, 53, 99
Eriksson, Ashe 174
Escoffier, Georges Auguste, *Le Guide Culinaire* 163
Etchells, Frederick 31
Eton College, Berkshire 18-19
Evening Standard 61, 83
Evora, Portugal 144

Fascism 39
Fergusson, J. D. 25, 98, 100
First World War 9, 21, 23, 25, 53, 79
Fisons 173
Fitzgerald, F. Scott 40
Flatford Mill, Suffolk 75
Fleming, Ian, James Bond books 125
Flight, Claude 81
Forbes, Stanhope 27
Ford, Ford Madox 37
Fox Studios 64
France 20-1, 33, 40, 44-8, 53, 59, 87, 105, 130, 152
Freud, Anna 138
Freud, Ernst 120-21
Freud, Lucian, 7-8, 40, 114-6, 120-4, 126, 134, 135, 150, 185, 186, **16, 20**
 Denise and her Suitors 134
 Girl on a Quay 124
Freud, Lucie 121
Freud, Sigmund 114
Friedlander, Eileen 76
Fry, Roger 21, 22, 35, 52, 79, 80
Funchal 181
Furst, Hubert 78
Futurism 20-21 25, 28, 32, 38, 44, 58

Gabès 48
Gainsborough, Sir Thomas 8, 10, 15
Galsworthy, John 25
Gandarillas, Tony 52, 56
Gardeners' Benevolent Society 155

Garden Museum, The 9
Gardening Illustrated 144
Garland, Madge 64, 150, 152
Garnett, David 65
Gascoyne, David 60, 103, 173
Gathorne-Hardy, Robert 165
Gaudier-Brzeska, Henri 43, 53, 54, 59-60, 73, 159
Gauguin, Paul 22, 39, 47, 58
Gaunt, William 187
German Expressionism 129
Germany 23, 97-100, 116
 Nazi party 65, 97
Gertler, Mark 98, 114, 164
Giardelli, Arthur 129, 130, 136
Gibraltar, 45
Gibson, Robert 188
Gielgud, John 7, 60, 64, 103
Gilbert, Philéas 163
Gilligan, Barbara 120
Gilman, Harold 165
Ginner, Charles 76, 98
Giorgione, *Sleeping Venus* 47
Girling, Arthur 122
Gironde 50
Glamorgan 90, 93
Gluck (Hannah Gluckstein) 30
Glyn Vivian, Richard 21-22
Good Housekeeping 43, 163
Goossens, Judy 114
Gordon, Archie (later 5th Marquess of Aberdeen) 46, 117, 177, 186
Gore, Frederick 66, 165
Gore, Spencer 165
Gorer, Mrs 110
Gower Peninsula 13-19
Grainger, Esther 65, 130, 137
Gran Canaria 109, 153
Grant, Duncan 18, 53, 65, 73, 79-81, 98, 99
Gravetye Manor, West Sussex 68
Great Bardfield, Essex 73

Greaves, Derrick 147
Greene, Graham 67
Greig, Geordie 114
Grenfell, David 88
Grey-Wilson, Christopher 171
Gribble, Vivien 63
Gris, Juan 37
Guggenheim, Peggy 7, 35, 40, 94, 109-10
 Out of This Century 109
Guide Michelin 163
Guinness, Méraud 77
Guinness family 77
Gwernllwyn House, Dowlais, Wales
 115, 119, 128
Gwynne, Elizabeth see David,
 Elizabeth
Gwynne, Priscilla and Felicity 92
Gwynne, Rupert 68
Gwynne, Stella 68, 75, 92, 100, 107, 119,
 163, 166

Hadleigh, Suffolk 8, 73, 107, 117, 124-6,
 139, 149, 158, 174
 bombing of 122
 church 188, 192
 Food Control Committee 121
 King's Head pub 123
 Labour Party 105, 124
 Marquess of Cornwallis pub 107, 131
 Shoulder of Mutton pub 137
The Hague 46, 61
Haig, Major Andy 149
Haig, Douglas Haig, Field Marshal Earl
 149
Haines, Sidney 17, 18
Hailsham, Sussex 24
Hale, Kathleen 40-1, 50, 57, 91, 105-6, 111-
 113, 119, 124, 132, 159, 174, 177, 178, 11
 The Garden at Benton End 22
 Orlando books
 Orlando's Home Life 113

A Slender Reputation 58, 112
Halifax Art Gallery 61
Hall, Radclyffe,
 The Well of Loneliness 63
Hambling, Maggi 7-8, 47, 55, 78, 150, 157,
 165, 174-6, 178-9, 188-192
 Cedric, 8 February 1982 191
Hamburg 98
Hamnett, Nina 35, 66
Hampden Turner, Charles 101-2, 111,, 112
Hampden Turner, (Charles) Michael
 101, 166-7
Hampden Turner, Eleanor 91, 101-103,
 107-8, 111
Hampden Turner, Peter 103
Hampden Turner, Shelley 167
Harding, Gerald 166
Harrow School 16, 17
Hartsburg, Hiler 37
Harvard Business School,
 Massachusetts 167
Harvey, Gertrude 1
Harwood, Lucy 119, 120, 124, 126, 134-5,
 148, 173, 175, 186
 Merlins aux Citrons 186
Hayes, Millie 120, 122, 124, 125, 123, 179,
 187, 192
Hazell, Reg 134
Heal, Ambrose 160
Hellaby, Felicity 114
Hellaby, Lucy 124
Hellaby, Mrs 105
Hemingway, Ernest 7, 40
 The Sun Also Rises 42
Henley-on-Thames, Oxfordshire 141, 183
Hepworth, Barbara 75, 81, 100
Herbert, A. P. 165
Herman, Josef 135
Heron, Patrick 147
Heron, Tom 79
Hicks, David 125

Hidcote Manor Garden, Gloucestershire 68, 154
Hitchens, Ivon 81 180
Hitler, Adolf 99, 100
Hockney, David 190
Hodgkins, Frances 24, 27-8, 30, 55-7, 61, 74-5, 78, 81, 92, 99, 116, 177
 Man with a Macaw 75
 Morris's portrait of 24
Hofer, Karl 80
Hogarth, William 15
Holmes, Dicky 1
The Homosexual (film) 139
homosexuality, attitudes to 31, 60, 63, 101, 138-9, 184
Hoog, Michael 171
Horizon magazine 123
Horsfall, Mary 115, 128
Howard de Walden, Thomas Scott-Ellis, 8th Baron 90
Hughes-Stanton, Blair 135, 152
Hunter, Kathleen 161
Hynes, Gladys 1
Hynes, Sheelah 1

Imperial Arts League 89
Impressionism 27
India 111
Industrial Revolution 87
Information, Ministry of 29
Ingram, Collingwood 44
 A Garden of Memories 44
Institute of Landscape Architecture 16
International Surrealist Exhibition (London, 1936) 60
Ipswich, Suffolk 155, 166, 180
 Art School 185
 docks 115, 139
 Hospital 186, 191-2
irises 9, 10, 68, 71-2, 80, 106, 109, 126, 128, 132, 143-9, 151, 155, 169, 173, 189, 192

'Benton Baggage' 145
'Benton Benedict' 145
'Benton Cerdana' 145
'Benton Cordelia' 146
'Benton Crathie' 144
'Benton Edward Windsor' 144, 145, 146
'Benton Mocha' 145
'Benton Nigel' 151, 169
'Benton Orlando' 145
'Benton Persephone' 145
'Benton Petunia' 145
'Benton Strathmore' 145
Italy 38, 46
Ixion Society 167, 174

Jameson, John 124, 139, 157
Jardin Serre de la Madone, Val de Gorbio, France 154
Jesus Christ 47, 88, 185
Jewels, Mary 28
Jews 65, 99-100, 126-8
John, Augustus 7, 25, 28, 64, 66, 68, 89-91, 98, 100, 164
John (gardener) 5
John, Gwen 42, 89
Johnston, Lawrence 66, 152
Jones, David 127

Kandinsky, Wassily 97
Kauffer, Edward McKnight 31
Keay, Margery and David 134
Kelly, Peter 180
Kentish, David 115, 120
Keynes, John Maynard 52, 79
Knight, Laura and Harold 27
Koppel, Heinz 128, 130
Krafft-Ebing, Richard von, *Psychopathia Sexualis* 101

Labour movement 88, 90
Labour Party 88, 107, 125, 131

Lambert, Constant 64
Lamorna Cove, Cornwall 29
Lanyon, Peter 147
Larousse Gastronomique 163
Laugharne, Wales 90
Lawrence, Bettina Shaw 106, 116, 120
Lawrence, D. H. 25, 63, 66
 Lady Chatterley's Lover 63
Lawrence, T. E. 89
League of Nations 31
Leamington Spa Gallery 61
Leeds Mercury 52
Léger, Fernand 37
Lehmann, John 163
Lehmann, Rosamond 64, 110, 188
Leng, Basil 154, 189
Lett, Charles 17
Lett-Haines, Aimee (née Lincoln) 24, 26,
 27, 31-2, 101 111, 140, 179
Lett-Haines, Arthur (Lett) **1, 19, 26**
 WORKS
 portrait of Nina Hamnett 66
 Amusement 38
 Aspects of Cedric Morris 180
 Aspirant 1971 Wood and Bone 187
 The Bad Queen's Magic Mirror 103
 Betrayal 103
 Birdlore 99
 Blue Trousers 73
 Boy Mounting Lion 39
 Brighton Railway Station 32, **2**
 Conjecture 180
 Cows 98
 Dancing Sailors 99
 Dark Horse 191
 Deities of the Lake 48
 Drama of Masks 103
 The Escape 80
 The False Banana 103
 Fantasy Landscape **6**
 The Garden (sculpture) 178

'The Harem' (essay) 48
Le Henry Moore 187
Improvisation No. 22 180
Incantation 182
Mud Pie 48
Nocturnal Composition 180
Objets Trouvés and Reforme 187
Pastoral 98
'Pioneers' (essay) 44
Piscatorial 80
Poems of Orissons of Sunnars 24
'Pontypridd: Public Appreciation of
 Art, Ditto of Artist' (lecture) 90
The Power of Atrophe 38, 191
Rites of Passage, Panganay 77
Tree of Knowledge 98
Vereda Tropicale **26**
Lett-Haines, Esme 17-18, 20, 48, 59, 71,
 85, 101, 102, 111, 117, 119, 165-66
Lett-Haines, Oenid 13, 17, 138
Lewis, Griselda 153
Lewis, Morland 129
Lewis, Wyndham 21, 25, 28-29, 53, 81,
 89, 191
Libya 180
Little Horkesley, Essex 105, 182
The Little Review 48
Liverpool, Adelphi Hotel 149
Llangennith 86
Llangyfelach copper works 14
Lloyd, Michael 153
London 8
 Anthony d'Offay Gallery 186
 Arthur Tooth Gallery 30, 32, 47, 61,
 72, 74, 82
 Beaux Arts Gallery 54
 Blond Fine Art, 'English Artists,
 1900-1979' (exhibition) 189
 Boulestin restaurant 72-3
 Brown's Hotel 166
 Burlington Gallery 78

Café Royal 66-7, 103
Camberwell School of Arts and
 Crafts 130, 176
Carlton Gardens 98
Carlton Terrace 100
Carlyle Square 24, 26, 28
Central School of Art 76
Charlotte Street 63, 64, 66, 102
Chelsea 24, 26, 176, 180
Chelsea Arts Club 25, 63
Claridge Gallery 52, 55, 59, 60
Cork Street 109
Courtauld Institute of Art 79
De Vere Hotel 167
Dean Street 67
Eiffel Tower (later White Tower)
 restaurant 66
Eldon Road 27
Fine Art Society 119
Fitzrovia 57, 66, 67
Fitzroy Street Studio 117
Fitzroy Tavern 66
Flood Street 25
Foreign Office 52, 99, 153
Fortnum & Mason 98
Gargoyle Club 67
Gloucester Road 73
Gower Street 43
Grafton Gallery 30
post-Impressionist exhibition (1910)
 22
Great Ormond Street 57, 63, 64, 73
Guggenheim Jeune Gallery 109
Heal's 73
Kew 17
Kew Gardens 1672, 178
Knightsbridge 176
Leicester Galleries 29, 74, 129-30, 147
 174
L'Escargot 163
L'Étoile 66, 103

Mansard Gallery 73
Margaret Morris Club and Theatre
 25, 31
Mayor Gallery 79
Mortimer Road, Kilburn 17
National Gallery 191-2
National Portrait Gallery 188
New Bond Street 52
New Grafton Gallery 187
Park Hill, Hampstead 109
Percy Street 66
Picture Hire Gallery 82, 103
Redfern Gallery 54, 78
Regent Street 66
Royal Academy of Art 29, 31
Royal Albert Hall 21
Royal College of Art 137, 150, 164
Royal College of Music 21, 26
Royal Military Academy, Woolwich
 21
Sackville Gallery 20
St Paul's School, Hammersmith 18
Slade School of Fine Art 29, 66, 104,
 176
Tate Gallery 7, 33, 53, 77, 98, 148, 190,
 191
Upper Grosvenor Galleries 177, 182
Walterton Road, Maida Vale 17
Wertheim Gallery 78
Westminster School 18, 19
Westminster School of Art 104
Wheatsheaf pub 66
Zoo 45
Zwemmer Gallery 179
London Artists' Association 52, 79, 81
London Group 53, 54, 55
Long Grove hospital, Epsom, Surrey 47
Long Melford, Suffolk 182
 Westgate House 186
Lucian, SS 149
Lys Turner, Jon, The Visitors' Book 123

MacCarthy, Desmond 22
McCormick, Frances 55
MacDonald, James Ramsay 87
McGill, Donald 158
Mackintosh, Charles Rennie 25
Maclean, Douglas 57, 113
Maclean, Mollie 113
Macnamara, Jack 52, 99
Madeira 181
Majorca 47
Man Ray 41, 42
Manchester 73, 126
Manchester City Art Gallery 85
Manchester Guardian 72
Manningtree, Essex 137
Manorbier Castle, Wales 90, 91-2, 94,
 102
Marais, Wessel 178, 183
Margaret Morris Summer School,
 Normandy 46
Margaret, Princess 163
Marinetti, Filippo 38
 Futurist Manifesto 20
Marrable, Rose 132
Marsh, Eddie , 60, 75, 147
Martin, Roy 49, 50, 57
Matisse, Henri 22, 24, 40, 46, 67
 Red Studio 67
Mawson, Thomas 16
Mayor, Freddie 79
Mellish Clark, Lilian 111
Merthyr Tydfil 89, 115, 127
Merthyr Valley, South Wales 87
Mesopotamia 21
Messel, Oliver 64
Methodism 88
Meyer, Richard 43
Michelangelo 185
Middleditch, Edward 147
Milner, Marion (Moll) 137-8
 On Not Being Able to Paint 138

Minories, Colchester 147, 179-80, 187
Minton, John 164
Miró, Joan 54, 179
Mitchell, Mrs (landlady) 122
Mitford family 67
Moon, Alan Tennant 135
Moore, Henry 37, 60, 81, 131
Moore, Nicholas
 The Tall Bearded Iris 144
Morgan, Glyn 130, 137, 139, 172, 185,
 188, 192
Morley, John 170, 189
Morning Post 52, 130
Morocco 48, 51, 147, 171
Morphet, Richard 7, 33, 53, 148, 190-1
Morrell, Lady Ottoline 94
Morris, Cedric 1, 5, 7, 10, 15, 18, 19, 27
 WORKS
 Alex Schlepper 30
 Arab Woman 46
 Arthur Lett-Haines 51
 At the Zoo 43
 August 73
 Barges on a Canal near Bruges 48
 Belle of Bloomsbury 141
 Benton Blue Tit 170
 The Bird (Crème de Menthe) 47
 Birds of the Barbary Coast 33, 61
 The Black Studio 72
 The Black Tulips 74
 The Blue Poppy 80
 Le Bon Bock 36, 3
 Breton Landscape 55
 The Brothel 36
 Caeharris Post Office 115
 Café La Rotonde 36
 Café Scene in Paris 54
 Celtic Twilight 53
 Church Knowle Dorset 61
 Composition 5
 'Concerning Plicatas' (article) 128

Cormorants 52
Corner in Tréboul 55
Cosmos 170
Country Life 98
Dancing Sailor 50
Djerba Flowers 61
*Dowlais from the Cinder Tips,
 Caeharris* 115, **13**
Dragonmouth 80
Ducks 61
Ducks in Flight 43
The Eggs 127, 164, 191, **23**
End of August 80
English Spring Flowers 61
*The Entry of Moral Turpitude into
 New York Harbour* 53
Experiment in Textures 39, 191
Floral Abstractions 52
Floreat 80, 148
Flower Piece 98, 100
Flower Piece with Red Lilies 170
Flowers in a Brown Jug 171
Go She Must 109
Gold Finches 72
Golden Auntie 39
Golden Plovers 72
The Green Beetle 72
Green Plovers 52
Greenland Falcons 32
Greenshanks 72
Halcyon 47
Heritage of the Desert 48
Heron **17**
House on a Welsh Hillside 91
Ibis among Cacti 82
Iris Seedlings 127
Irises 127
Irises and Tulips 147
The Italian Hill Town 38, **4**
The Jardin d'Essaie 46
The Jay 33

July 73
Landscape of Birds 172
Landscape near Tréboul 61
Landscape at Newlyn 30
Landscape at Penalver 30
Landscape of Shame 172-3, 190, 191,
 28
Langham Mill 73
Lilies 170
Llangennith Church 78
Lord Hereford's Knob 129
'The Love Story' (story) 128
Lucian Freud 135, 191, **20**
Minton Pot 171
Mohammadan Cemetery 61
Monchique Foothills of the Algarve
 149
Mottled Irises 61
Newlyn 54
*Nursemaids in the Borghese
 Garden* 42
The Orange Chair 127
The Orchard 82
'Passage On' (poem) 128
Paul Odo Cross 49, **12**
Paysage du Jardin 180
Paysage du Jardin in 2 80
Peregrine Falcon 72
Pheasants 73
Plovers 54
Polstead, Suffolk **14**
Poppies 52, 61, **8**
portrait of Mary Butts 110
portrait of Mrs Gorer 110
portrait of Rupert Doone 35, 110
portrait of Barbara Gilligan and
 David Carr 120
portrait of Arthur Lett-Haines, 30
Portrait of a Political Extremist 46
Prelude to Spring 98
Proud Lilies 80

Pumpkin and Pots 173
Ratatouille 162
Rhodesian Summer 177
Seagulls at Douarnenez 55
Senegalese Boy 46
Senegalese Soldier 61
September 73
Several Inventions 180
Shags 172
Shells 82
Shipping 54
The Sisters (later The Upper
 Classes, Two Sisters) 92, 189
Spanish Landscape 52
Still Life Fruit before a Sussex
 Fireback 173, 182
Still Life of Garden Produce against
 an Old Chimney 162
Still Life Garden Produce in Old
 Kitchen 173, 182
Still Life Garden Produce in
 Spanish Basket 173
Storm Prelude 74
Succulents in African Pot 127
Succulents on an African Stool 127
Summer Veld 177
Vallée de l'Ouvèze 50
View from a Bedroom Window, 45
 Brook St 53
Wartime Garden 120
Wood Pigeons 72
Yalta 131, 24
Morris, Francis, The Morris Book of
 British Birds 158
Morris, George Lockwood (later Sir
 George) 13, 15, 141
Morris, Henry 15
Morris, John 14-15
Morris, Margaret (dancer) 25, 46
Morris, Margaret (née Jenkins) 14
Morris, Muriel 14

Morris, Nancy 13-14, 30, 51, 57, 64-5,
 74-5, 141, 183, 7
Morris, Robert (Cedric's uncle) 15
Morris, Robert, junior 14
Morris, Robert, senior 14
Morris, Robert Armin 15, 57
Morris, Wilhelmina (Willie, née Cory)
 15-17, 64, 141
Morriston, Swansea 14-5
Mortimer, Raymond 78, 110
Moss, Arthur 41
Mould, Philip 61
Mount, Frances 183-4
Moynihan, Rodrigo 66, 164
Mullan, Conor 54
Munich 97
Munnings, Alfred 23, 27, 29, 76, 116
Münter, Gabriele 97
Murphy, Lady 177
Mussolini, Benito 39
Myers, Leo 31

La Nación 44
Nan Kivell, Rex 78
Napoleon I, Emperor 15
Nash, Christine 144
Nash, John 31, 60, 134, 135, 143, 148, 151,
 155
Nash, Paul 18, 31, 55, 60, 79, 98, 100, 101
Nation newspaper 47
National Art Collections Fund 133
National Gardens Scheme 152
National Trust 16, 148
Nazism 97
Nevinson, Christopher 73, 98
New English Art Club 55
New Ipswich Art Group 180
New York 7, 21, 42, 157
 Little Review Gallery 53
 National Art Club, Brooklyn 46
 Wanamaker Department Store 39

New York Herald 43
New Yorker 54
New Zealand 182
Newbolt, Sir Henry, 'Vitai Lampada' 19
Newbury race course 15
Newlyn, Cornwall 22, 28-32, 48-50,
 54-55, 141
 The Bowgies 28, 30, 33
 fancy dress party **1**
Newlyn School of Painting 27
Newman, Algernon 107
Nicholson, Ben 54, 56, 76-78, 81, 100
 1924 (first abstract painting, Chelsea)
 39
Nicholson, Winifred 54, 56, 77, 178
Nicolson, Harold 53, 98, 146
Normandy 46
North Africa 45, 46, 51, 61, 99, 116, 147
Notcutts Nursery 147

Oates, Mrs 51
Odo Cross, Florence 49
Odo Cross, Paul 49-50, 68, 117-19, 127, **12**
Ogden, Laurie 127
Ogilvie, Patrick 122
Olympic Games (London, 1908) 18
O'Malley, Peter 135, 176
Omega Workshop 79
Ontario, Canada 21
Orde, Cuthbert 22, 92, 116
Orde, Eileen 92
Orpington's Nursery 145
Our Time (magazine) 127
Oxford, University of 18
 Exeter College 106
Ozenfant, Amédée 37

Palestine 138-40
Pangbourne, Berkshire, Copper Inn 179
Paris 7, 35-44, 45-6, 49-50, 54, 56, 60-2,
 94, 97

Académie Colarossi 27-8, 37, 47
Académie Delécluse 22, 37, 55
Académie de la Grande Chaumière 65
Académie Julian 36
Académie Moderne 37
Avenue Montaigne 42
Boule de Cidre 41
Boulevard Saint-Michel 41
École des Beaux-Arts 22
Lapin Agile 41
Lapin Gilles 41
Monocle club 36
Montmartre 36
Montparnasse 22, 36, 37
La Petite Chaumière 36
La Rotonde 36
Rue Jacob 40
Rue Liancourt 36
Rue Lepic 36
Paris Times 41
Partridge, Frances 125
Pears, Peter 9, 164
Pemberton, Mrs 149-50
Penclawydd, Wales 91, 93
Penderi 14
Philip (servant) 108
Piaget, Jean 138
Picasso, Pablo 24, 42, 46, 78, 81, 179
Picton Warlow, Tod 90
Picton-Turbervill, Edith 90, 92
Picture Hire Ltd 82
Pissarro, Lucien 53
Pittsburgh, Carnegie International
 Exhibition 80
Pointillism 171
Poland 135
Ponterwydd 92
Pontypridd 129-30
Portmeirion 92
Portugal 144, 147, 153-54, 170, 187, 189
Poslingford Hall, Suffolk 20

post-Impressionism 7, 22, 25, 27, 29
Pound, Ezra 25, 37
The Pound, Higham, Suffolk 62, 69, 72-3, 75-7, 85, 94-5, 101, 102, 104, 105-6, 109, 113, 116, 119, 121, 141, 148, 160, 171-2, **7**, **9**, **15**
Pratt, Mr (bus driver) 155
Procter, Dod 27
Procter, Ernest 27
Pyrenees 46-7, 58

Quakers 128
Queen Mary, QMS 79
Quennell, Peter 65

Ravilious, Eric 73
Rawnsley, Derek 82
Raydon, Suffolk 158
Raymond, Ernest, *Tell England* 18
Red Cross 183
Reid, Norman 190
Reynolds, Bernard 132, 146, 185
Reynolds, Gwyneth 108, 162
Reynolds, Sir Joshua 14
Richards, Ceri 136
Rimbaud, Arthur 41
Rivera, Primo de 47
Roberts, William 55
Robertson, Bryan 116
Robinson, Jenny 155, 189, 192
Robinson, William, *The English Flower Garden* 68
Rome 7, 38-39
 Casa d'Arte Bragaglia 38
Romney, George 15
Roper, Lanning 149, 155
Rosslyn, Lord 23
Royal Field Artillery 21
Royal Horticultural Society 16
 Award of Garden Merit 171, 177
 Dictionary of Gardening 170

Rugby School, Warwickshire 18, 19
Rushbury, Henry 107
Russell, Bertrand 98
Russell-Smith, Mollie 126
Rutherford, Canon 192
Rutter, Frank 30, 81

Sackville-West, Eddy 65
Sackville-West, Vita 9, 53, 65, 146, 162, 169
Sainsbury, Geoffrey 135
St Albans, Duchess of 184
St Austell, Cornwall 182
St Helena (island) 177
St Ives, Cornwall 24, 28, 56, 147
St Just, Cornwall 51
St. Vincent (island) 46
Sandhurst Military Academy, Berkshire 20, 21
Santa Barbara, California 140, 179
Sassoon, Sir Philip 82
School of Metaphysical Art 39
The Scotsman 74
Scott, Nigel 151-5, 178
Scottish Colourists 25
Second World War 45, 98, 115, 131, 164, 166
Seegers, Dennis 184
Senegal 46
Seven and Five Society (later Seven and Five Abstract Group) 55, 56-7, 60, 73, 81
Severn, River 13
Shakespeare, William 144, 184
Shell Oil 65, 78
 'Artists Prefer Shell' campaign 78
 'Gardeners Prefer Shell' campaign 78
Shotley Peninsula, Suffolk 115
Shrewsbury, George Hotel 91
Sickert, Walter 53, 75, 78, 129, 165
Silvertoe, Mr (architect) 110

Sissinghurst Castle Garden, Kent 10, 146
Sitwell, Edith 28
Sitwell, Osbert 28
Sitwell, Sacheverell 28, 67, 144, 152
 Cupid and the Jacaranda 144
Skeaping, John 60, 63, 66-7, 75-6, 79, 137
 Drawn from Life 61
Skeaping, Paul 75
Sketty, Gower Peninsula 15, 88
 Sketty Hall 22
 Sketty Lodge (earlier Machin Lodge)
 13
 Sketty Park House (reconstruction of
 Clasemont) 15
Smart, Elizabeth 173
Smee, Mr (bus driver) 155
Smith, Jack 147
Smith, Matthew 73, 78, 100
Smith, Mina 186
socialism 23, 87, 88, 131
Société Anonyme 42-3
Solva, Pembrokeshire 86
South Downs 19
South Wales 13-16, 87-88, 91, 129, 135
South Wales Art Group (later Welsh
 Group) 136
South Wales Daily News 37, 80
Southall, Middlesex 162
Southwark Echo 67
Spain 47, 99, 147, 149, 153, 154, 161, 170,
 181, 185
Special Areas Act 87
Spencer, Stanley 60, 98
Spender, Stephen 120
Sousse, Tunisia 52
Spry, Constance 148
Staite Murray, William 43
Stalin, Joseph 131
Startston Hall, Norfolk 173
Steegman, John 135
Stein, Gertrude 39-40

Stewart, Gerry 138-40, 182, 187
Stewart, Patrick 138
Stiff, Mr (gardener) 76
Stour, River 63
Strachey, Alix 65
Strachey, James 65
Strachey, Lytton 65
Stratford St Mary, Suffolk 137
Strathmore, Claude Bowes-Lyon, Earl
 of 144
Stuart Thomas, Graham 146
Stubbs, George 155
The Studio (magazine) 32, 62, 82, 127,
 158
Sudbury, Suffolk 10, 164
 Gainsborough's House Museum 10
Suddaby, Rowland 135
Suffolk 9-10, 16, 20, 23, 62-4, 72-4, 85,
 91, 95, 99, 109, 113 115, 123-4, 130, 134,
 139, 141, 143-4, 147, 161, 164, 172, 174,
 182, 185, 189
Suffolk Free Press 173
Sunday Times 54, 81
Surrealism 7, 8, 27, 37, 39, 47, 54-5, 60, 73,
 78, 80, 98
Swansea 13-15, 21, 88, 89

Talybont 92
Tanguy, Yves 54
Tawe Valley 14
Tchelitchew, Pavel 78
Tenerife 152, 154-5
Tennant, David 67
Tennant, Stephen 64
Tennyson, Alfred Lord, 'Maud' 106
Thesiger, Ernest 64
Thomas, Caitlin 77
Thomas, Dylan 77, 188, 103
Thorburn, Archibald 33
Thornton, Valerie 179
Tidcombe Manor, Wiltshire 68-9

The Times 28, 71, 72, 108, 114, 185, 190
Tizi Ouzou, Senegal 46
Todd, Dorothy, and Mortimer, Raymond, *The New Interior Decoration* 78
Toklas, Alice B. 39
Torremolinos, Spain 153
Transatlantic Review 42, 67
Tréboul, Brittany 55-6, 60
Tredegar Fawr 14
Tregurtha, Mrs 24, 29
La Tribuna 38-9
Tunis, Tunisia 50
Tunisia 48
Turner, J. M. W. 27
Twysden, (Mary) Duff (Lady Twysden) 42, 62
Twysden, Roger 62

Unit One Group 81
United Kingdom coalition government 87, 128
United States of America
 Depression 80, 87
Utrillo, Maurice 7, 80

Vail, Laurence 94
Vail, Michael Cedric Sinbad 94
Van Gogh, Vincent 22
van Horn, Countess 158
Venice Biennale (1930, 1932) 74
Venison, Tony 62, 143, 146, 156, 167, 181, 187, 189
Verlaine, Paul 41
Vignotti, Signor 21
Vlaminck, Maurice de 80
Vogue 55, 64, 67, 78, 150
Vollard, Ambroise 97
Vorticism 27, 29, 44

Wadsworth, Edward 28, 29, 31, 79, 100

Wakefield, Felicity 132, 176, 180, 185, 188, 190
Wakefield, Peter 132, 176, 180, 188
Wales 13-24, 68, 78, 83, 85-95, 115-17, 128-129, 180
 National Eisteddfod 130
Wales Magazine 129
Walker, Frederick 18
Wallace's Nursery 145
Walsall, West Midlands
 Art Gallery 147
 New Art Gallery 149
Walton, Allan 65, 68, 72, 79, 98, 115, 119, 126
Walton, Roger 79
Walton, William 64
Warburton, Joan ('Maudie') 105, 121, 153, 175, 184, 186, **15**
 at Dedham 105-108
 on fancy dress party 107
 on fire at Dedham 116
 on Guggenheim exhibition 110
 and Lett 184
 marriage to Peter O'Malley 137
 and Morris 189
 on Morris and Lett as teachers 107
 moves to Little Horkesley 182
 'Part of a Life' 106
 and refurbishment of Benton End 119
 and textile companies 126
 in Wales 115
 and Women's Royal Naval Service 120
Waterhouse, Alfred 18
Waters, Derek 125-6
Wells, John 147
Welsh Home Service, 'Welsh Art' (radio programme) 135
Wertheim, Lucy 56, 75, 77, 78, 119
Western Mail 33, 52, 86
Weston Hall, Northamptonshire 144

Whistler, James McNeill 25
White, Antonia 41, 94, 110
White, Trevor 126
Wickham, Anna 77
Wilde, Oscar 31, 66
Wilenski, R. H. 43, 44, 58, 61, 81, 100
Wilkes, Cicely 19
Wilkes, Lewis 19
Williams, Ivor 135
Williams, Shirley 107
Williams-Ellis, Clough 89, 92
Wilmington, Sussex 102
Wilson, Angus 68-9, 117, 119, 121
Winchester College, Hampshire 18
Wirth-Miller, Dennis 123-5, 126, 139,
 175
Wishart, Michael 133

Witch, Mr (solicitor) 123
Wivenhoe, Essex 175
Wogan, Judy 43
Women's Royal Naval Service 120
Wood, Christopher (Kit) 52, 54, 55–6,
 59–60, 62, 77, 81, 116, 180
 Boats in the Harbour 78
 memorial exhibition 77-8
Woolf, Leonard 65
Woolf, Virginia 7, 65, 66
Wootton Manor, East Sussex 68
Wright, Elizabeth 158
Wright, Tom 124, 137

Zadkine, Ossip 37
Zennor, Cornwall 23
Zimbabwe 177

PICTURE CREDITS

Front cover: *The Orange Chair*, Cedric Morris, 1944. © Bridgeman Images
Back cover: Cedric Morris (*left*) with Rubio the macaw, and Arthur Lett-Haines
(*right*) in Suffolk, early 1930s. © Tate London 2018

1. Fancy dress party in Newlyn, 1919. © Tate London 2018
2. *Brighton Railway Station*, Arthur Lett-Haines, 1920. Private collection
3. *Le Bon Bock*, Cedric Morris, 1922. Philip Mould & Company/Bridgeman Images
4. *The Italian Hill Town*, Cedric Morris, 1922. Philip Mould & Company/
 Bridgeman Images
5. *Composition*, Cedric Morris, 1922. Philip Mould & Company/Bridgeman Images
6. *Fantasy Landscape*, Arthur Lett-Haines, 1922. Private collection
7. Nancy Morris, Cedric Morris and friend, 1930s. Private collection
8. *Poppies*, Cedric Morris, 1926. Private collection/Philip Mould & Company/
 Bridgeman images
9. View of The Pound, 1931. ©Tate London 2018
10. Cedric Morris in Paris, 1920s. © Tate London 2018
11. Kathleen Hale in Paris, 1920s. Private collection
12. *Paul Odo Cross*, Cedric Morris, 1925. National Museum of Wales,
 Bridgeman Images
13. *Dowlais from the Cinder Tips, Caeharris*, Cedric Morris, 1935. Cyfartha Castle
 Museum/Bridgeman Images
14. *Polstead*, Suffolk, Cedric Morris, 1933. Cartwright Hall Gallery, Bridgeman Images
15. Cedric Morris with Joan Warburton, 1939. © Tate London 2018
16. David Carr and Lucian Freud, 1940. © Tate London 2018
17. *Heron*, Cedric Morris, 1941, Astley Cheetham Art Gallery, Stalybridge/
 Bridgeman Images
18. Cedric Morris resting in a hammock, 1941. Photograph by Elvic Steele
19. Cedric Morris and Arthur Lett-Haines, 1950s. © Tate London 2018
20. *Lucian Freud*, Cedric Morris, 1941. © Tate London 2018/Bridgeman Images
21. Pupil Ellis Carpenter at his easel, 1948, Private collection
22. *The Garden at Benton End*, 1950s, Kathleen Hale. Private collection
23. *The* Eggs, Cedric Morris, 1944. © Tate London 2023/Bridgeman Images
24. *Yalta* , Cedric Morris,1945. Prudence Cuming Associates, Private collection,
 courtesy Offer Waterman/Bridgeman Images
25. The Walled Garden at Benton End, 1950s. Private collection
26. Arthur Lett-Haines in his studio, 1960s. Private collection
27. Cedric Morris in the garden at Benton End, 1960s. Private collection
28. *Landscape of Shame*, Cedric Morris, 1960. © Tate London 2018/Bridgeman Images
29. Iris time at Benton End, 1960s. Private collection